One Brit, One Bike, One BIG Country

Or

How I Got Screwed By Harley
But Didn't Get A Kiss

By

John McKay

One Brit, One Bike, One BIG Country

www.onebritonebike.com
© John McKay

Published by Bronwyn Editions in the United Kingdom 2010

Edited by Bernie Morris

Cover design © by Robert Morris and Koi Quittenton

Photo's courtesy of John McKay

Printed by Lightning Source UK 2010

Dedication

To all my friends on both sides of the Atlantic who helped
me to make the trip
but especially to Tanja who first got me thinking that I could
write a book about it.

Names have occasionally been changed to protect the
innocent
And sometimes the guilty!

Table of Contents

WHAT'S THIS BOOK ALL ABOUT ?

To answer that question, this book is about the biggest adventure of my life. It's about ninety days of discovery and fun; it's about what I saw and what I experienced. It's also about having a laugh, and I hope it makes you smile from time to time. Really, this book is a diary of the trip. I don't claim to be the best writer in the world and I have to admit that I found putting it all on paper extremely tough. Therefore I sincerely hope you enjoy reading it – I really do.

So why does a man in his forties pack in his job and decide to earn nothing for a while? I wish I could give you a simple answer but there isn't one. A Mid-Life Crisis perhaps.

What I can say is that I was a hard-working salesman for an engineering company, putting in sixty to seventy hours a week; though in Britain I wouldn't think that was particularly unusual. The problem was that, although I continued to grow and develop the business for my employer, I was getting paid less and less, which didn't seem like a good deal to me. I'd worked for them for three and a half years and had increased the sales in my area by 350% but I was getting paid less than the day I started. Something had to be done!

I could have just changed jobs but didn't really want to find myself in a similar situation without doing something for myself first. You see, at that particular time I was hearing of many people with awful diseases, often terminal and, when my father was in hospital, I was shocked to see the young age of some of the cancer sufferers there. None of us know when our time is going to be up

so we need to make every day count. Somewhat a morbid and overused statement, but nonetheless true.

I needed a challenge that had something in it for me. I could have started my own business but I knew I wanted to do something different before throwing myself into a different job.

Motorbikes have always been a big interest for me so I started thinking about "tying" the challenge to them. I own a modern Triumph and a Harley Davidson, and it struck me that I could do a big journey somewhere. The more I thought about it, the more I was sure it was the right thing to do. The UK couldn't really offer a trip on the scale I was looking for, and anyway the weather wouldn't be all that brilliant. I thought about Europe, but again the weather isn't all that special and I had already travelled a lot around the Continent. I was toying with Australia but, quite honestly, the thought of doing a lot of camping in a country that is home to nine out of ten of the world's deadliest snakes didn't tick the right boxes. Then I started giving the USA more thought. It's a huge country with plenty to see, and incredible variations in terrain and weather but, best of all, I had never spent any time there.

About three days after I had made up my mind that the States was the right place for me, there was a man interviewed on Radio 2 who had just done an almost identical trip to the one I planned. Tom Cunliffe spoke with such enthusiasm for the adventure that it had to be an omen: somebody up there was telling me something.

Even though I'm single, or at least I was then, there was a lot to plan, and the task grew monumentally when I was invited to help relatives with a house restoration project in the Caribbean. The finances became more critical as I would now be without paid employment for about a year and I had to decide what to do with my own house, my two motorbikes, etc, etc.

I was lucky enough to have some money behind me and, with care, I could see that the year off was feasible within the budget. I put all my belongings into storage with the exception of the motorcycles, which friends offered to look after. The house went up for short-term rent through a local agency, and I found myself on a plane to the Caribbean.

Unfortunately, the project didn't go to plan and, two months later, I found myself back on a plane to the UK, with no house, car or job waiting for me. Not a great situation but I was sure that with some positive thought I could overcome these problems. I am also extremely fortunate to have the friends that I have. Within a couple of hours of being back in England, I had somewhere to live, the loan of a car and, shortly afterwards, a temporary job. I was overwhelmed by the way people helped me and I hope that one day I will be able to repay the debts.

Nevertheless I couldn't see any reason not to undertake the American trip, and the plan was to "kick-off" from Daytona Beach in Florida, because at the beginning of March there is one of the biggest motorcycle meetings of the year.

I intended to go for three months, which meant that I didn't need to apply for any special visas. There wasn't any real route plan in my mind as I envisaged making it up as I went along, partly because I suspected that I would be dodging bad weather so early in the year, and partly because I wanted to take advice of locals wherever I went. The only places I really wanted to see were the Grand Canyon, Death Valley, and possibly Las Vegas, but I was game for anything else along the way.

I would just add that on the request of some other bikers, I have sometimes put in road numbers and mileages so that if they find

themselves making a similar journey, they can pick and choose from my experiences. I hope that you will be amongst those making such choices. You would be amazed at how many people I met in the USA who asked about my trip and, when I told them where I had been and where I was going, they said they were planning on doing a similar trip "one day". Some of them had never been out of their home state. If this is the sort of thing that you want to do, then I can heartily recommend it. So go do it before it's too late!

All the best

CHAPTER ONE
CAMBRIDGE, ENGLAND TO DAYTONA BEACH, FLORIDA
AND BIKE WEEK

At last February 28th had arrived and my flight to Florida was the following day. I'd checked coach and train times and decided that the train was the best choice, as there were several leaving quite late at night that would get me to Gatwick very early the next morning. It seemed better than using the alternative as I would have needed a taxi to get into Cambridge at an unreasonable time. As it was so early on in the journey I had to watch the finances. I must confess I'm not one who likes doing a lot of planning, especially when it comes to trains and so forth, so I spent as little time as possible researching this part of the journey. That may sound odd for someone who was about to embark on a mammoth expedition, but that's just me. However, what I also know is that travelling in the UK without your own transport can be a real challenge, especially if you want to go, to or from, the "middle earth" of East Anglia.

I just had to say goodbye to all my mates, and the usual venue we chose for get-togethers was a local Indian restaurant. There we were, all sitting around a table, having enjoyed an excellent meal and all I had to do was make sure I left on time to get the train in Cambridge. Nothing to it really except the goodbyes stretched out too long and, although a friend took me to the station, I arrived just too late to catch the last train for London. The first one in the morning departed at 04.25 so I resigned myself to sleeping in the waiting room for a few hours, which didn't matter as it was pretty much what I would have done when I got to Gatwick. I had just arranged my bags around me and was making myself comfortable when the nice uniformed man from the station informed me that the waiting rooms were being locked up and that they closed the station completely between 01.30 and 04.00. As he threw me out

into the cold night air and locked the doors, he expressed his surprise that I wasn't going by coach, as it was, in his opinion, "much easier and better to get to the airports". Not a very useful comment but there was little I could do about it. Besides, the long wait outside wasn't too bad and, out of the wind, the weather was reasonably mild. I found a nice sheltered spot in the staff doorway to the café kitchen and fought the temptation to erect my tent, as it seemed more trouble than it was worth. Anyway, I would have missed the conversations that I enjoyed with Cambridge's pussycats as they strolled past the door, their startled little faces showing their surprise at seeing me. I daresay that I saved the lives of a few station mice that night by just being there, as there were so many cats out hunting.

Whilst it wasn't cold, the minutes ticked by very, very slowly. I hoped that missing the train was not another of those omens and indicating bad things would be happening on the rest of the trip; though, at the same time, if things were too easy, the journey would seem like more of a happy holiday rather than the great adventure I was looking for. Eventually though, the station staff rolled in and opened up the place, just a few minutes before the train was due. I struggled back into the old building with my battered suitcase and big holdall containing what I hoped would be sufficient for ninety days of travelling the American highways. Whilst it was a lot to carry, it didn't seem much to take for such a long trip. I was looking for a challenge and I was guessing that getting it all stowed away on a motorcycle might be the first hurdle.

Later, sitting in the airport, I marvelled at the amount of business the shops seemed to be doing. The consumer society was alive and well, and living in every one of the World's International Departure lounges. It's amazing that shortly after the Duty Free allowances had been abolished for travel across Europe, the airports seemed to have increased their shopping facilities

dramatically. For example, I know Stansted and Copenhagen airports quite well and they have sites that would challenge the facilities in reasonable sized towns. You could easily make big dents in your bank account if you were seized with the passion to buy all these things that you couldn't live without. I wondered what the driving forces were behind people spending money in the shops if they didn't qualify for the Duty Free discount. The prices wouldn't be much different from what they could get outside the airport. Was it the need to use up the local currency they had; was it boredom, or could it be that they had found the very thing they had forgotten to pack? I suspected that a lot of the purchases were just using up time, but that didn't matter to me. As I was travelling outside Europe, I did qualify for Duty Free and I could hear a bottle of Mount Gay Barbados rum calling to me. It was yet more luggage to carry, but I suspected that it wouldn't take up the all too valuable room on the bike as it wouldn't last long enough.

Having parted with my money, I hung around with loads of other bikers who were making the pilgrimage to the Mecca of Daytona. They were clearly identifiable by their biking jackets or sweatshirts with various motorcycle names and logos across them. One fellow by the name of Keith was covered with tattoos down both arms, with biceps stretching the thin material of his T-shirt. The artwork was intricate with dragons, knights, scantily-clad women and gothic- looking designs that apparently covered most of his body and had cost him frightening amounts of money. Tattoos don't appeal to me much, but I had to admire the workmanship as he told me the stories of what had inspired him to ask for particular designs. This was often women that he knew but he'd been sensible in not incorporating names into the images, with the one exception of his mother – Sally. Keith also related stories of his previous eight trips to Daytona Beach and the good times he'd had, as well as one particularly bad experience at one of the bars when he'd stopped in for a couple of beers in the early evening. It had been fairly quiet at first but he'd got talking to a

local lady there who was impressed with the artwork adorning his arms.

What she failed to mention was that her boyfriend was also a big hairy biker and was due to arrive any minute.

Keith and the young lady had shared a couple of beers and she was making such positive comments about his ink, he decided to give her sight of some of the ones I wasn't able to see, and wasn't going to ask to see either. Although he was in a bar, the drink had made him a little foolish and he dropped his jeans to show a particularly graphic example (or so he told me) on his inside thigh of a young lady in a tower who had lowered her hair to the knight below. He told me that she was naked. He trailed the line of the tattoo down his left inside thigh through his jeans, from his groin to his knee. Alas, just as he was showing the young lady, her boyfriend arrived and apparently the fellow disapproved of Keith's artwork. He walked up to him from behind and punched him in his back. Keith was a big lad but went down, probably partly due to having his jeans round his knees and not being able to stabilise himself. He wasn't sure how, but the fight was taken outside and although he was in a lot of pain he quickly recovered his position and started fighting back. Keith had learned to look after himself in the army and was gaining the upper hand when the other guy drew a knife. Without much trouble Keith took the weapon away from his opponent and tossed it as far as he could but, at that moment, two of his opponent's mates appeared and gave Keith a beating. As he told me he laughed about it and said they did a good job. He was just lucky they didn't use a knife and the boyfriend probably only drew it as he realised he was outclassed. I never did actually find out what made the tattoo so graphic or whether it was the British army in which he served, as I could detect an accent suggesting he wasn't originally from our shores.

I thought it would be good if the people I sat with on the plane were experienced Daytona visitors, as then I might learn a few

more things, though I suspected that I would get the only nerd out of the 400 passengers getting on board, just as I usually get the weirdo on a bus. My neighbours hadn't arrived as I took my seat and I was more than pleasantly surprised when a "thirty-something" vision of beauty asked me to get up from my aisle position, to allow her and her daughter to take their seats. Things are looking up, I thought. I obviously hadn't been paying attention, as it turned out that the man and boy sitting in the seats immediately in front were her husband and son, all off to do the usual theme park attractions in Orlando.

Her accent told me that she was from the southeast but I wrongly guessed at Essex. In fact, Jane was from Kent and her husband, Wayne, was from somewhere in south Wales, but I couldn't dismiss the Essex idea as I imagined a Mk II Ford Escort with a sun visor depicting the rhyming names of these two people across it in big white letters. Nevertheless, the nine-hour flight seemed to go a lot quicker with sporadic conversation with this lovely lady, about all sorts of everyday topics, including her family and job, whilst she kept me supplied with boiled sweets robbed from the bottomless bag that she had to pacify her children on the trip. When we landed in Orlando, I felt lucky to have had such a pleasant fellow traveller sitting by my side. She, on the other hand, probably thought how unfortunate she had been to get the only nerd out of the other 400 passengers on board. Funny how things turn out.

However, something was obviously not quite right in the State of Florida. It was cloudy and, according to the Captain's announcement, not at all warm. This was not what I had ordered and I thought that perhaps I had come to the wrong place. Alas, the ridiculously complicated arrival procedure confirmed that, yes, this was indeed the USA and the various signs around further confirmed that this was Orlando. Whilst in the Caribbean a few months previously, I had taken a week to visit Florida to organise

some of the more important points of the trip and had been just as dumbfounded by the bureaucracy then. What confused me greatly about it was... well– what is it all about? I appreciate I had to queue up to get through immigration and I have certainly been to worse places on that score. There was nothing wrong with collecting baggage and then getting through Customs, who seemed to base everything on the little white form I had to fill in, which incidentally I got wrong and got a real "telling off" for. What completely stumped me was that I then had my baggage taken off me again and got instructed to pick it up at some far off destination the other side of the airport. More queues followed as everyone, along with their hand baggage, got scanned and frisked, which to me seemed a little strange as every other country I have been to does this before passengers get on the plane, not when they get off. I think that's a sign of the American paranoia and lack of faith in anything non-American, in that they don't trust anyone but themselves.

After much walking and a train ride, I was once again re-united with my luggage whilst it enjoyed a second carousel ride, only one door away from the outside world, without any security method to prevent someone else walking away with it. I wondered if that ever happened, leaving some poor unsuspecting people without their personal possessions. I would have to admit, however, that the presentation of my cases would likely put it way down on the "most wanted" baggage list a thief might draw up. In fact, I was a little embarrassed myself in yanking my old battered suitcase off the conveyor, but it was my intention to ditch it anyway, so there had been little point in taking a sparkling Samsonite suitcase on the trip.

Hiring a small car was easy but, when I got out of the airport, I was confused by the road system, so ended up going north instead of southeast to the hotel at Kissimmee, that I stayed in on the last trip. No problem there though as, with a week's worth of USA driving under my belt from the last trip, I was "very experienced",

16

and I found my way without too many more difficulties. The good part of this was that the route took me past a Harley Dealer that I had not spotted the last time I was there.

I had done a lot of research into the possible places to buy the bike: in Orlando, Daytona and as far south as Miami, where friends had taken me on recommendation from a biking neighbour. Whilst it was important to get a good deal when I bought one, the most critical thing was to buy a machine that had a good chance of getting me round the States, a distance I estimated would be around 12,000 miles.

Once back on track, I found the hotel quickly enough and booked in, not expecting the massive price hike since my previous visit three months earlier. Apparently, Americans had got over the shock of September 11th and were now travelling again, resulting in hotel prices spiralling back to where they had been before. I consoled myself that for the next week I would be in a tent and that would be cheap enough, so I settled in for the evening to watch the TV and sample some of the weak-tasting American beer.

The USA has a 24-hour weather channel which can be useful to travelling bikers, so I spent a lot of time watching it and unfortunately it confirmed that the weather was not only cool in Florida but the rest of the United States was experiencing snow, rain and temperatures which put serious concerns as to my sanity in undertaking the adventure at this time of year. I could feel a little shopping trip for warmer clothes coming on if things didn't improve, and although it was damp across much of the USA, the weather wasn't going to dampen my spirits. I was so looking forward to this trip.

The following morning, the Interstate took me to Daytona and the campsite, which was looking extremely busy. People were flooding in, driving pick-ups, motorcycles and RVs, some with trailers and some without. A security guard on the gate was checking people's wrists for the plastic straps that indicated they

had already registered at the office. These bands were riveted on, meaning that they could only be removed by cutting them off, and were therefore in place for the duration of the stay. I later discovered that other sites used a similar system but with different colour bands.

As I couldn't offer the guard this fetching little fashion accessory, he radioed the site office that I was on my way, though so many people were booking in, it was obvious that the office staff were overwhelmed and had no idea which of the new arrivals had registered or not. Some of the staff were more "camp" than the site itself, but were friendly enough and were efficient in registering the guests. With so many coming through they had to be. I was instructed to follow a golf trolley down to the allotted area of short grass surrounded by undulating sandy ground. It reminded me of Thetford Forest, the bits that don't have any proper trees in the immediate vicinity, though you can see them in the distance.

I looked around for a place flat enough to put up the tent and with lack of sharp objects to penetrate the ground sheet. As I kicked the grassy tufts with my trainer, a question came to my mind as to whether alligators came this far north, but I decided that as there wasn't a great deal of water about, they probably didn't. They are far from being my favourite animal and, whilst I've seen people on TV dealing with these dinosaurs by hitting them on their noses with little sticks, I really didn't relish the opportunity of meeting one face to face.

I remembered a conversation that I'd had a few months previously with a man called George who works at Cambridge University. He told me that many years ago he had hitchhiked all round the Eastern seaboard of the USA, camping everywhere including the Everglades. George reckoned that he was quite safe as long as he remembered to do the tent zip up at night, otherwise the big old gators would likely put their heads in to see what was on offer. It seemed to me that if you're sleeping in a tent, with or

without the zip done up, it is just packaging around dinner to a hungry gator. Also, if you're in a tent when an alligator attacks I suspect there is very little you can do about it, unless you have a gun that is. I didn't have one and nor did I want one, but it did seem like a good idea to have some sort of protection against anything that might cause a problem, and I decided to see what I could find over the next few days. It was OK for people sleeping in trailers, but I was one of the few in a tent and I thought that I might be better off somewhere with a few more people around. There were almost no other campers on my side of the sandy track that led off further into the campsite and, although there was a tent to my right, the inhabitants were nowhere to be seen. Similarly, the tent closest to me on the other side of the track was closed and quiet, with no vehicles at either. Not to worry, I thought, I'm sure there can't be any crocs about, or they would have told me when I registered. Wouldn't they?

As I started erecting my little tent, a voice boomed from behind me asking if I had a fold-up motorcycle in the trunk of the car. I turned to see a tall slim man with glasses and a leather jacket, with a badge on the left lapel in the shape of the Indian motorcycle logo. I laughed in response to the joke and, with deliberately slow speech, I briefly explained that I intended to buy a bike whilst I was there. Jim and his younger girlfriend Kathryn had come for Bike Week and, like most people, had brought two vehicles with them. In their case it was Kathryn's car and Jim's Indian Chief, which he was utterly passionate about. After the introductions and setting up the tents, I offered to do a grocery run up to Wal-Mart. Jim decided to come with me and along the way he told me about his background and why he had bought an Indian. He was a very sprightly and young looking sixty-two-year-old, a serious biker who had done a staggering 24,000 miles on his machine since he'd bought it eleven months previously, though as he didn't own a car and was retired, he had plenty of time to use it. Nevertheless,

19

that's an incredibly high mileage for most bikers, let alone for someone in his sixties and on an Indian, as they make Harleys look like "state of the art" bikes.

It was through his biking interests he met Kathryn, but she was still working, so Jim took any opportunity he got to go on long distance rides. I was impressed that Jim was still biking so much at his age; the average age of bikers is probably higher in the USA than in the UK. Whilst there are many comments about Englishmen in their forties and fifties trying to relive their youth by buying plastic rockets, the biking scene in the States is very different. Harleys are the bikes that most people aspire to, despite their age or sex. The roads are generally straighter, so there is much less fun to be had from a modern sports bike, and bikers tend to ride longer distances so need cruisers or tourers, as plastic crotch rockets can be very uncomfortable after a couple of hours. My own Triumph gives me neck and shoulder ache after that sort of time and my Harley is comfortable as long as I'm not doing any sort of speed. The only plastic protection it comes with is a Plexiglas screen but I tend not to use it as it destroys the look of the machine. Therefore at speeds the wind force can make it very uncomfortable in a "sit-up and beg" position.

I dropped Jim back at his tent and saw that my nearest neighbour, across the track, had returned on his Harley Sportster. We introduced ourselves and I was amused to find that his name was Randy. I'd only been in the country twenty-four hours and I'd met someone with that unfortunate handle, though now I think about it maybe it wasn't his name. I'd just gone up to him, said, 'Hi, I'm John,' to which he shook my hand and replied, 'Randy.' Maybe it was a question; maybe it was a statement, but to be honest I prefer the original assumption. Anyway, having been amazed by Jim and his annual mileage, this man impressed me further by telling me that he had come down on his bike from New York, a distance of around 1,500 miles, but had only taken a couple of days. As I had

seen on the Weather Channel the conditions were pretty bad and, as a Sportster offers no protection from the elements, that was quite a trip. Good on him, quite some ride, and not like so many of the other bikers who had brought their machines down, on, or in trailers, only to off-load them when they arrived. Randy's journey was an achievement in itself and, quite frankly, not one I would have liked to make in that weather. We talked for a little while but he was a quiet guy and it was difficult to keep the conversation going. So, as I wanted to get down to the real "bike area" of the town, I made my excuses and left.

The area I was headed for is made up of Beach Street and Main Street and, despite the fact that there were so many visitors to the place, I managed to park up very close to the hub of it all. It seemed like everyone was out cruising on two wheels and mostly American wheels. I reckoned that, at a guess, around 95% of the bikes were USA born, and probably around 90% of those were Harley Davidson's. Whilst Indians, Victories and Buell's, as well as a full complement of foreign brands could be seen, the main manufacturer was very definitely HD. Apparently, Harley likes to include within its marketing, the statement: "Be an individual, buy a Harley". You would be more individual buying a Big Mac, which to me represents quite an interesting analogy as the material that used to hold together the main ingredient of the beef-burger, covered nearly every individual walking around the town. Everybody was wearing leather and nearly all of it was black, whether it was jackets, trousers, chaps, boots, gloves or just a waistcoat to pin all the badges on. Looking past the leather, there were so many big guts and long grey beards that you could be forgiven for thinking that you had stumbled on a convention for department store Father Christmases, though the acres of tattoos may have given it away. I didn't once spot "Noel, Noel, the Angels did say" in ink. Everyone was displaying their allegiance to the breed of motorcycle they rode, whether it was through tattoos, badges or T-shirts. How sad, I thought, that people need to show

their lack of individuality, and discreetly covered the small Harley emblem on my shirt with a pamphlet that some young lady had stuffed into my hand.

The bikes ranged from the bog standard, mass-produced items, to completely amazing works of art that individuals had poured huge amounts of money into. Many of them would have cost in excess of £40,000 and some probably as much as £60,000, without taking into account the hours that the owners had dedicated to their masterpieces. It was impossible to pick out individual creations as they merged into the utterly fantastic gallery of art that surrounded them. My eyes and brain became blind to the displays of imagination and skill that their creators had spent long winter nights on. Some of the machines were bizarre, from natty three-wheelers to a huge armchair being driven around the town by its owner, looking very relaxed, perched high upon it, though – like a four-year-old boy – dwarfed by the size of the seat.

There were vendors' stalls stuffed into every corner of every car park, belonging to the dealers and shops along the way, with a complete bikers' market crammed into the space behind the Harley dealership. You could pretty much buy anything you wanted at these stalls, from leather underwear to engines or complete bikes, though unlike British shows and meets, the prices weren't reduced. In fact they seemed pretty high to someone on a budget. I did treat myself to a bottle of leather cleaner which I was told was good for waterproofing too. The girl that sold it to me was clearly having a bad day and looked about as happy as a bulldog chewing a wasp. She reluctantly gave me a short and half-hearted demonstration of the black liquid and whilst it seemed to work wonders in hiding scratches and scuffs, I doubted its effectiveness in waterproofing as it was too runny. I wished that I had brought my little tub of Renapur with me, as I knew how good the wax is at protecting leather from rain. I had no doubt I would have some opportunities to assess the stuff, and I only hoped it was half as

good as the wax product, because Renapur was probably the only product that I didn't see.

Just a few stalls away I came across a company called Boss Hoss that I had heard of, but had never seen any of their products. These people take Chevrolet V8 engines and wrap trike bodies around them, resulting in machines upward of 300 horsepower, with one example on display capable of producing 550 horsies. Absolutely incredible to look at but I wouldn't want to ride one on anything but the straightest of roads. Got to say though, they must be a lot of fun pulling away from the lights, if you can keep the thing on the ground that is. I wasn't planning on doing the trip on a trike, however, and was keen to make progress in finding my wheels. I spent some time looking at the models on sale outside the Harley Dealer that purports to be the biggest HD agent in the world, though I found out later that this is only because the owner has seven shops around the States, so whilst the place was big, it wasn't as impressive as I imagined it would be.

Since watching the weather channel, I had changed my views on the type of bike that I was interested in. I had been saying that I would under no circumstances buy one of the monstrosities that Harley make with all the plastic luggage, screen and lower fairings. Having seen the video footage of the snow further north, those monsters weren't looking so bad after all, and there were definitely one or two bikes that were of interest to me in the used bike area. This was only an initial bit of research though, and there may have been other interesting machines available elsewhere, so I was in no rush. Besides, the day was drawing on, so I decided I'd come back for a better look in the morning.

Heading over the bridge toward Main Street, walking the pavements of the main cruising area was easy, but on hitting Main Street things changed. It was difficult to make progress as there were just so many people milling around like sheep, looking at all the wares the vendors had, or watching the pavement to pavement

bikes as they stop-started their way along the road, the riders gunning their engines and the loud exhaust noise reverberating off the buildings. Many people just stood on the side of the street and soaked up the sights and atmosphere, though there were a few shy young men who liked to try and introduce themselves to the lady bikers by holding up signs inviting them (in the time honoured fashion of bikers across the States) to "Show us your tits". I noted with some interest that several young ladies obliged by showing off their "Big Twins", which unsurprisingly promoted rapturous applause ☺. There was one rather suntanned beauty who stood up on the footrests of her partner's bike to ensure that everyone could see that she wore nothing but a skimpy little G-string. Whilst the garment could have been leather, I don't think it classed as good protective biking gear and showed a blatant disregard for health and safety. Shame that! ☺ ☺

When it comes down to it, it's what Bike Week is all about: showing off, letting your hair down and simply enjoying the fantastic atmosphere. There is always something to see and if you want to really get an idea of what it's like you need to be there. If you can't do that, there are some great videos about and I recommend Carl Foggarty's second video, which is all about Bike Week 2001, the sixtieth annual event. If you haven't seen it then get it, put it on, turn the TV up loud, sit back and enjoy!

I stood for a while on the corner of Beach Street and International Speedway Boulevard which is an area of the town where the bikers usually manage to open up their throttles a bit, after the slow cruise down Main Street. The noise was fantastic as the thousands of modified exhaust systems thundered by; in fact, I didn't so much hear the bikes as feel them from the shock waves and the vibrating pavement. If it doesn't give you a headache, it'll make you deaf! Not wanting to experience either of these physical problems, I decided to head back toward the car, stopping on the way to see a rolling road set up as a drag race event on the back of

a trailer. The idea was to bring your own bike along and race it against your mate's, who was right next to you, though neither of you moved an inch. Instead there were two strips of lights that illuminated as the imaginary quarter mile race progressed. When the bikes had endured the guts being revved out of them and turned the rollers of the road enough times to qualify them for the distance, the winner was announced, along with the time taken and terminal speeds. To me this got over the boring bit of drag racing. At the real thing, you can be near the start but only peer at the machines as they finish a quarter of a mile away just a few seconds later. Whereas if you're at the finish you don't get a good view of the start.

Of course, with this staged event you don't get the wind resistance slowing the bikes down, but I was impressed to see the Harley V-Rod manage 10.4 seconds with a final speed of 124 mph; not bad for a standard bike. I was also interested to see the different looks on the competitors' faces as they sped down the imaginary raceway. Some took a technical approach and looked down at their instruments to judge when the best time was to change up a gear, whilst others stared straight ahead, eyes glued to the "track" in front of them, with gritted teeth and the look of grim determination showing across their faces.

By the time I got back to the campsite it was nearly dark and I thought it would be a good idea to check out the toilets and showers whilst I could still see where I was going. With a beer in my hand, I wandered the several hundred yards along the tracks to the admin block where they were situated, and wasn't impressed to find that the Gents washroom had only one toilet, three basins and three showers. I had heard that there was another temporary shower block set up elsewhere and had seen some portable toilets, but these meagre facilities were intended to service hundreds of people, most of whom were camping in tents and not RVs, meaning that they had no choice but to use the

washrooms instead of their own onboard facilities. I could see that it would pay to get up early and beat the masses to their daily ablutions though, as I was to find out, many other campers would have the same idea.

I made my way back toward the tent, marvelling at the size of some of the recreational vehicles (RVs); a lot were coaches and often hooked up to trailers. Whilst walking past a portable toilet and gazing across at one fine example of a "Royale" RV, the toilet door burst open. A stocky dark-haired man emerged from the toilet and nearly walked into me, but then stretched out his hand and said, 'Hi, I'm Barney.'

Now don't think me unsociable but there were not too many options as to what that hand had just been doing, so I was a little reluctant to take hold of it. However, seeing as he was built like a brick version of the construction that he had just vacated, I thought it rude not to shake, so as briefly as I felt I could get away with, met his palm with mine. Barney took me over to the RV that I had been admiring and introduced me to his friend Phil, who owned the vehicle as well as a communications company in Dallas. Now, from Dallas to Daytona is around 1,100 miles and pretty much the same distance back again, which doesn't sound so bad until you take into account that the vehicle did somewhere between four and eight miles to the US gallon. That depends of course on traffic and whether it was hauling the big trailer that the boys had their Harleys in. This little trip was costing them dearly, but money seemed not to be a big problem to them. They took me to the trailer to show me the bikes and they were real works of art, particularly Phil's as he had spared no expense in building it up from scratch, choosing any component on its merit, never on the price tag. The guys had only arrived that afternoon and hadn't yet taken their mounts out of the trailer, fearing that the forecasted rain would mean a mammoth cleaning session ahead of them. Instead they had chosen to relax over a few beers and Barney was fuelling up well on the stuff. As he hadn't touched a drop of

alcohol in seven months, it was taking its toll but, as I said before, Bike Week is all about enjoying yourself. Before I was halfway down the tin of beer he had given me, he stuffed another into my hand and this continued for several more trips to his cool box. Phil was not drinking heavily and was beginning to get embarrassed by Barney's antics, so I decided on a tactical withdrawal back to my tent. I was glad of the beers though as this was to be the first night under canvas or, to be more accurate, my first night under nylon for many years and I was not really looking forward to it. I knew though that I had nearly ninety days ahead of me and there would be many more nights sleeping in the tent, so I had better get used to it. I crawled through the little doorway, zipping it shut behind me and bedded myself in the sleeping bag. I had taken the precaution of bringing a woollen hat with me and the cold night air proved it was a wise decision. Snuggling down into the bag with my ears covered by the hat, I fell asleep in just a few minutes. The sound of the other campers returning on loud bikes and the constant chugging of the generator powering the powerful campsite lights didn't bother me at all, and I slept through until morning.

When I awoke and ventured out of my synthetic cave, I noticed that there was still nobody occupying the nearby tent. There were no vehicles near it, so it seemed unlikely that the occupants had met an untimely death due to visiting alligators. Nevertheless I looked around the area from where I stood and noticed, some distance away, some logs on top of a grassy mound. I was fairly sure that they really were logs but couldn't understand why I hadn't noticed them before. I decided that whenever I was in the area of my tent, I would keep a wary lookout for "moving logs", though I still didn't feel inclined to go over and take a closer look at the ones on the mound.

Turning on the car radio, the news gave the tragic information that one person had already been killed at Bike Week. The

accident was really quite a freak and didn't involve any motorcycles at all. It seemed that a pedestrian was crossing the drawbridge to Main Street and paused to watch a boat approaching on the river. The bridge is the sort that opens up like Tower Bridge (a bascule bridge) to allow passing marine traffic, and then closes again afterwards. Unfortunately, the guy was standing right where the barriers were to stop traffic, but wasn't paying attention to them. The barriers move fairly slowly but have thin metal signs attached, and one dropped onto his head, apparently slicing into him. Had he been standing a few inches either way he would have been fine. The accident was quite bizarre and of course one feels sympathy for him, his friends and his family but it must also have been a major shock for the bridge operator. It was a most tragic and extraordinary incident.

I drove down to Denny's Diner for breakfast: a restaurant that is part of a nationwide chain and intended to be a traditional American roadside café, with a choice of sitting at the table or the counter. Waitresses were delivering the orders on massive trays, the size of dustbin lids, and the sight of these women with the platters held high above their heads reminded me of the cover to the Supertramp album "Breakfast in America" and that of course was exactly what I was there to have. This was my second visit on the trip, meaning that I was about to exhaust the vegetarian options. Yup I'm a vegetarian but, as they say, "You are what you eat" I guess that makes me a cabbage or something similar.

I chose the cheese omelette that apparently came with "grits". Now I don't know what it was about the thought of something supposedly edible that has such a name, but I had to work on the enthusiasm and challenge of eating it, whatever it might have been. There was a picture on the menu of the white goo and it was really testing my resolve to go through with it.

No, I thought, I will try this stuff, whereupon the waitress came and took my order.

'Grits or hash browns?' she asked.

Without hesitation my good intentions evaporated and I replied, 'Hash browns'.

It was in fact a couple of days later that I tried grits and, in my opinion, the stuff was easily as bad as I had anticipated. I can't understand the attraction of something for breakfast that seemed to me like some sort of tasteless tapioca, though it is actually made of corn and very much a southern dish. My recommendation is that if you haven't tried grits, keep it that way.

Back at the campsite, I found that Kathryn had abandoned Jim as she had to go back to work for a couple of days, providing him with a spare pillion seat, and me with an opportunity to take my first ride on an Indian. He told me that he had named his "Chief Low'an" after a ride through a canyon where he felt the bike was singing to him. Well, it had probably been a hot day and he hadn't been riding with a helmet, so maybe his mind had been playing tricks on him.

At the end of the Canyon, he had met some Sioux Indians and he had asked them what Sioux was for singer, to which the response was, 'Male or female?' Jim decided that the bike was male; after all it was an Indian Chief, and the Sioux gave him the translation of Low'an, with the additional comment that it was a very Indian habit to name something in that fashion. I climbed aboard Low'an and, as both front and rear seats had backrests, it was much akin to squeezing oneself into a snugly-fitting toast rack. Not only was it a little on the tight side, but I discovered that the front backrest could move, resulting in an increased pressure on my delicate parts whenever Jim leant back. Fortunately, it was only a short ride to the International Speedway where most of the major motorbike manufacturers were exhibiting. On arrival, Jim ignored the signs and marshals pointing to the bike park, and instead he headed over to the exhibitors' area, coming to a halt in front of the Indian stand itself. It was a habit he had got into to

limit the chances of his bike being stolen and, as there are few enough Indian motorcycles around, the staff never complained. I have to say that at that point I wasn't sure if my most delicate parts would ever recover and it took a while to wander up and down the stands looking at what was on offer. Whilst many of the manufacturers were offering demonstration rides, I couldn't take anything out without a US driving licence, though to be honest I wasn't that interested due to my "saddle-soreness".

Jim secured himself a ride on the new Indian Chief and looked very serious as he climbed aboard the machine. To him this was a big event as he was considering investing in one, but it didn't look like he was enjoying the moment at all. I noticed that the handlebars were extremely wide and, for someone as short as me, I would guess it would be quite a struggle during slow manoeuvres, as I would be unlikely to be able to reach one of the grips as it swung away from me. Despite this, it occurred to me that I could perhaps do my journey on an Indian and, whilst Big Jim headed around the test route, I had a chat with one of the salesmen to see if there was anything in the range that would be suitable.

Indian motorcycles were the first American bike; they produced the world's first V twin and are the oldest marque still in existence, but they have not kept up with the times. Looking at these bikes was similar to looking at a modern Royal Enfield made in India. They were shiny and new but very, very basic. There was nothing that could offer the weather protection I thought I would likely need; they were not particularly comfortable and it would be difficult to stow all my luggage on them. I had a long chat with Scott, one of the salesmen on the stand, but he admitted that their machines were not really the type of thing I would need for my trip and besides, I would almost certainly be buying a used bike and there were not too many Indians around. Nevertheless, he invited me to visit the factory in California and I promised that when I got to the area I would give him a call. It was at that point

that a completely non-serious looking Jim returned, beaming from ear to ear, and we made our exit, heading for the Harley dealership I had visited before.

There was a salesman, whom I shall call Jack, waiting to pounce, at the Harley dealer, in the way that I had come to expect from HD salesmen on the east coast of the USA. Basically, he didn't seem like he could be bothered to get off his arse and come over to talk to me, but with some persuasion and coaxing he reluctantly led me over to the "dressers". Dressers are bikes with all the fairings on and, after I explained my plan to sell again in three months, hopefully without losing too much money, he took me over to one fairly clean three-year-old machine with 8,570 miles on the clock. He managed to get a few words out about the bike – not too many as it would have taken too much effort – and then explained to me that they really were very keen to sell bikes during Bike Week as they "had to pay for all this". He gave a nod of his head out toward the stalls lining the street. Well, I thought, so you guys are being really generous and not charging all these vendors for the space? I don't think so somehow.

I enquired as to how much the bike was, and he told me $17,000 plus tax. I explained that I was going to have a look round and maybe come back later. His mouth dropped slightly but he took a business card out of his pocket and wrote the price down on it. Handing it to me he said, 'The price is negotiable, we can do a deal.' It was only later that I looked at the card and saw that he had actually written $17,995 with the word "TODAY" underneath and heavily ringed. Not bloody likely, I thought. If you want that sort of cash then the least you could do is work for it.

The bike was clean and in good condition but the colours weren't at all appealing in a burnt orange and silver. OK, colour may be a bit of a "girly" thing to pick up on, but I was going to be spending three months with the bike of my choice and we were likely to be having a close relationship, like being with a woman

for the same time. Well, perhaps not quite like being with a woman, but I hope you see what I mean. We needed to be compatible.

Jim and I spent the rest of the morning looking around the vendors' stalls as I had done the day before and, over lunch, we discussed the Harley V-Rod. He explained to me that Harley Davidson had no choice but to produce a new and water-cooled engine because of the rulings of the Environmental Protection Agency. The bike is a very radical shift of design for HD but it meant that the bike should return a higher mileage per gallon than the rest of the range. This is important because the EPA look at the whole offering that a manufacturer produces, along with the quantities produced for each model. They basically take the line that you can produce as many "gas guzzlers" as you want but the average consumption over the whole of the output of your range must meet certain figures. Failure to do that means heavy penalties and of course Harley were keen to avoid them. I wondered what Royale would be expected to get from their massive RVs when the EPA had done its stuff. Although the USA has the reputation of not caring about environmental issues, it is plain to see that they are making some progress with fighting pollution and, when it comes to vehicle emissions, the greatest opportunities arise. Take Bike Week for instance. There are somewhere in excess of 600,000 bikers expected at Daytona for the week's festivities. It probably isn't unreasonable to think that half of the bikes use about two gallons a day just cruising around or going to wherever it is they are headed for entertainment. If you then multiply that by seven, because not all the bikers come for the full ten days, you have 4.2 million gallons of fuel being burnt. Adding in the trucks and cars too, you can see that it is a serious event in terms of environmental damage. Of course it is one hell of a good thing for the local economy and you can add the accommodation, the food, the thousands of gallons of beer plus all

the extras that 600,000 people can consume in ten days, but at what cost? On top of that, you could include the smaller bike meet in October, as well as all the race meets for the NASCARs and so on. This just relates to Daytona, let alone all the similar events across the country.

Jim wanted to find some bike dealer friends of his by the name of Iron Horse Motorcycles (a very common name to be found during Bike Week) so we headed out along US1 looking for the sign on their trailer. There were bikes wherever we looked and, on every spare patch of ground there were stalls offering bikes and bike accessories. As passenger on the back of the Chief, I had the opportunity to look at our surroundings, though it was Jim who spotted a Harley with a number plate of a style he didn't recognise. We pulled up next to the bike at some traffic lights, the rider looking the part with his bandana, wrap-around shades, T-shirt and fingerless gloves. Jim leaned over and shouted to him above the roar of the bikes surrounding us, 'Where are you from?'

In a broad English West Midlands accent, the reply came, 'England.' As the lights turned green and the Harley pulled away, I saw the black on yellow English number plate, a fairly rare sight even at a major event such as Daytona, though this rider could obviously afford the shipping charges to get his pride and joy across the pond for the event. I have heard various figures as to what this costs and whilst I have not looked at it seriously, it seems to be around £700 for the return trip for a motorcycle. Wouldn't it just have been cheaper to hire one?

We headed on south in search of Iron Horse and I noticed an undertaker's sign, prominent due to its sheer physical size. Whilst all of America is prone to an excess of signs advertising every type of business, it seemed to me to be poor taste for this service to be promoted so strongly. After all, it is unlikely that the huge advertisement would pull in passing trade though, to be fair, Bike

Week was likely to bring them a concentrated amount of business, as there are a number of fatalities each year, with the first having already been announced.

Jim eventually found the Iron Horse Motorcycles stall which was purely aimed at selling bikes, though there was nothing appropriate for my trip. One of the staff was keen to promote his own Harley Ultra Classic, but the price was high and I would have to have driven eighty miles to see it, so it wasn't an interesting option. The search for my steed would continue and I would take another visit to Daytona Harley Davidson in the morning.

CHAPTER TWO
THE ADVENTURE BEGINS !

Someone I know was visiting Bike Week for a couple of days and I had made an arrangement to meet up with him and his mate; so after Jim and I had freshened up, and my voice had returned to normal after the tight squeeze on the Indian, we headed into town once again but this time in the hired car.

Carl is actually the Road Captain for the Harley Fenlander's Chapter in Suffolk, which means that he organises the rides out. We were to meet him at the Iron Horse Saloon (no relation to Iron Horse Motorcycles) about eight miles up US1 from the centre of Daytona.

As we drove out of the town there were fewer streetlights and less shops to illuminate the way until we got close to our destination. Suddenly we were in a brightly-lit area of organised chaos and I got the impression of something akin to the "Thunderdome" from *Mad Max*. It was an oasis of light amid the darkness, with police doing their best to direct the traffic into expensive $10 car parks or special (free) bike areas, that were usually outside the drinking establishments.

Inside the Iron Horse Bar, the impression of the Thunderdome was stronger, though the layout was something like a rodeo ring with a bar in the centre. Instead of seats around the outside there were stalls where you could buy just about anything made in leather, fast food, tattoos, bike parts and a whole other selection of items too long to list, but which were available all over Daytona. The building was constructed from wood with logs giving a rodeo effect and steps led to a gantry where there were more bars and an observation area overlooking the "burn-out pit".

We met Carl and Mike and went up the steps for a beer, non-alcoholic in my case, of course, as I was driving. It was quite interesting that many of the bikers were not drinking, especially

the older ones. Jim's theory was that as younger guys they used to do so much drugs and alcohol that their bodies now reject anything more than an occasional drink. Besides, the temperature was now down in the thirties and a cold beer was probably not as tempting a proposition as a hot coffee, but this was a biker place where coffee was for wimps.

Carl and Mike were both wearing jackets that had their Chapter patches or "colours" on the back showing that they were members of the Fenlanders Harley Owners Group. In England there is nothing sinister about this, but the history of the Hells Angels and other biker groups in the USA is very different, with the "clubs" fighting each other, often to the death, to defend or gain territory. It's just another form of gangland stuff where drugs and other vices are always involved, so the gangs are protecting illegal income.

Needless to say that the establishments do not welcome anyone they feel could be a potential source of trouble, so club colours are completely and rigorously banned. When the petite barmaid spotted the guys' badges, she told them to remove them immediately. Both Carl and Mike misunderstood what she said and thought she meant that they couldn't drink in this particular bar, so without removing the offending clothing they started to walk down the stairs. The little lady moved like a shot and was out from behind the bar to block their path. She stood up to these two men who dwarfed her and made it very clear that they had to remove the clothing there and then. Having had the message spelt out, the guys complied willingly; Mike took off the jacket completely whilst Carl turned his waistcoat inside out. The lady was satisfied with that and we positioned ourselves close to the burn-out pit to watch any action that might take place below.

The pit was an area specifically designed for people to destroy their tyres: a strange idea you may think and in my opinion you'd be right. For some reason volunteers put their front wheel up to a solid wall and then drive the rear wheel on a hard surface that has

been lubricated, usually with water, though sometimes an onlooker will add to it by pouring his beer on the ground, thus another big waste. A biker was already preparing for a demonstration and the smell of smoke and burning rubber soon filled the air. From where we were, looking down on the activity, the stench was overpowering, just like being next to a bonfire with a tyre on it. We retreated to prevent being overcome by the black smoke and had another couple of drinks, though the temperature was freezing and was exacerbated by the horrible wind ripping through the place.

It had been a short evening but we eventually decided that enough was enough and went our separate ways, Carl and Mike back to their warm hotel and we back to our freezing cold campsite. I noticed that despite the temperature, which seemed to be dropping even further, many bikers were still not wearing helmets. They had jackets, chaps, gloves and boots but still no helmets. It seemed strange that people would protect most body parts from the cold and unwelcome contact with the road but not the most important and vulnerable area. They would likely have said that they were exercising their right not to wear head protection as Florida had repealed the helmet law some time back.

Back at the site, the neighbouring tent still showed no signs of life and I couldn't make out the mound with the logs through the inky darkness, though I wasn't going for a closer look. It was good to get into my cosy sleeping bag, especially as the wind was building up further, lowering the temperature a few more degrees. I got to sleep quickly but woke in the night to find that it was also raining and raining hard. It combined with the wind to form a horizontal spray and had penetrated half the tent. Of course it just had to be the half that I was sleeping in and the damp was just beginning to soak through the sleeping bag. Wide-awake as I now was, it seemed that I had four options:

1. Hope that the water didn't penetrate my sleeping bag any further and try to go back to sleep.
2. Move my bedding to the other half of the tent and try to go back to sleep.
3. Go outside and see if I could adjust the flysheet to reduce the exposure to the horizontal rain.
4. Go and sleep in the car.

There wasn't much thinking time required. The car was dry and I spread the sleeping bag over me as well as running the engine for a few minutes to get the car warm. This was the sort of camping I could handle and I slept through until morning, whereupon the radio reported that the temperature had dropped to 34° Fahrenheit during the night, with 35mph winds, even though this was Florida. Looking around I could see that the campsite was extremely flooded in places, which got me wondering as to whether the area might now be more attractive to alligators. On top of this, I had fallen foul of the most terrible thing that can befall any man. I had a case of the sniffles with nobody to complain to or to give me sympathy.

The radio now reported that there had been thirteen biker admissions to the local hospitals.

After breakfast at The Waffle House, an experience I had no intention of repeating, I headed into town to have another look at the Ultra Classic. I hated the colour scheme of rusty orange and silver, but had pretty much decided that if we could negotiate a reasonable price, and Jack didn't pull any more fast ones, we would have a deal. The sooner I got a bike the sooner I had the option of getting off on the trip.

As I approached the machines lined up outside the shop, I noticed that Jack was nowhere to be seen. Instead there was an older man with long grey hair tied back in a ponytail. I started looking over the Ultra Classic, inspecting it for damage, looking at

the tyres and generally giving the man lots of "buying signals" just in case he felt that he might like to come and talk to me.

Interestingly enough, Ron was over like a shot and came straight in with a starting price of $16,400, quite a difference from Jack's opening gambit. I couldn't make eye contact with the guy as he wore sunglasses all the time along with a fixed smile, so it was difficult to gauge how much he was prepared to move on the price. Without too much difficulty he came down to $16,000 (plus tax) but no further, though this was actually the target I had set for the deal to take place. As he led me inside to sort out the paperwork, I asked him if business was good and he told me that this was to be the 56th bike that they'd sold that week. To him the week had started on the previous Friday and this was only Tuesday. The number struck me as being quite incredible, though Bike Week is undoubtedly their busiest time of year.

The paperwork required to buy a vehicle in the State of Florida, is a complicated business, with enough red tape to circle the town and still have enough left over for some pretty bows. Just as we seemed to be getting toward the end of it all, Ron dropped a fast one on me in the form of another $489 for the full service that the bike had received before going on the forecourt. He kept his fixed grin and still hid behind his shades as he explained that this was standard practice. The figure was already printed up on the sales form so this certainly seemed true, for this dealership at least. I thought, the bastard! But my choices were limited. He didn't look as though he was going to budge on this so I could either walk away or I could pay the money. I made the decision to pay, as this bike was the only suitable one on their forecourt. I could have spent a lot of time going around other dealers in Florida, but I would need to keep the car to do so and the overall cost would likely be higher. Besides, I knew that he was going to be upset when he saw that I was paying by credit card, as the charges would take a chunk of their profit.

I had set up a nice healthy limit with my credit card company before I left the UK as it was going to be the simplest way to take care of the transaction, and the method was a non-negotiable point as far as I was concerned. We completed more paperwork and I signed a few more forms and then Ron looked at me, or at least I assumed he did – it was impossible to tell.

'How are you going to pay,' he asked. This was my time to score a point back. I took out my wallet, opened it, and casually tossed my Visa card over the desk to him. Without even a hint of surprise, or a change to the fixed grin, he thanked me, picked it up and then left the room to get the authorisation. Well, that really took the wind out of my sails, but hey! I had wheels!!

Okay so the deal had cost me an extra $489 that I could have done without, but there was worse to come. If you've read Tom Cunliffe's book "Good Vibrations" you'll know that he had great problems getting insurance when he did his trip in the USA. I had looked into the difficulties when I had come to Florida on the trip a few months previously and knew that I could get insured as long as I had a base address in Florida. Fortunately, my friends, Anna and Vince had volunteered their address to use as a base, so I was not expecting any difficulties. Ron phoned The Riccard Group: the company most of the Harley Dealers seem to use for insurance and Bill Riccard came up with the best deal that he could, taking into account that I had no history of driving in the USA. The cost was a staggering $1,215 or, in English money £850, though this was for a year and he said that I could cash in the unused portion of the coverage when I left in ninety days. Looking at it that way, it was only costing me £213 and that hurt a lot less.

I'd asked Bill if the credit could go back against my credit card as I did not have a US bank account and he told me it could, so I coughed up again. Whilst Ron was faxing forms and copies of my driving licence back and forth to Bill, he left me with the lady who sorts out all the money side of things. She offered me the opportunity of taking out a Harley Davidson extended warranty at

a cost, for one year, of $649. Now one of the challenges of this trip was to get the bike to Chicago by whatever route I chose, facing whatever fate had to throw at me whether it be weather, mechanical problems, human intervention or my own foolishness. This was man and machine against the elements, against whatever the gods had to throw at me. On the other hand, a little extra insurance couldn't hurt, especially as I could also cash in the unused part of the cover when I came to sell the bike. 'Yes please,' I said and parted company with more hard-earned cash. This two hour episode had therefore cost me around £13,700 all on my Visa card, but with approximately £980 to come back on the two insurances, as well as whatever I was to sell the bike for when I left. On top of that, Ron announced with great enthusiasm that the purchase entitled me to two FREE T-shirts, maximum value of $24.95 each. With that news I was feeling much happier about the deal! Actually the outlay was pretty much what I had bargained for and I told Ron that I would pick up the beast in a couple of days.

There was a little unexpected bonus though, when Jack turned up and saw me completing the deal with Ron. His face was as black as his leather jacket when he stuck his head through the office door to ask why I hadn't asked for him. I simply retorted that I hadn't seen him about so got talking to his colleague. On one of Ron's trips to the fax machine I heard Jack corner him just outside the office door and voices were raised. Jack was clearly unimpressed that the bike had been sold to me for nearly $2,000 less than he had quoted. Shame!

I spent the rest of the day sending emails in the library, catching up on my writing for this book and general little things, but on my way back to the campsite I stopped at GI Jeff's Army Surplus Store to see what "security" I could buy. For some reason the shop was full of Germans stocking up on stuff, which apparently they couldn't obtain in their homeland. I thought it would be interesting to see the looks on Customs people's faces should they

search these visitors' luggage. However, I also found the perfect device for me, in the form of a flick-open truncheon, around ten inches long but, with a flick of the wrist, two spring sections would extend from the end giving a full length of about two feet, terminating in a nasty little solid block of metal. I was not intending to look for trouble but wanted something that I could keep handy on the bike just in case. With it being so compact, I could easily store it on the Ultra but within reaching distance if I should need it suddenly.

Pleased with my purchase, I headed back out of town to the campsite. The ground was still sodden with the previous night's rainfall and some of the tracks around the place had been closed, as the ruts were so deep. Taking a bike through them would have been asking for trouble but most people had wisely stored their machines away in trailers or under tarpaulins, waiting for the sun to show itself and dry the ground out. I noted that the owners of "the tent" had still not returned but it seemed like the logs might have moved just a little bit. I wasn't too happy at the thought, but there were more campers in the immediate facility, closer to the longer grass and mound where the logs were. Good news, I thought, except for the fact that these campers were all sleeping in RVs. Given the choice of food in a plastic wrapper or in tins when you haven't got (and don't know how to use) a can opener, you really don't have much of a choice to make. Even an alligator can work that out. It seemed like a good idea, purely because of the weather you understand, to sleep in the car again that night. It was warm, comfortable and with in-car entertainment in the form of the radio.

That night, I also faced one of the temporary toilet facilities for the first time. To be successful at this, you either needed to get to it just after it had been emptied, or you needed a very strong stomach. If neither of these requirements were met, then it was vital not to look into the abyss or you would be lost. The pile of

human waste building up just inches below your exposed body parts would likely cause involuntary constipation, as the brain took over and refused to allow your intimate areas anywhere near the mess. I thought back to something that occurred whilst I was serving in the RAF in Germany and working on Harrier aircraft. The Harrier Force would go off en-masse and hide in the German woods with the aircraft taking off from fields, temporary runways or even from roads. Whatever the location, the guys were all working as teams, a little community within a community if you like. Each team tended to organise their domestic duties and all built their own toilet facility, usually comprising a portable toilet in an enclosure, formed from extending a roll of hessian around three or four trees. There was one particular individual called John, not me in case you are thinking it, who liked to carry out practical jokes on people. One evening, just as it was getting dark, he moved the toilet to one side, dug a hole six inches deep, placed two sticks across the hole and put the toilet onto the sticks. He had no idea who his victim would be, but an armourer sergeant named Pat happened to be the first along. Pat did what one would expect, in dropping his lower garments, and sat on the toilet. The sticks broke, the toilet dropped the six inches and all the content of the container shot upwards from the shock. I really don't think that John had realised that the chemicals used to dissolve the matter are so aggressive, but you could hear Pat's screams from quite some distance as they attacked his most sensitive areas.

In the morning, I told Jim about the deal I had struck on the Ultra Classic and he immediately offered to escort me back to Orlando, so that I could drop the car off and he would bring me back on the Indian. If I were to deliver the car to the local agent in Daytona, it would cost me around another $200 and, amazingly, there was no easy way to get between Orlando and Daytona by train or coach. Despite my reluctance to give up my nice warm, dry, nightly refuge and not being overly keen on spending more time on a bike

where the seat rest in front put pressure on my delicate bits, it did seem like an excellent idea. I excused myself for a minute and donned an extra pair of underpants for padding before we started up the Indian and made our way out to Interstate 4. The only event on the journey to Orlando was a traffic jam due to an accident and the progress was slow. There were plenty of bikes about and the queue emphasised something that is very different between American and British motorcyclists, because Americans wait in line as though they were driving cars. It wasn't what you would have seen on a UK road, where the bikers would work their way up the line, taking advantage of the manoeuvrability of their machines. I guessed the American approach was partly because most bikes are cruisers and the rider isn't in the frame of mind that he would be if he were atop a plastic rocket, but to me it's a waste of one of the main benefits a motorbike offers you. Anyway, where was the rebel spirit of James Dean, Marlon Brando, or Roseanne Barr? Then I noticed in the wing mirror that there was a sports bike coming up the hard shoulder and therefore bypassing the slow moving queue. Great, I thought, but as he went past I noticed that it had German plates. That in itself was a little surprising as my experiences of Germany also suggested that they are a race to obey all the rules.

I remembered hearing a story about the local town where I was stationed, and they would ban all traffic from the town centre on particular days of the year. Now I didn't actually experience this but it was said that the locals would press the buttons at pedestrian crossings and, despite the fact there was not a hint of any traffic, they would wait for the green man to show before venturing onto the road. Mind you, had they not, they may well have received a jaywalking fine from any policeman that spotted them.

After dropping the car off, I climbed aboard the toast rack for the pleasant ride back, though Jim's bike was not really set up for

someone heavier than Kathryn on the pillion. The suspension bottomed out over the bumps and despite my extra underwear, one particularly heavy landing had me convinced that my physical condition had reverted to its state before my voice broke. I tried singing a few Bee Gee's numbers and was happy to establish that Brothers Gibb could still manage a couple of octaves above that which I could.

The relief to see the signs showing the mileage to Daytona decreasing was immense, but the traffic was so bad as we approached the town, Jim chose to take a different route in, via Ladies Professional Golf Association Boulevard. You just have to respect a nation that has street names longer than the actual roads don't you? The route was a good one though and we found ourselves at the Harley dealer in good time. A few minutes later I was the proud new owner of a Harley Davidson Electra Glide Ultra Classic, but as we drove back onto the road and past the shop, I noted that there were three more Ultra Classics in the used bike sales area. All of them with much prettier colour schemes than the one I had bought.

Now I do appreciate that beauty is in the eye of the beholder and that taste is a personal thing, but to me this was the ugliest motorbike on the face of the planet, excluding old BMWs of course. However, in terms of a touring bike there was not a lot to beat it, and actually nothing at all as I wanted to buy American. I was, after all, touring the USA. If I were touring the Far East I would buy Japanese, if I were touring the UK I would do it on a Triumph; Italy would probably be a Moto Guzzi and the Czech Republic... well, anything but a CZ as you have to draw the line somewhere.

However, with respect to the American creation I now owned, I have since been told that there are more American-made parts on a Honda Gold Wing than there were on the Ultra, as Honda make the Gold Wing in the USA. Oh and apologies to BMW owners, but as I said, beauty is in the eye of the beholder.

So what does the near-on 800 lb (before oil and petrol) Ultra Classic have, to make it a good touring motorcycle? It's got fuel injection. It has fairings to keep the weather off with little "glove compartments" in the bottom part. It has luggage space in the form of panniers and top box. Up front there are spotlights to make sure you get noticed. In terms of instruments it has the usual speedo and rev counter along with gauges for volts, oil pressure, fuel and air temperature. I noticed that the speedo and temperature gauge both went up to 120, but I knew that neither one of the needles was going to see their end stops, whilst I was riding it anyway.

The gear lever is a toe and heel set-up and the last thing I rode with anything like that was a Honda 90 back in the 1970s. There was a four station pre-set radio which also had a digital clock built into it. Controls on the right handlebar allow you to select between AM/FM, or automatic tuning to the weather channel that has an automated voice sounding much like Stephen Hawking. There were speakers front and rear if you were unsociable enough to blast your fellow motorists out with up to forty watts of power. With a helmet on, it was pretty difficult to listen to the radio anyway, and I'd guess that most people would use a headset helmet with microphone, allowing them to make use of the intercom and CB system, neither of which I really needed. If you know about big touring motorcycles, you won't be surprised by the next point, but I didn't and was amazed. The bike had cruise control. I kid you not! Cruise control on a motorbike! Not a thumbscrew to stop the throttle moving but full-blown cruise control.

Most unlikely of all, it actually had, as standard, a cigarette lighter. I felt like giving up a life-long abstention of the weed just so as I could make use of it.

So what did it lack? Well obviously it didn't have air conditioning and, as with most Harleys more than a couple of

years old, the brakes were an optional extra. When pulling up to a red light, it was best to think about it well in advance, as it was not so much like stopping the bike as landing it. I also found that there was some sort of psychological barrier to putting my feet down, but I got over that one as quickly as possible. I think it was probably due to having footboards rather than the footrests most motorcycles have. Jim told me that over long distances I would get to really appreciate the boards and he was right. They are much more comfortable than pegs. One thing that I knew I would find useful if the bike were to have it, was a compass. This machine is intended for serious touring work and, if you are lost, a compass is an extremely nice thing to have in front of you. I spent a lot of time over the next few days trekking round the vendors' stalls, trying to find a suitable item, but to no avail. Though one trader did tell me that I was the fourth person to ask him that week if he stocked them, so come on Harley Davidson – build one in!

A fellow biker told me that some models of Gold Wing also have a reverse gear and little wheels that come down when you're travelling below 4mph, but the Harley certainly doesn't have those. The person telling me could have been winding me up, of course, and yes I did realise that he was.

Something else it has that, in my opinion, a Gold Wing doesn't, is a hell of a lot of character, but I completely understand why some people would prefer a modern design of motorcycle against character, especially with the long distances that some American motorcyclists do each year.

Returning to the campsite, after we were both nearly knocked off our bikes, just half a mile from the dealership by some idiot in a pick-up jumping a red light, I confirmed something that I had discovered before taking the car to Orlando: I had lost my passport. I phoned the police and they gave me instructions on where I would have to go in order to complete the necessary

47

paperwork. A job for the next day, I decided, and happened to get into conversation with some new neighbours (still no sign of the missing tent people).

Mike, Sarah and Mary were three friends who had come to Bike Week, though none of them owned a motorcycle. I found it amazing that within an hour of meeting these people we had discussed American and world politics, motorcycles, books and the various parts of their bodies which they'd had pierced. Odd isn't it how a lady you have never met before, will share, in some graphic detail, how her most private parts had been operated on to have little bits of metal inserted. She didn't actually volunteer to show us, which was a good thing, as both Jim and I were completely embarrassed by the conversation already. However, I couldn't knock the hospitality of these people and Mike asked me over to their camp for a beer, before apologising profusely as it was cold. Americans still believe that the English like warm beer: a misconception due to American servicemen coming over in the war, when most pubs in the UK did serve warm beer. This fact migrated back to the USA and, like so many other things, it takes time to lose the reputation.

These three were party animals who planned to drink well into the small hours: a worthy cause for which to donate the bottle of rum, I thought. Several more of their friends turned up and joined us, whilst Sarah, a glamorous grandmother and bartender, ensured that everyone had a drink in their hands. She certainly made a mean rum and coke and the evening slipped by quickly. I just wish I could remember more about it. Much the worse for wear, I managed to make it to my tent many hours later and, in the morning, felt in no state to do anything requiring sudden movement, deep thought, driving or even stringing words together, so I spent most of it lying on my bedroll looking out of the tent door at my new bike. You know, despite what I said above about taste being a personal thing and all that, I looked at it with

the sun gleaming off the bright chrome and the dew glistening on the paintwork, and I thought... Bugger me, it's ugly!

It seemed like the rum had killed off my sniffles though.

Later in the day, when I was more coherent and could focus properly, I wrestled the bike over the bumpy campsite ground and went into town to do the appropriate paperwork for the loss of the passport. It was a simple task and only involved filling in a single sheet form, which the officer then photocopied and gave to me.

The remainder of the week slipped by as the sun came out and temperatures increased. I made several more tours around the stalls, buying bits and pieces for the journey, the most important of which was a cable lock to add to the bike security. The Ultra Classic has a very strange ignition switch design, meaning the key is taken out after switching the ignition on. Jim told me about bikers who would fill up at petrol stations and go inside to pay without locking the ignition off. Thieves were sometimes lying in wait and would jump on the bike, riding it away before the owner had a chance to react. Whilst I had no intention of locking up the bike wheels when refuelling, it was clear that I needed to do something to make it more secure, particularly as over 100 bikes are stolen each year at Bike Week. Unfortunately, I made a classic gaff and it is one I am reluctant to tell you about because I have made it before, and the ribbing I got from my biking buddies was merciless then. You can imagine what it will be like when they read that I rode off with the lock still fitted. Fortunately, the robustness of the Harley simply destroyed the lock without any damage to the bike.

I didn't partake in much of the high quality entertainment to choose from at various venues around the town, ranging from a multitude of wet T-shirt competitions, jelly and coleslaw wrestling, ice and sand sculptures, as well as live music at nearly

every drinking establishment about. The only band I did see, albeit briefly, was at the Indian motorcycle enclosure and had Johnny Six Guns as the lead singer. They were very good, but I wasn't tempted to see more as I was itching to get travelling, finally deciding to pack up on Saturday and head south. The original route plan only included a few places that I really wanted to see, such as Death Valley, the Grand Canyon and possibly Las Vegas, but as I was going south as far as Fort Lauderdale to see Anna and Vince, I thought it would be a good idea to go all the way down to Key West, which would be a good place to effectively "start" the trip.

Trying to get everything loaded on the bike was a challenge, but all part of the fun. The recommended maximum weight for items in the luggage was only 25lb, or a little over 11Kg, but this was a totally impractical amount for someone touring. Not surprisingly, I had to discard my old suitcase but was pleasantly surprised to find that the holdall would fit in the top box if it were folded. It was then a case of putting as many of the heavier items in the panniers, in order to get the centre of gravity down low. Even with the tent, sleeping bag and bedroll in bags across the pillion seat, it was still a tight squeeze to get everything on board and the back end of the bike was very heavy, meaning that it would be difficult to steer at low speeds.

After lots of hugs with all the ladies in the neighbouring tents, I waved goodbye to everyone and fought my way across the rough ground and out into the heavy Daytona traffic. The journey had begun!

It took a good hour to make it through to US1 and the temperature was building up. On the colder days we'd had previously, I hadn't noticed the heat from the engine, but now it seemed like there was a fan heater on my legs, slowly roasting me. I was glad to leave Daytona traffic behind me, heading south with the wind cooling the engine and me.

First stop was Cape Canaveral, just a short hop south and, after stopping the night in a small motel, I hit the Kennedy Space Centre when it opened at 09.00. It was a full $26 for entry, which was much more than I had bargained for and, although I planned to do a lot of sightseeing, this was one of the few extravagances I was going to allow myself. To be honest, I think it was well worth the money and I wished that I had been able to spend the full day there. Unfortunately, I needed to be away by about 1pm in order to get down to Anna and Vince at Fort Lauderdale at a reasonable time.

The entrance fee bought me a bus trip to various areas of the site and that on its own was fantastic in terms of the wildlife I saw. We had hardly left the visitor centre and saw a baby alligator; sweet it was, then shortly afterwards one much bigger. Okay it was probably only about six feet but that was plenty big enough for me. Apparently, there are around 5,000 of them in the Cape Canaveral area, and that got me thinking that it really wasn't that far to our campsite and those logs came back to mind. The bus drivers were also keen to point out a Bald Eagle's nest; that is apparently about the same size as a Queen-size mattress, but lumpier. It was interesting to hear that there are around 130 different species of bird life, as well as manatee and turtles (crusty meat pies if you're an alligator).

The exhibitions were dramatic, and I found the little information signs that were put up wherever I had to queue, most interesting. The highlight of the morning was the visit to the Apollo Centre where there was a real rocket, which I paced out to about 200 steps. I hadn't realised that the early days of the space program were so disastrous, and the fact that so many souls were brave enough to climb into these vehicles, knowing how many of the previous attempts had ended in failure. They were very brave people.

The tour included a presentation in what was said to be the original command room for the Apollo missions, where much of the equipment is not only on show but re-wired to show a simulation of the launch. Lights on the consoles flashed and overhead spotlights shone down on the seats in front of the desks, to indicate which position the audio was supposed to be coming from. Much of the presentation took the form of recordings of astronauts and ground crew on the Apollo program, but I have to say that, for a nation that first landed on the moon, with such incredible technologies on show and, as a tribute to the people who risked, as well as lost their lives, it would be nice if the engineers at the Apollo Centre could get the audio and video in synchronisation.

Before leaving the place I looked around a reconstruction of a space shuttle that is a fascinating spectacle on its own, allowing a cursory comparison of newer technology compared to that in the Apollo era. I wished that I could have afforded more time at the Space Centre as well as visit the nearby Astronaut Centre, but it was getting late. As I prepared to leave, the thought of the "logs" came to mind again and, whilst I have been told that alligators do not normally attack humans, unless they are splashing around in water, the alligators themselves may not know that. The exit route would take me alongside areas where there may well be alligators, so I put on my helmet and jacket, and then moved the truncheon from the top box to the glove compartment by my right knee. I doubted that it would be enough to see off one of these prehistoric creatures, but it made me feel a little better.

Fortunately it wasn't required and I continued the drive down US1, though it was slow and hot despite the breeze coming off the Atlantic. It was really surprising how the temperature had increased so much from a few days back and I was glad of my Roof helmet. It allowed me to use it as in "open face" style rather than full-face. They're a great design and being able to change quickly between the two modes meant that the style is ideal for changing

weather. Unfortunately though, it was such a good fit that I was unable to wear sunglasses for very long and discarded them, using the clear helmet visor to give me wind protection. As I was heading directly south, the "sit up and beg" seating position on the Harley, meant that the sun was right in my eyes, giving me a problem seeing where I was going, but I adjusted the full-face part of the helmet to just above my line of vision providing a good sunshade. It also gave me a little protection for my nose, which had been sunburned over the last few days and was peeling already. Unfortunately, the helmet could do nothing about the surprisingly poor road surface and all the traffic lights along the route, both of which were slowing me up considerably.

Where I could, I experimented with the cruise control but found it unnerving as I was not in command of the throttle and it wasn't very satisfactory on such a surface. I needed to be able to respond to any irregularities I spotted and take evasive action, using the throttle to accelerate or give me engine braking.

As I made my way through the heavy traffic, I caught sight of the reflection of the Harley in a polished aluminium lorry panel, and made a mental note that if I were to come across any Sioux Indians I would ask them what "bloody great ugly thing" was in their language.

With all the traffic and the lights, I was averaging under 40mph and, as the afternoon wore on, I realised that I was going to have to take another route, or I would arrive at Anna and Vince's place in Fort Lauderdale very late in the evening. I followed signs for the I95 highway, though the route took me west and I got only a little protection from the full-face visor as the setting sun was now very much shining in my eyes. It was difficult to read the road signs and make sure that I knew what the traffic around me was doing. I finally found I95 but my next problem was that the left-hand side indicators had apparently developed a fault, and were not flashing properly. For most Floridian drivers this wouldn't matter as they don't use indicators anyway, but as I was

now on a busy highway where drivers will overtake on either side, much more than even the worst UK drivers, I was a little uncomfortable with the situation. There was probably more traffic than normal on the road as many people were returning from Bike Week and some seemed to believe that they were actually on a race track, so I was very cautious. I arrived at Anna and Vince's place at about 7.pm, tired, with an aching backside, a sore nose and no left hand indicators. Vince was waiting for me in the driveway, concerned that I was so much later than expected, but they both extended a warm welcome and I was so very glad to see them.

CHAPTER THREE
THE HIGHLIGHTS OF FLORIDA

The problem with the indicators was not, as I had thought, a blown bulb. All were lighting, but dimly, and the flash rate was too fast. The only two things that I thought it could be were a bad earth or the flasher unit itself and, as the overall condition of the bike was so good, it seemed unlikely that it was the former.

Anna and Vince used Yellow Pages to establish where the nearest dealer was and we made our way down to it in the morning. I offered Anna a ride on the back, which she accepted and, on my insistence, she wore my Roof, meaning that I rode bare-headed. It was something that I wasn't used to doing and certainly not something I was greatly happy about once we got into the heavy traffic of the freeway. In some respects though, it may have been safer than riding with a helmet, because layers of fibreglass and foam weren't impairing my hearing and I could clearly hear the cars overtaking me in the nearside lanes. Maybe helmets could be better designed for sound, possibly with ear holes.

We arrived at Plantation Harley Davidson to face a big sign stating that they had moved, though this was still the correct address for police and other fleet bikes. Just as I was getting back on the bike to follow the others down to the new premises, two guys who obviously worked there, approached the building and, after a short dialogue, one of them who appeared to be in charge, told me to bring the bike round the back. They tried new bulbs to no effect and told me that they would need to investigate further, so there we left my new acquisition. It stood out like a sore thumb in its orange and silver amongst around forty other bikes, all of them black and white police machines. A rebel without a cause. Well, without indicators anyway.

Vince drove us down to the AAA: the American Automobile Association, which is similar to the British AA or RAC but on a larger scale. The plan was to get me maps and travel guides as well as roadside assistance cover, though I couldn't work out what had happened to my idea about man and machine against whatever the gods could throw at us.

However we found that AAA will not actually take on a motorcycle as a main means of transport so, instead of the fifty-something dollars they charge for a car, they actually wanted $114 for RV cover. This was going too far in my opinion and I really didn't want to fork out for a plan that would cover me for a forty foot gas-guzzling motor home when all I had was a two wheeled beastie. I declined the offer but, as Anna was a fully paid-up member she was entitled to maps and guide books for the whole of the USA should she so wish, and we left clutching a forest of paper that covered all the States I planned to visit at that time.

On my way down from Daytona, I had decided that I should make Seattle my most northerly destination, as it is the furthest point from Key West and I would then have been to "opposite corners". All in all, I had maps for eighteen states as well as some hotel guides, though I intended to camp as much as possible. Vince's view on things was that planning is all part of the fun, but had I got to this level earlier on, I would probably have been scared off. When looking through the detail at this level I fully realised the enormity of what I had taken on and it was scary. The details became gigantic hurdles that needed to be crossed, when in reality those problems might never have arisen, so there was little point in planning too hard to overcome them. I thought back to a book I read not so long ago by Robby Marshall: the story of going around the world on a Triumph motorcycle and appropriately titled "Triumph Around the World". I can almost respect his lack of planning. I say almost because I think he took the lack of maps much too far when he intended making the whole journey using

an old school atlas for guidance, but you should read the book and make up your own mind.

Despite the huge mound of paper I was destined to leave with, I am eternally grateful to Anna and Vince for getting me organised.

Anna and I spent much of the afternoon on the Internet in an attempt to find some low cost accommodation in the Key West area, the most southern part of the Florida Keys and, in fact, the most southerly part of the USA that you can reach by road. Only a hundred miles or so south of the Key is Cuba, and about two hundred miles to the east are the Bahamas. Unfortunately, this was March and Florida is very definitely "in season" with many people coming south for the winter, or at least part of it. These "snow birds" push the prices up and the result was that there was nothing available that could be described as low cost. What we did manage to find was the Kampsites of America website (www.koa.com) and it was very useful providing information on all the franchised sites across the USA. With such good information, I felt that I would likely be staying with them wherever I could and, whilst they are definitely not the cheapest, there is a discount system for regular users who buy a membership card.

Whilst I continued searching the web, Anna scanned the daily papers and read aloud to me, a report telling that there had been nine bike-related deaths at Daytona that week, which was three more than the previous year and was also the worst year on record for police call-outs.

It was grim news, but I was looking forward to getting back on the road so, when Fred from the Harley dealership phoned a little before closing time, I was eager to hear what he had to say. Alas, they had not been able to fix the bike but had ordered a flasher unit, as it seemed the most likely item to be causing the problem. It seemed strange to me that it had been so difficult to ascertain

what the problem was. Admittedly I'm from an electronics background, but I would have thought that some simple wire-swapping and voltage measurement would have done the trick. Of course I was in this man's hands and had no choice but to accept what he told me, but it was late the following morning that he phoned again to say that the part had arrived. However, they were also having problems getting authorisation for the repair to be carried out under the extended warranty, as the policy was so new. Nevertheless, when I arrived with my copies of the paperwork, Fred was well on the way to getting it resolved and "all" I had to part with was the $50 "deductible" or in English, the excess. I can't say that I was happy about paying anything but the problem was not the dealerships' and, if I was going to have any recourse, it was with the people at Daytona.

Whilst everything was being sorted out, I also had a conversation with Fred as to what grade of petrol I should be using. Unlike the UK where you basically have the choice of leaded substitute, unleaded or diesel, in the USA the octane ratings are stated on the pumps and can vary depending on manufacturer and location. Vince had advised me that in some of the more mountainous states, it was difficult to get high-octane fuels, and I was also a little concerned as to whether the mixture would need altering in some way in the mountains. I'm not used to fuel injection on a bike and wouldn't have had a clue what to do.

Fred advised that I should always use the highest octane that I could obtain and the fuel injection would be fine. Petrol is much cheaper in the USA than it is in the UK and, at around $1.2 per US gallon in Florida, it works out to be about a quarter of the English equivalent, so I wasn't too worried about the price.

Having got my steed back in working order, Anna led the way to the Turnpike (or toll road) and we waved our goodbyes. I had decided that I would take this road as far as it went purely because it would get me south quickly and I would make the KOA campsite twenty miles north of Key West during daylight hours. The traffic

58

was relatively light but that wasn't surprising considering the frequency of the toll plazas. It made me wonder why there isn't a more efficient system for collecting these charges as well as why a motorcycle is classed at the same rate as a car, though I suppose I should have been grateful that it wasn't classed as an RV. It seemed to me that there are a lot of countries around the world that impose tolls on their roads to a far greater extent than we do in the UK, so perhaps our government should impose a tax on anybody who holds a driving licence from those countries who either brings in a vehicle to the UK, or even rents one when driving on British soil. On the other hand, the American (and other) governments could give foreign visitors a pass to get them through the tolls without charge. OK, I guess that's just wishful thinking!

Once off the Turnpike, I was back on to US1, which is the only way in and out of the Keys by road, being 126 miles long with over forty bridges connecting the small islands. Traffic is slow with the speed limit often down to 45mph or below, though I would have been grateful to have made that pace at times. Over the years, the developers have attempted to increase the road capacity and build up the Keys for more tourism, but have never been allowed. The result is that during this time of year the traffic is very near peak capacity and there were few opportunities to overtake because of the oncoming vehicles. On the first part of it there were signs reminding the impatient driver that there are overtaking points coming in a few miles, and that not all drivers that have taken a chance have made it. I could easily understand why people might take the risk when stuck behind a slow moving truck for mile after mile, maybe with kids in the back of the car doing the "Are we nearly there yet?" bit.

The first time I got a good view of the sea I was completely struck by the most amazing colour of it. It seemed an almost luminous

azure and, with the road being so low, I wanted to stop and take it all in, though there were few opportunities on US1 unless I'd taken a side road off into one of the other Keys. As I was keen to get on and find the campsite before dark, I pushed on through islands with names that struck familiar tones, such as, Key Largo, Marathon and Sugarloaf Key, all of which were beautiful despite the Floridian propensity for signs advertising just about anything. I lost sight of the water for quite a while whilst passing through Marathon, but then got the full benefit of the Seven Mile Bridge that, according to my instruments was 6.9 miles but hey, that's close enough. For the first part, the view to the right was partly obscured by a footbridge, but then the road rose to allow ships a route underneath. There was a break in the footbridge at that point; anyone wishing to cross it needed to push out an extendable gangway, so I took my eye off the road momentarily for a quick look around. My gaze was met with a great view of the Atlantic on my left and the Gulf of Mexico to my right, the sea now closer to a beautiful aquamarine and was as calm as any I've ever seen, but it also felt a little strange. There was less and less land in sight; it seemed as though I was driving to the end of the earth and when I got there I would fall off. It was a truly weird and unnerving feeling. I also noticed that there were an increasing number of bikers coming the other way and, for the first time since arriving in the USA, they had started acknowledging me. Unlike the usual nod of the head that I am used to in the UK, it was a much more relaxed extension of the left arm terminating with one or two straightened fingers, and I should perhaps emphasise that arms and fingers were always horizontal and never vertical. It was a good feeling of camaraderie and made the journey all the more enjoyable, though I was feeling more pressured to find the campsite before dark as progress had been so slow. As it was, it turned out to be very easy as the website had indicated that it was just north of Mile Marker 20.

In the Keys, the method of indicating how many miles something is from Key West, is by the green and white signs at the side of the road, that state the mileage on them. It is an important navigational tool and some shops and restaurants are even named after the mile marker within their proximity.

Booking in for two nights, I paid the $10 for KOA membership, which allowed me 10% discount from the extortionate $88 for the stay. The site was probably the most expensive campsite in the whole American KOA Empire, and was much more than I wanted to pay, even for any motels I was to stay in. It was high season and the price reflected the popularity of the Keys, though the campers were packed in like sardines in a tin. To be fair, the place had plenty to offer in terms of facilities such as a café, a bar and entertainments for children, though I just needed a place for the tent as I wasn't staying for long. Of course, it would have been rude not to have shown some appreciation for the facilities so, once I'd pitched camp, I took a trip to the bar for a couple of bevies before bedtime.

It was a short ride into Key West around 9.am the following morning and I was pleased to discover that motorcycle parking is plentiful, with lots of designated areas, all of which were free, so it was my kind of place. I wandered around for hours just taking in the sights, seriously impressed at the way the place was set up to relieve visitors of their money. Apart from the shops offering all the normal sort of tourist souvenirs, other opportunities included the chance to sail in a glass-bottom boat, go snorkelling, parascending, swim with dolphins, jet ski and so on. Venturing away from the main tourist areas of Duval Street and Mallory Square, I got to see the local architecture, which mostly dated back to the nineteenth century. The quaint little houses were invariably made from wood, with balconies, and shutters to protect the windows from violent storms and the hot sun. Though it's had a chequered history, the island is once again wealthy and the

buildings well maintained, looking as if they had only just been built with perfect painted boards and neatly maintained gardens. There was very little traffic on most streets, so I got a real look at what the place was like a hundred and fifty years ago. It wouldn't have been at all surprising to see the occupants emerge from their houses in period dress.

As with the rest of Florida, Key West is a popular place for bikers. The island is only seventy miles or so north of the Tropic of Cancer, and the almost guaranteed sun attracts many a Harley owner; so the quiet was often disturbed by the sound of a big V twin cruising up and down the local streets.

Back in the real tourist areas, the high number of groups of young women wandering around struck me as being unusual. They were obviously from out-of-town from the guidebooks in evidence, though there was little in the way of other clues to suggest why they were there. The numbers in the groups varied between two and six and were mostly four in size, but there were so many of them. Key West has a large homosexual and lesbian community and I wondered how many of these groups were attracted there because of the reputation. OK maybe my imagination was working hard there!

I stopped to read up on the history of the place and learned that the island was originally inhabited by the Calusa Indians, but later replaced by the Seminoles. The Indians left the bones of their dead in the sand dunes along the beaches, causing the Spanish to call the island Cayo Hueso, meaning Bone Island. Past ownership of the place seemed to be unclear and, although the Spanish claimed it in 1763 as part of Florida, the English didn't recognise the claim until 1863, when they "gave the islands back" to Spain to prevent the United States claiming them. Along the way, the name of Cayo Hueso got anglicised to Key West and eventually, in 1821, the United States took control of Florida and the Keys.

In the 19th century the island and islanders got very rich through "wrecking" or salvaging the goods washed up due to ships

being destroyed on the many Keys and coral reefs. In fact, at the height of the industry there were between fifty and seventy-five wrecks a year off the coast, most of which were laden with valuable cargo. Vince had told me that the $20 tours of the island on the Conch Trains or Trolley Buses were very good, but I opted for an $8 visit to the Shipwreck Historeum instead. What I got for the money was around forty-five minutes of top-notch entertainment with actors, videos and artefacts, dating back to the 1856 wreck of the Isaac Allerton and the years of a gentleman called Asa Tift, who was one of the richest men on the island when it was the richest place in the USA. I would guess that his sort of position carried a lot of weight and power in those days.

Most people would likely think that the wreckers were leeches making profit on the misfortune of others. This is of course true, but they saved thousands of lives whilst doing so and, even today it could be argued, there are many who make their living from others' bad luck, such as, car body repair shops, doctors and even plumbers on occasion.

The wreckers were acting legally and risking their lives to save the wrecked mariners, and the cargos the ships carried. You could say that the booty they recovered was their recompense for the aid they gave the mariners and, if the opportunity to recover it had not been there, there is little chance they would have been out on the beaches in stormy weather or even lived in Key West at all. Many people would have subsequently lost their lives.

The presentation gave an insight into what life was like for the inhabitants of the Key, as well as pointing out the local historic buildings that Asa Tift was responsible for, some of which I could see from the wrecking look-out tower on top of the building.

In the 1800s, the residents of the Keys and the mariners of the ships that sailed in the area, had no benefit of modern navigational aids or weather information. It is hardly surprising that so many vessels came to grief shipping their cargos between New Orleans, the Keys and the rest of the world. The fragility of

life around the islands was brought home to the residents only four months before I visited, when they'd had a compulsory evacuation due to Hurricane Michelle heading in their direction, though fortunately it never hit.

The importance of the Key as a strategic military position meant that a naval base was established as early as 1822, and later in the century many Cubans had begun to settle on the island, bringing their culture with them. One of the single major influences on the island happened in 1912 when the railroad arrived, using many bridges daisy-chained between the islands, though by this time the wrecking industry was also coming to an end. The railroad, steamships, better navigational instruments and lighthouses, all took their toll on the island's way of life, but the build-up of World War I and then the prohibition, provided opportunities for rum-running from the Caribbean. These helped to sustain the wealth of Key West, but later two factors that hit the economy were the depression and then in 1935 a hurricane destroyed the railroad. A unique long-term recovery plan was formed to attract artists, writers and tourists and the old railroad bridges were utilised to form an overseas highway. The plan worked and attracted great historical names such as Ernest Hemingway and Tennessee Williams. Now the tourist industry brings in hundreds of thousands of visitors each year so the island is once again flourishing.

I took the opportunity of visiting the library to pick up emails, as I was beginning to miss all my friends and, whilst I knew that I had to get through many more weeks travelling alone, the ability to communicate so easily via email made things better. Most USA libraries have internet facilities but a few of them are a little restrictive if you don't live in the area and Key West is one of them. I was told that as I wasn't a member I wasn't allowed internet access, but seeing my surprised face, the lady told me that if I took a seat there would be a PC available in a few minutes so I

could use it if I wanted. I sat down, whereupon the woman immediately forgot about me and went to lunch. I did get my time on the computer but only after explaining the situation to two more people who also told me that I wasn't allowed because I wasn't a member before they too relented. Whilst I appreciate their view, perhaps they should also consider that the area is so wealthy because of the tourists that visit the island.

It occurred to me that it would be a good idea to see if I could cash travellers' cheques without a passport before I really needed more cash, so I found a bank and ventured in. The only two people inside were two young, stunning, black ladies who were clearly bored as they were doing their nails and talking to each other as they did so. One of them reluctantly got off the desk she was sitting on and headed over to her own position, which was at the front of the office. The place wasn't like a normal bank in the UK but more like something out of the old western films with the absolute minimum of security. There were no high dividing walls and glass screens, just desks really. I walked over so that I was in front of the desk she was now occupying and explained that I wanted to cash a traveller's cheque, and the transaction proved remarkably easy. I produced my new-style UK driving licence and was not even asked for a passport. However, the young lady produced an inkpad and said, 'Please would you give me a thumb print on each of the cheques?'

I must confess I was a little surprised but replied, 'Of course. Is this normal procedure?'

She looked at me briefly whilst filling out the necessary paperwork. 'Oh yes,' she said, 'We ask everyone to do this.'

I started putting my print on each of the ten cheques and then a little joke crossed my mind. I said, 'At least you can match this with my criminal record.'

She said nothing for a second or two and I could see that she was processing the information. Slowly, deliberately, and without looking up she asked, 'Do you really have a criminal record?'

I couldn't resist the opportunity and came back with, 'Oh yes, Geri Halliwell singing "It's raining men".'

I waited for her to get the joke. Then I waited some more. Now she may never have heard of Ms Halliwell, but I didn't think it was particularly difficult to understand. I would have been happy with a hint of a smile or anything else that showed some appreciation of the humour, but there was complete silence, not even a glimmer of recognition or understanding showed across her face. Instead she counted me out the $200 and handed over the cash. 'Thank you,' she said, 'Have a nice day.'

Feeling cheated, I made my way back to Mallory Square and, as it was now 4pm, I decided that I would wait until sunset for the "world famous" Sunset Celebration. At Daytona, Jim had told me about something called "The Green Flash" which can occur in extremely clear air at the very last second the sun sets below the horizon. Apparently pilots will often see four or five of these events in one day as, when they have seen one, they will gain altitude so that they can watch it all over again. I had served twelve years in the RAF and I didn't think that I had ever heard of the phenomenon but definitely wanted to experience it. Sunset was due at around 6.30pm so I found myself a shady seat on a low wall and watched the world go by. Before too long the evening street artists and vendors began to appear and stake out their pitches. Slowly, the wall began to fill up around me too, including two young and very attractive young ladies immediately to my left.

One male performer, not ready to start his show, left his group and came over to sit on the other side of the girls. He immediately launched into a "chat-up" on the girl closest to him and was obviously enjoying himself. After around fifteen minutes or so her friend got bored, or jealous, and leant over sideways to put her

head into the girls lap. The first girl started fondling the head and shoulders of her friend in a manner that gave a very strong signal to the male visitor. He tried not to show any surprise or disappointment on his face, but I could see it in his eyes. He had received the message loud and clear, so shortly afterwards he got up and returned to his colleagues. See, I wasn't making it up about the gay community!

As the sunset drew closer, I took up a place in the crowd gathering at the edge of the dock to view the spectacle. There was plenty to entertain me whilst waiting, for if the people and conversations happening around me were not enough, there were show-offs on jet-ski's performing just off the dock. A pleasure boat made its way past too, full of young guys, many of whom thought that the crowd would be entertained by the sight of them mooning. More than one camera caught the moment for posterity so I guess that they were right.

The pinks and reds of the sky were beautiful, but there was only slight cloud, which I thought a bit of a shame, as a little more would have made the sight more spectacular. As the sun sank lower and lower, a hush fell over the crowd and all heads turned to the west, many of the people clutching cameras, some cheap "point and press" and others expensive, professional-looking equipment.

It has always struck me as interesting that the sun takes all day to go from horizon to horizon, but at its extremes you can see it moving like an express train. It's like its diving for cover, trying to catch people out before they get a chance to take a picture of the great moment, and that night was no exception. The last few moments passed quickly as it disappeared. Did we see the Green Flash? Well, just at the critical moment a boat passed and blocked our view, though I think it was too far away for the people on board to hear the jeering that came from the dock. Unfortunately, then it was all a bit of an anti-climax and I was left wondering what to do next. Although I had been told that the nightlife in Key

West is pretty wild and should be experienced, I decided to return to the campsite for an early night. Despite being only twenty miles, this was the first part of my journey north, and I felt I had hit a "milestone" on the trip. It was the real start of the journey from coast to coast, and between the diagonal points of the southeast and the northwest. I felt like I had a destination to get to and I wanted to make some progress towards it. I was looking forward to getting on the road in the morning; but first of all the nightly beer was called for, so once back at the campsite, I headed to the bar. Before I had even ordered it, a fellow camper started talking to me and, within ten minutes, he had told me how lucky we English were that the USA had won the war for us; that his home state of Wisconsin is the size of Europe, and makes the only beer and cheese worth having in the USA. I was getting wearier by the minute and made my excuses, but later I measured Wisconsin on the map. It's approximately 240 miles wide by 320 miles long; allowing for our coastline, the area probably isn't much different from the British Isles.

Breaking camp early in the morning (odd expression), I pointed the Harley back up US1 hoping that I would have the opportunity to see the bright green of the sea again. Unfortunately, the sky was very overcast and with no wind, the sea was incredibly still. The reflection of the clouds on the water made it look as though it were milk, so it was more "interesting" than "impressive". Further north, the sun shone briefly giving it some colour but alas, it was nothing like I had seen on the way down.

As I had left early, there was little traffic and I made good time to the top end of the Keys where I saw a temporary road sign announcing "State Prisoners At Work". I had visions of Paul Newman in "Cold Hand Luke", stuffing hard-boiled eggs into his mouth and tying a string to a bush so that he could pretend to be behind it relieving himself, when in fact he was making his escape. Passing the prisoners, I looked out for an overweight guard with

shotgun and sunglasses, no doubt chewing tobacco. Unfortunately, there was nothing of the sort and the workers looked like any other group of men cutting back the undergrowth and loading it onto trailers. Still, the incident put Chrissie Hinds singing "Back in the chain gang" blasting away in my mind for hours and I was grateful for it.

I wanted to get some miles behind me and had decided not to take the route through the Everglades, but instead to go back up the Turnpike and across State, via I595 and I75. The latter part of this route is known as Alligator Alley, which I thought would be interesting and I was glad to see that the waterways next to the road were fenced off, making the route very animal free. I had seen a large variety of dead wildlife next to many of the roads I had travelled to date, but of course the wildlife was very different to what I was used to in the UK and was hard to recognise. On Alligator Alley there is almost nothing, as the animals can't get through the fences.

Around half way along the road, I spotted a van pulled over on to the grass and there was a man with two boys standing by the fence, peering at something on the other side. Curiosity got the better of me and I slowed down to see that only a few feet the other side of the mesh were two alligators around six feet long. I must confess I was tempted to stop for a look but still wanted to get some distance under my belt, so drove on. Only around another hundred yards further, and before I had really got the speed back up, I spotted another gator through the fence, but this was black and, by my estimate, a twelve foot long monster. I very definitely didn't want to stop now and wound the throttle wide open until I reached 80mph. The sight of that thing really woke me up and I kept another wary eye open for "logs" on the road but was glad that I saw none.

The I75 took me north to the I275, across to Madeira Beach near St Petersburg and via the Sunshine Skyway Bridge. The toll to cross this construction was the sixth that I'd had to pay that day, but it was worth every cent as the bridge is five and a half miles long with views that were fantastic. It seemed like there was no land on either side of it, though I knew that somewhere to the east there was the west coast of Florida and the city of Tampa. Looking directly west, it was the Gulf of Mexico and no land until the Texan coast over 1,400 miles away. If there is one thing Americans do well, it's building amazing bridges and, if you find yourself in the vicinity of this one, then make sure you go over it. It's like flying when still on the road and utterly amazing.

From the north end of the bridge to the KOA was only a short ride and, whilst it was cheaper than the one I had left that morning, it was still Florida in high season, so the $35 was again more than I wanted to pay. However, the lady in the reception office allotted me a site on the waterfront, which was one of the nicest spots I stayed on the whole trip. It seemed like it was on the edge of a lake with little islands off shore and I could make out what appeared to be the opposite bank some distance away, but I was really on the edge of the sea and I was looking at part of the coastline. The fact was given away by the multitude of shells on the bank, as well as thousands of tiny crabs that would scuttle down their holes in the muddy sand whenever they spotted movement. There were lots of squirrels running around the trees and ground, as well as a woodpecker, pelicans and an extraordinarily tame crane strutting around the site. The weather was hot and everything felt good.

A young couple: Chris and Steve, along with their four children: two girls, and two boys, occupied the tent site next to me, and we got talking when one of their young sons confused me for another biker who had been staying on the same pitch the night before. I asked how old the children were and Chris pointed to each of them

in turn, saying, 'Five, four, three, two.' I was willing to bet that there was a one-year-old stashed away somewhere and Steve must work for NASA. He told me, however, that he was a Professor, involved with helping schools to incorporate more IT into their curriculum and confided that it was far from being the best paid job in the world. Yet within minutes of meeting them they invited me to share their evening meal. They were a thoroughly nice family and, as the kids were put to bed, they each called a "Goodnight" to me through the tent wall. I couldn't resist a "Goodnight Mary Ellen, goodnight John Boy" in response. Chris, Steve and I continued talking well into the evening, joined by the campers on the other side of their pitch, and we exchanged email addresses, as became a common theme throughout the trip.

Leaving the next morning, my plan was to travel up Highway 19, which would be more likely to offer interesting sights than an Interstate. The first forty-five miles were stop-start heavy morning traffic, in temperatures in the low 80s. The thought of that sort of traffic jam in the UK is frightening, though at times the M25 can almost offer the same. However, it seemed like an everyday occurrence for this part of Florida, and the fingers of my left hand were aching with the constant work of pulling in the clutch. I could feel the heat of the engine again and it seemed incredible that the big air-cooled, un-fanned monster, could cope with the punishment it was getting. Several times I considered pulling over to let it cool down and to get a drink, but pushed on hoping that I would soon escape the congestion. Just as the traffic started thinning a little and the speed increased, the driver of a pickup truck, without warning, decided that he wanted to occupy the same space in the outside lane that I was in.

The switches on the Harley are, in my opinion, very cumbersome, but my thumb found the horn button first time, and I left it there whilst I considered my options. In a car, the instinct would be to brake hard, but on a bike you need to equally consider

what is happening behind you, as it is of no consolation that the car behind should not have been so close as it mashes you into the road surface. The first option was to accelerate out of trouble. Actually that wasn't an option on a standard Harley and even if it were, I would then need to stop the thing again. I was frantically assessing whether to put my bike on to the very narrow and rough central reservation or brake as hard as I could and, had just decided to do that, when the driver of the pickup heard the horn, probably because his window was open, and he pulled back to his own side of the line. The whole episode lasted less than four seconds but, at worst, I was down to a strip of road only slightly wider than the bike, and the situation was potentially lethal.

I expressed my displeasure with the other driver's manoeuvre, but to make things worse I noticed that the sign on the side of the truck stated that it belonged to a company called "Florida Pest Control". To try and kill me is one thing, but that was positively insulting! A little shaken, I stopped for some breakfast and a cold drink at the next available establishment. Unfortunately, this turned out to be a "Hooters" and it only served to get my heart pumping faster!

I made the KOA, east of Tallahassee without further event. This campsite had limited facilities with no bar, a small shop, no waterfront and no water in the swimming pool. It was $14 a night. Perfect. I was the only "tenter" there – "Johnny No Mates", but I had now clocked up just less than 1,000 miles on the speedo and was beginning to feel happier about the progress.

The tent went up quickly and I crawled into the sleeping bag. Alas, along with the busy nearby road there was also a railway and the constant haunting moans of American trains warning people of their approach. This did nothing to aid my sleep. They are not like British trains that give a short two-tone whistle as they speed by. The noise from the American whistles seems to last forever and the drivers apparently take extreme pleasure in sounding

them as much as they can. My rest was uneasy and I was yet to discover just how many KOA's are close to the railroads.

The morning weather was cool and dry. It was the first time I had not been able to use the overnight condensation on the screen to clean it, but around fifty miles after I set off, I hit the first batch of fog and had all the moisture I needed. I stopped at a garage to refuel and clean the screen and, as I was filling the tank, three old Harleys pulled in. The riders hurriedly dismounted and one of them came running over to me. I was expecting some momentous announcement that would explain their haste, but he just asked where I was headed. I replied that I was going west and returned the question which, as it happened, was exactly what he wanted. He told me that they had left home that morning to do a 1,000 mile ride, they had just reached the half way point and were now turning round to go home. I didn't get a chance to speak to the guy any more as his buddies had decided that the grade of fuel on offer was not of high enough octane, and were already firing up to drive to another garage. Without a look back at me, the man ran to his machine and followed his friends out of the petrol station. They had to be crazy. Up until then I thought that my 400 miles a day was pretty good, but these guys made it look like nothing. If they were lucky and could average 70mph it would take them fourteen hours to do 1,000 miles. Add on to that the numerous fuel stops and the time required for food, drink and nature's call, it was going to be a very long day. I was feeling saddle-sore with the distances I was doing with my much more modern, and well-padded seat. Their old hardtails lacked suspension and had much less comfy saddles. Theirs would be an impressive achievement.

I left Florida on the I10 two weeks, almost to the hour, after I arrived and sailed on through the bottom of Alabama via the city of Mobile. Another spectacular bridge took me across Mobile Bay and once again the fog struck as the temperature dropped

dramatically. I enjoyed the relief from the heat that had again built up to an uncomfortable level, but unfortunately the relief was short-lived as the temperature was soon back up into the 80s.

My original plan had been that on leaving Florida I would pass, as quickly as I could, through Alabama, Mississippi and into Louisiana, just so that I could hit four states in one day. I wasn't sure if I wanted to go to New Orleans or not, as I had heard some fairly uncomplimentary things about the city. To be fair though, everyone should make up their own mind about a place and I'm sure that some of the places I would likely enjoy on the trip, others wouldn't. However, the heat was getting really oppressive and wasn't helping the denim induced saddle soreness, so after getting into Mississippi I swung north onto US63, in an attempt to find some cooler weather. This road heads directly north but terminates quite suddenly in a right angle with high kerbs and a "Stop" sign before it joins US98. It had me tap dancing on the gear lever whilst testing out just what the brakes were capable of, and I must confess that I was quite impressed as I halted well into the right angle, but just short of gravel and the stop sign. Had the gravel come earlier, I think I would have been doing a good Wall of Death impression on the high kerb, as the tyres would have likely slid away into it.

The road was now dual carriageway and seemed to stretch for miles in front of me with the terrain reminding me more and more of Scotland, though mostly the lowlands, as the hills were small. It was the pine trees that gave me the impression and I was really enjoying the scenery, though I could see a problem looming. In the USA, there can be great distances between petrol stations and my fuel gauge was falling to dangerous levels. There didn't seem to be any sign of a garage and I decided that I would only look at the gauge through downhill left-hand bends, when the needle would come up a bit. Mile after mile passed by, increasing my concern, and making me question whether I should leave this road and take one of the routes to towns that were signposted, but these didn't

give any indication of distance. The problems with running out of petrol on a bike are: that if you need to walk you have to leave your luggage, which could be easily stolen as could the bike itself. Not that it would be easy to haul the Ultra onto the back of a lorry without lifting or towing gear. At last though, and some miles after the low fuel warning light came on, I spotted a busy BP garage on the other side of the road and thanked whoever was looking down on me for it. I was now extremely aware that I needed to refuel when the gauge was down to around halfway. I had already heard that crossing Texas could be "interesting" with miles of nothing and, if need be, I was going to have to find some way of taking extra fuel with me. However, the world was now good again, and the plan was to stay the night in a cheap hotel to catch up on some writing, so I followed signs into a town called Hattiesburg. I booked into the first place that had a vacancy and was advised that I should remove everything from the bike as it was at risk of being stolen. I didn't need telling twice and, as I did so, I realised that there was even a night security guard who was situated in a hut only a few yards from my room and bike. I decided that I would keep the truncheon close at hand just in case of emergencies, but the most threatening thing I faced when I opened the door of the room were some very large cockroaches. Fortunately they were to be my only visitors.

After all my kit was safely stowed away, I did something I don't think that I have ever done before in an hotel, and looked to see what was in the drawers. I was surprised to find that a previous occupant had bequeathed me a small, half-full bottle of washing-up liquid, a large and full jar of garlic powder, and about one and a half inches of Canadian scotch in a very large plastic bottle. As I lined these prizes up on the dressing table, I felt like I was a contestant in some weird version of *Ready Steady Cook*. Go on, I thought, See what you can make of these, Anthony Worrell Thompson. I could see his withering look as his imaginary figure stared back at me. There again, perhaps it's not such a silly idea.

Well BBC, just remember who thought of it first. "Ready Steady Do What You Can With Things Found In Hotel Rooms". The possibilities are endless and I guess at times could be a little unsavoury, so maybe it'll never get off the ground!

I phoned for a pizza and when it arrived I smothered it with garlic powder.

The good thing about staying in hotels instead of camping, is that they have cable TV, and one of the films showing in the morning was a Sally Fields movie called "Places In The Heart", a story about a recently widowed lady in the depression era trying to keep her Deep South farm together. I watched the part where she and her family survived a tornado, and then I walked across the road to a garage to buy a coffee. As I paid for the steaming brown liquid I noticed there was a stack of local papers on the counter. The front page caught my attention and I read the first paragraph of the lead story telling of a tornado hitting the town of Laurel the evening before, damaging two schools. When I got back to the room I found Laurel on a map and was a little shocked that it was only twenty miles away, making it too close for comfort. I added a barometer to the Ultra Classic "wish list" and tuned to the Weather Channel. The forecast was poor with big black rain cloud symbols over Mississippi. It really wasn't weather that I wanted to ride in, so booked in for another night.

CHAPTER FOUR
FROM MISSISSIPPI TO NORTH TEXAS
AND THE LIFE OF A REAL FRONTIER HERO

It rained only lightly but this carried a fine yellow dust that smothered every exposed surface of the bike. As I wiped a line of it from the petrol tank with my finger, the maid walked by and I asked her if she knew what the powder was. She shook her head, shrugged her shoulders and said it was common around the area, and most probably the result of the traffic. It seemed more likely to me that it was the residue from some factory production and, whatever the dust was, it was unlikely that it was healthy. There has been a lot of publicity in the British Press about President Bush's attitude to pollution control and how the USA, the main perpetrator of worldwide pollution, is being slow to respond to the need for it. Hattiesburg seemed like a good place to start to me.

I hadn't realised that I had crossed an International timeline and the clocks had moved back an hour, putting me on Central American time and giving me an extra hour of daylight. I therefore decided to take a back road or two and, instead of directly hitting US98, I travelled down I59 and then picked up US10 that leads back on to US98 west. The ride took me through little towns with mostly small and run-down houses, paint peeling from their timber walls and patched-up roofs. The small gardens were often unkempt with battered old rusty pickup trucks sitting in them, though it was impossible to tell if the vehicles were still capable of running. I found it surprising that the houses were so small as land is plentiful, as is the timber the houses were built from, but it emphasised how poor many parts of the south are. It is a farming community and, like farmers in many parts of the world, it seemed like they were finding it tough. There was more than one man of working age sitting on his porch on this Monday morning, suggesting that unemployment might also be high. They mostly

wore denim dungarees and straw hats, but their chairs were not rockers as would have befitted a scene from the Sally Fields film. Instead they were the modern white plastic patio furniture that seems to have found its way into all corners of the world. Apart from that, it really did feel like the Deep South and the Confederate flag was evident on the backs of trucks and flying from poles outside the houses. In every community and often in-between, there were small churches, mostly in better condition than the nearby dwellings. They had names such as "The Flaming Fire" and "Dodson United Reform", though the latter sounded more like a headline from a local newspaper sports page to me.

I didn't feel the least bit uneasy, even though most Hollywood depictions of the South seemed all too real.

Continuing on US98 there were more and more places of worship, and, whilst religion is evidently big business in the Deep South, no one has cornered the marketplace. The big religious names or denominations do not control the masses such as the likes of McDonalds, Pizza Hut, Subway and so forth do with food, so there is a greater choice of sustenance for the soul than there is for the body. America spawned the business phenomenon of franchising but it doesn't seem to have extended to the churches, as so many of the names are unique.

The Southern people display their religious beliefs quite openly and I saw some people, particularly young women, wearing T-shirts or badges, stating their allegiance to God. The need for worship was evidently incredibly strong, and I was somewhere between amused and amazed to find that one petrol station incorporated a chapel for lorry drivers. I am sure that the strength of belief has always been such and I don't understand the prejudice against black people. I remembered seeing a TV programme not so long ago reporting how strong the Ku Klux Klan still was and, specifically, how open they were with their brand of fascism to the point where they bluntly advertise fund-raising events such as car boot sales, and sell fascist products on

their web site. I can't remember if the report said that these activities were legal or not, but it seemed very hypocritical when there were so many churches and religious radio stations. From what I understood, the KKK are anti any non-white race, and do not really care for anyone who is not American. Many of the cheaper hotels and motels in the States are either owned or run by Asians and I wondered how they have coped with living in the South. I suppose that the area is just like everywhere else in the world, mostly full of good people but there are always bad apples in the barrel. In the UK, we have far more than our fair share, a lot of whom call themselves football supporters, but they exist in some form or other everywhere.

The countryside was green and lush, and again reminded me of parts of East Anglia with resemblances to Norfolk. The road however, varied between "fairly good" and "pretty bad", the worst parts being where repairs had been made. It seemed as though any defect in the surface would be filled by over-generous workmen, who would likely shovel the tarmac from the back of a lorry, ensuring that there was probably double the amount needed to fill the hole, before driving over it a few times to flatten it a bit. The result was great lumps in the road surface that were probably just as damaging to tyres and suspension as the holes would have been. If you pass over a small hole at speed, you only feel part of the effect, as the suspension doesn't have the time to extend and fully put the tyre on the surface below it. If you hit a bump at speed the result is worse than if you hit it slower which is, of course, what is intended with the design of speed bumps and sleeping policemen. To a biker, these mounds were potentially catastrophic and lethal, demanding constant and focused attention.

Back on US98, I diverted into a town called McComb, to send some emails and get something to eat, but not being able to find my way into the heart of the town, I stopped at a bakery for

directions. The lady running the place asked me where I was from and I told her, 'Cambridge in England.'

She replied, 'Oh my cousin lives near Cambridge; his name is John Wilson.' She looked at me expectantly as though I should be shocked that she was the cousin of my old buddy John.

'Sorry,' I said, 'I don't know him.' Her face dropped and it seemed as though she didn't quite believe me. I realised later, that in American terms "near Cambridge" might well have meant Birmingham, Brighton or Bristol. The scale of the USA is so large that such geographical hurdles of battling with congested British roads, makes terms such as "near", take on whole new concepts.

Anyway, if you're out there, John Wilson, your cousin in Mississippi says "Hello".

After exchanging emails and a narrow escape with an almost invisible rope stretched across the road to indicate "No Entry", I travelled back to a busier part of town and found all the usual eating establishments. It really is amazing how well these global companies have captured the American diet, though it seemed that the chains of stores selling other commodities, such as furniture and pharmaceuticals had performed equally well. I suppose that we in the UK are seeing more and more of our independent companies disappearing, as we head like trained monkeys into these giant sheds. I have never been strongly opposed to globalisation but I can see why so many others are. I remember, a few years back, hearing a report on Radio 4 about a guy trekking around India, Tibet and Nepal. He was in Nepal, hadn't seen a white face for three weeks and was walking through a small village, when he found that he urgently needed to relieve himself. Looking over a wall he spotted what was clearly a rubbish dump, so jumped the barrier in order to "do the business". Unfortunately, whilst completing the task, he noticed a discarded Pizza Hut box. I'm sure that the discovery must have been quite revealing when he thought he was so far removed from the

Western World, and to me it really is a great shame that the world has shrunk so much. It seems that there is now no escape from the ubiquitous giants such as McDonalds; in fact I also heard somewhere that world economists no longer use the price of a loaf of bread as a tool to measure the cost of living around the globe. Instead, they prefer to compare the price of a Big Mac, as it is far more standard across the planet and, let's face it, is usually readily available wherever you are.

At a small town called Jackson, I stopped for a hasty look around the town museum, which concentrated on the apparently endless wars the south has seen. It also provided me with the opportunity of talking with the Curator who was even more interesting.

He was a collector of Triumph Spitfires and showed me round the one he had just got roadworthy. It was just a pleasant conversation between two enthusiasts, albeit for different forms of transport. Interesting though that he was such a supporter of British machinery and there was I, in his words, with an American icon.

Just before I left, I commented as to the amount of Confederate flags flying in the State and asked him why it was. He told me that Southerners are proud of their heritage, so I said that I thought maybe the people were making a statement. In his deep deliberate, southern drawl and with a big smile he said, 'Oh we are, we are.' It seemed that the north-south divide is something we share with the USA, only in their case it is the Southerners resenting the Northerners, and dates back to before the Civil War.

The Mississippi was as muddy as I had heard it would be, partly due to the torrential rains that had been falling upriver. I nearly experienced just how muddy, as I didn't see the sign warning me of the forthcoming end of the road and ferry jetty. Just in time I noticed the huge expanse of water and it was fortunate that the brakes worked just well enough to bring the bike to a stop, literally

before I found myself in the river. I tried to look cool as I dismounted, though I don't really think I fooled anyone in the small group of people watching me from some yards away. They seemed a surly lot and I didn't feel like facing any embarrassing questions as to whether I had been aware of my fast approach to the river, so I maintained the distance between us. We were all waiting for the ferry to arrive back from its trip to the other side, and when it did I was surprised at how small it was. It also seemed odd that neither up, nor downriver was there another boat or even a fisherman to be seen, though I guess with the water so high and fast-flowing, things were far from being in their usual modus operandi.

Once on the far bank, I checked my KOA map and continued, now on US10. Just as I was thinking how good the road was, a sign indicated that US10 turned a sharp right and I then had my first confrontation with what Louisianans very generously call a "local road", an experience I could have done without. It was made entirely of loose pebbles, mounds of them with the occasional larger stone thrown in to knock the front wheel to one side or the other. I came gently to a halt and checked the map. It indeed confirmed that I still wanted to be on this route and some way up ahead I needed to take a right fork. The only other option was to take the nice tarmac highway, but it was a considerably longer route so it seemed the best option was to continue on US10. The thing about Harleys is that with every bump or hole you pass over, the bike rattles and groans and you feel like you are leaving a trail of nuts and bolts behind you. With every jolt along this track, I had visions of so many parts falling off that it was like some sort of cartoon, with important motorcycle items disappearing behind me, until I was left flying through empty space clutching the handlebars and sitting on fresh air.

The progress was slow, doing 15 to 20mph to avoid the ruts and pebbles, as well as to limit the amount of stones being thrown up at the paintwork. After a few miles, mostly with my feet down

and fighting the front wheel as it wandered around the worst road I had ever ridden on, I came to the fork and a sign announced that the right one was the road to another river crossing. I checked the map again. Bugger! There it was, a ferry crossing I had missed. Well, according to this map the fork only led to the ferry and, seeing as I hadn't seen another soul during the twenty minutes I had been on the road, I decided that there was a good chance the ferry wasn't running. As it was several miles more until I would reach the spot (and no shorter back) it seemed a better idea to continue on the left fork.

Another very slow mile-and-a-half later, I emerged from woods to a crossroads, and it was clear from signs that both right and left tracks led to farms.

There was a black Honda Shadow cruiser parked up a few yards along the right track. The owner stood next to the machine: a short stocky man with biceps bulging under his tight white T-shirt, blue denim jeans and short black biking boots. I couldn't see his eyes through the wrap-around sunglasses he wore but, apart from his short curly ginger hair, he made a passing resemblance to The Fonze from "Happy Days". The only item missing was the black leather jacket but that was lying over the saddle of his bike. In his right hand he was clutching a can of beer and, as he saw me riding toward him, his jaw dropped. I was in two minds whether to stop or not. The way he stood and the way he looked suggested that he might be the sort of guy who welcomes a little trouble from time to time, and as soon as I opened my mouth he would know that I was not a local, which was something he may find provocative. On the other hand, I could do with some directions, hadn't seen anyone for quite a while and there was no real reason to think this man would not be helpful. I coasted to a halt on the loose stones, kicked down the side stand and gently leant the bike over. I knew I couldn't fool him into thinking I was "from around these parts" so with the clearest English accent I could manage, I announced, 'Good afternoon.'

His jaw came up again and, with a voice that indicated he was very definitely a local, he drawled, 'Shit man, where did you come from?'

The surprise in his voice was so evident I couldn't help a little laugh, and guessed that he was referring more to my passage along the bad road than my own accent. I explained that I was attempting to get to the town of Alexandria and pointed to it on my KOA map. He showed more surprise as he whistled through his teeth and said, 'Shit man, I don't know the best way from here. I guess you could go back the way you came and there SHOULD be a ferry running.'

The stress on the word "should" did nothing for my confidence and I opted for the alternative of taking the long route around and up I49 to Alexandria. The guy told me that if I drove on for another couple of hundred yards I would be back on the nice road I had left a few miles of torture back, but to be careful through the small towns up ahead as the law loved to pull bikers for speeding.

I thanked him and turned the Harley round, back toward the good road. On his advice I kept religiously to the speed limit, though after a couple of miles discovered that my new-found friend had finished his beer and caught me up with little concern for his own speed. He escorted me part of the way to the I49 then waved me to the side of the road. After giving me more directions and a final parting comment of, 'Good luck man,' he roared back in the direction we had come from.

When I finally found the I49, I realised that I was not going to get to the campsite in daylight. Deciding that it would be good to get as far as possible before dark, I opened up the throttle for the next sixty miles, doing 90 to 100mph, which was well over the speed limit and pretty risky for a foreigner in the Deep South without a passport.

The road headed north, meaning that the sun was setting to my left and I didn't really like the idea of finding my way through

Alexandria to the campsite in the dark. I opted to take the last Interstate exit before the town and head west, which should have brought me close to where I wanted to be.

It was completely dark when I left this good highway and, after a couple of miles, I came to a crossroads in a small town. A sign by the side of the road told me that the carriageway I was about to cross was US165 and I made use of a streetlight to check the map. It seemed that I was right on course and drove on through the town keeping just below the 35mph speed limit. Up ahead there was a sign on a high pole but it was too far away to read and, as I got closer to it, the beam from my headlight fell below the level of the writing. I peered and peered at it as the distance narrowed but it was only when I was just a few yards away that I could read the words. They were words that will haunt me to my very core for the rest of my life. Words that in days to come will give me nightmares, causing me to toss and turn in my bed and no doubt eventually make me waken in a cold sweat, sit bolt upright with eyes open wide, arms outstretched gripping imaginary handlebars and repeatedly shout them, 'Rough road, rough road'.

All I can say right now is, 'Road? What bloody road??'

Taking into account that the "local road" I had seen earlier that day was the worst thing that I had ever taken a road bike down, then trust me when I say that this "road" was the most diabolical creation that anyone has ever called such. It was more akin to something that the army would train tank drivers on, to see if they were up to it or not.

Initially, I hit loose stones and pebbles and considered stopping to turn around. Unfortunately it looked near impossible to turn the bike with the road camber sloping sharply away on both sides with a high ridge in the middle. It would have needed at least a three-point-turn to reverse direction of the Ultra and, pushing the big monster backwards up a hill with all those loose

stones meant a high chance of failure, most likely resulting in a dropped bike. Anyway, I thought, this track can't be very long as the map has shown me that there's another major road up ahead.

I drove on as the surface got progressively worse, with big stones, holes, ridges, ruts and ripples. On a trail bike, in daylight, it would have been fun, but this was a heavily-laden Harley Davidson with both front and rear wheels slipping and sliding down the camber if I drove too slowly. I had to keep the machine moving at around 20mph in second gear to prevent the sliding, but then I had less time to pick my way between the worst of the hurdles. It was hard work and I was feeling dog tired, but had to keep concentrating on the road and what the bike was doing, responding to every twitch of the handlebars and sideways movement of the wheels. It was completely dark and there was now forest on both sides of me, so the option of stopping became increasingly less attractive. Who could tell what may be lurking in them there trees?

Suddenly I became aware that flying insects surrounded me and that the headlight was making them look like fireflies. Then it struck me that these insects really were fireflies, millions of the little flashlights all around, surrounding me as I battled on.

Imagine the scene of me in motorcycling helmet and jacket, fighting this great American mechanical beast, trying to keep it moving forward, gripping the handlebars and watching what was ahead in order to try and steer an easier course, despite the front wheel wanting to go its own way and shaking me about. All around me are little exploding lights, some in front, some at the sides and some disappearing behind me as I made the slow and treacherous way forward.

Now visualise James Stewart in World War II flying helmet and jacket. He is sitting in his hulking American bomber aircraft, gripping the controls and fighting the plane onwards to its target, grim determination on his face. All around him the anti-aircraft

flak is exploding, lighting up the sky and making him change direction to take the best and easiest course.

Okay, he was a lot taller than me but I hope you can see where I'm coming from.

The visions of nuts and bolts falling from the bike had crossed my mind again, but the machine was coping with the appalling surfaces of this road. Someone I know in England who rides a Harley has a favourite expression about the "solid engineering". He likes to say "Why build it out of aluminium when you can make it out of pig iron?". I guess now I understand why Harleys are built so solidly; it's for Louisiana roads.

I have no idea how long I was on that track; it seemed like all night but I guess the distance was only a few miles. Finally the surface improved, turned to a metalled road and then, hurrah! There were lines painted down the middle. It seemed unlikely that it would deteriorate again after that.

I came up to a T-junction and, after flicking a mental coin, I turned right. The traffic was minimal but at one point the lights of an oncoming car blinded me and, through luck, I just missed what appeared to be a large dead animal lying to the side of the road. It was the size of a couple of bin bags, or a small bear, though I knew there were no bears around the area.

There was a petrol station a way further on and the bike and I both had a much-needed drink. Whilst I paid for the purchases I asked directions and the attendant told me that she knew the way to the campsite. She even drew a map for me, with road names and numbers, highlighting one that was around five miles back, though she stressed that she wasn't good with distances. I rode up and down trying to find the road but after I had been fifteen miles, I gave up. To hell with it, I thought, it's getting late, I'm tired and it seems unlikely that I will find the place. I need a hotel. The incident again brought something home to me that was a good lesson for the rest of the journey. This was that the average

American has no idea of distance. On the trip I had experiences of someone telling me that it was a quarter of a mile to my destination when in fact it was only a hundred yards, and also someone telling me that it was just down the road, when in fact it was nearly twenty miles. This appeared to be an example of the latter, so I turned the bike around and headed back to where I had come from.

A couple of things happened then which I can't explain and probably never will be able to. There were two noises: the first being like a truncated and distant clap of thunder or sonic boom. The second was a noise like a big engine being gunned, but it wasn't restricted through a normal exhaust system and only lasted for a second. The bike continued unabated with no changes to the revs or handling.

It sounded like a bear had jumped on the back seat and given a brief growl in my right ear. It scared the living daylights out of me, though of course there aren't any bears in that area, are there? I increased the pace toward Alexandria and noticed that whatever animal had been lying apparently dead in the road, was now gone.

Heading north again in the morning, I crossed into Arkansas, with the idea to camp that night at a KOA near Little Rock. There wasn't any real thinking behind this, apart from the town name sounding like a real Wild West place. The roads no longer seemed as bad and the dodgy repairs were much more acceptable after the previous night's experiences.

It was a pretty run north with lots of wooded areas, but the recent heavy rain meant that many of the roads were blocked and, in particular, US7 that should have led to my destination, had a sign stating that it was closed and that violators of the instruction would be prosecuted.

Whilst parked at the side of the road to consult my map (incidentally if you ever want to engage a local US citizen in conversation there is no better way than to look at a map), a guy in

a pickup offered to show me a way on to the highway further north. He headed off up the road and left me to fight off a lady who had also seen me looking at the map and wanted to demonstrate her local knowledge. I followed him at some speed down country roads, not having a clue in which direction we were headed, and it occurred to me he could have been planning to take me down more "local roads", "rough roads" or perhaps there was worse still that I needed to experience. Perhaps there were "Really Rough Roads" or "Tracks" or "Hey Dude, You Don't Want To Do This" kind of roads.

After around ten miles he stopped at a junction and, as I pulled up behind him, he jumped out to tell me that the right turn I should take also had a "Road Closed" sign. He gave me instructions to get the rough direction I had wanted and then abandoned me – the GIT! I hadn't a clue where I was and wasn't overly sure of the way back, but after some thought decided that it would be wise to drive south again, away from the floods and back toward Texas.

I managed to almost retrace my steps and, back on a major route, I chose to head for the first KOA campsite inside the Texan border. It was at Texarkana, a town named after the States of Texas and Arkansas as it straddles the border between them, though the final "A" in the name is taken from Oklahoma, as it only lies thirty miles away! This was a town that was clearly another fine example of Bill Bryson's point about Americans taking an easy option of naming something; though to be fair, the old name for the town that I live in is Slepe, which sounded nice until I learned that it is the Anglo-Saxon word for "muddy", so-named due to the state of the river banks in that time.

Apparently, Texarkana also makes the proud boast of being the only town in the whole of the USA to have a municipal building divided by a State line. What a claim to fame.

Booking into the campsite, I was offered a reduced rate for a cabin because, as the man put it, 'We are in for a rough night.' There was that "R" word again but despite the offer, I declined, as I really needed to start being careful with my spending. I also added that right now all I needed was a beer.

'You're in the wrong state,' he said, 'Texas is dry and you'll have to cross the State line.' Seeing my shock, he then added that the laws actually change from county to county and anyway, the State line was around two hundred yards away. He told me where I could buy beer and where Wal-mart was, as I wanted to get a ground sheet to help waterproof the tent.

No wonder George Bush is so belligerent, I thought, the man probably wants to chill out with a cold beer but can't get one. Still, you would have thought that as Governor of Texas and now President he could have done something about changing the laws.

I did my shopping, buying a tarpaulin for the tent and another for the bike and had just finished setting it all up when the storm struck. It was many hours of thunder, lightning and heavy rain, but the advantage of all this was that it drowned out the nearby road traffic and the incessant trains, which were now really getting on my wick. It seemed that nearly every KOA in the land is situated right next to a railway. On top of this, and despite the increased protection offered by the tarpaulins, the rain managed to seriously penetrate the tent, getting through to my sleeping bag as it dripped from the inside.

Assessing the situation the following morning, it was obvious that I was going to have to do something about it, especially as more bad weather was promised. However, the best immediate option seemed to be to try and avoid the oncoming storms, and several fellow campers who had seen the weather channel forecast, advised me that if I left straightaway and headed south I would miss the worst of it.

I did so, but still had just under a hundred miles of what we bikers call "crap weather", where the sky turned black as thunder and it seemed like it was getting dark, even though it was only mid-morning. The rain came pelting down, making it difficult to see as it clung to the windshield and my helmet visor. The amount of water that settled on the screen was dependant on the speed that I did; the slower I went the less I could see, but once I had slowed down for other traffic it was difficult to build it up again. I followed a respectable distance behind a lorry, where I could follow its taillights but far enough back to avoid the spray. The truck made good progress meaning that I could too.

It was interesting to see that the raindrops on my windshield would travel up the front and then, either run down the edge, or would come over the top and down the inside, giving a strange effect of water going both up and down the screen. A windscreen wiper went on the Harley Wish List in big letters. Then as we passed through the weather front, the rain stopped quite suddenly and the sun came out, though it was still very cold.

The one good thing about all the water was that it had completely removed every trace of the Hattiesburg dust.

Harleys have ridiculously low service levels of 2,500 miles and I was about to exceed the figure, so I stopped at Wichita Falls for a couple of nights to get the maintenance done. The temptation had been to do no servicing, with the exception of an oil change every 5,000 miles as specified, but the extended warranty stated that the bike must be regularly maintained, so I compromised. It should have been a 10,000 mile service, but the bike had supposedly got this at Daytona, the charge for which still stung whenever I thought of the way Daytona Ron had dropped it on me. Instead I decided on a 2,500 mile service which covers all the important points and is considerably cheaper. As the technician came out to my Ultra to make a few notes, I was embarrassed by the dirty state of the machine and made a weak apology for it. He told me that a

good clean was all part of the work I would be paying for, so it seemed unlikely that I would have to do much cleaning of the bike myself, as it wouldn't take me long to hit each service interval.

During the long wait I noted there was an Ultra Classic a year older than mine for sale, with over 17,000 miles on the clock and, whilst it had a few accessories, it was a single colour model, whereas mine was two-tone. The best thing was that the price was marked up at $16,995 (plus tax) so maybe Daytona Ron was not so bad after all.

I took a good look around at all the merchandise that you can now buy with the HD name and logo emblazoned across it, and it was quite amazing what was available. Besides the expected bike accessories and clothing, the list included: Christmas decorations and cards, decorative glassware, dog and cat leads, hats, coats, coffee, knives, watches, models, toy trains, pewter plates, piggy banks, cool boxes, suitcases, ice buckets, car mats, bar stools, boxer shorts, baby clothes, a $4,000 gas fired barbecue and, of all things, a wind sock. Any manufacturer out there who has a retail type of product that has not yet been subjected to the Harley Davidson marketing machine should consider it an option, whether it is motorcycle wallpaper, baked beans or toilet brushes. The last suggestion is not actually as silly as it may sound, as you can also currently buy a HD toilet seat! I should point out that this item isn't padded and doesn't come in leather.

Personally, I think that such heavy merchandising has hurt the brand image, and it makes me less inclined to own a Harley Davidson, though I guess I must be amongst the minority or Harley wouldn't be badging all those products.

I wondered what there was to see in the area and, on returning to the hotel, I asked the receptionist if the Wichita Falls still existed. 'Yes and no,' he replied. 'The original falls were destroyed many years ago so they built some more.'

The thought of non-natural beauty is much less appealing to me – a bit like silicone implants – but especially if it is likely to be surrounded by the tourist money-taking mechanism.

'What else is there to see?' I asked.

He looked thoughtful for a moment and then replied, 'Well, if I didn't live here, I wouldn't come here.'

Time to move on, I thought.

It was cold in the morning but the sky was completely clear and a great day for riding. A few miles along US287 I pulled off to refuel and, quite unexpectedly, another customer: a lady on the forecourt of the petrol station, started asking about the bike, where I was going and the general chitchat that I would have expected from another enthusiast. Jana liked bikes but didn't know much about them, so the questions were surprisingly relevant and technical. After a few minutes, she asked if I would like to get a coffee and something to eat, so we went to a local diner where she told me that she had given up her job as a carer because she found it so frustrating that the old people were not being looked after properly. She had no other job to go to and was now headed back to her parents' house in Fort Worth, firstly to do some decorating for them and then to find a job there.

I couldn't help but feel, that although she gave great detail about all the places she had lived and a lot about her children, she was leaving something out. She never spoke of the children's father and her future plans seemed very vague. We talked for about an hour and went our separate ways, but I noticed that for a lady who had just given up her job and life in California to drive halfway across the country and live with her parents again, she had precious little in the car. I think that she was taking "travelling light" to extremes and I found it very mysterious. We exchanged email addresses and kept in touch for a while. A few weeks later she wrote that she had just got engaged, so it seemed she was indeed keeping something back.

There are lots of roadside historical markers around the USA and I stopped to look at most of those I passed on the route through Northern Texas. One in particular caught my imagination; it was in a lay-by sheltered by some trees and the words read as follows:

TOWN OF GOODNIGHT
NAMED IN HONOUR
OF CHARLES GOODNIGHT
1836-1929
NOTED SCOUT, INDIAN FIGHTER AND
TRAIL BLAZER
WHO ESTABLISHED THE FIRST RANCH
IN THE TEXAS PANHANDLE
IN 1876
AND IS ALSO KNOWN AS
THE BURBANK OF THE RANGE

The first thing that struck me was that the old boy had lived a remarkably long life; in those days ninety-three was quite an achievement in its own right. If you think of all the things that he saw in that life then it is even more amazing. There was the war against the Mexicans (1846-1848), the Civil War (1861-1865), the Indian Wars that spanned many decades and then the late but committed response of the USA to the First World War. He saw the telegraph facilitating long distance communication, the railroad "taming" the West, the huge influx of settlers from all over Europe and the division of the plains with the infamous barbed wire. The first automobile was developed in his lifetime and the Wright brothers' first flight took place in 1903, which incidentally was the same year that Harley Davidson was founded. You have to be impressed by what he lived through, though we could of course find the modern equivalents in our own lives.

Depending on your age, you may have seen a major war, or the relatively minor skirmishes of The Falklands or Kuwait. It was

only a little over thirty years ago that man landed on the moon, we have had supersonic passenger travel for around the same time and, in the last decade, the Internet has grown to be an incredible tool for business, education and pleasure.

If you read the epitaph above you may ask what the "Burbank of the Range" meant and it took me a lot of time at a later date to find out, though the research into Charles Goodnight's life proved incredibly interesting.

He was actually born in Illinois. At the age of eleven and with no more than six months of formal education, he accompanied his mother and stepfather on the 800 mile journey to Milam County, Texas, riding the whole way bare-back on a horse named Blaze. He was proud of the fact that he was born in the same year that the Republic of Texas was formed, and moved there the same year that it joined the Union. He grew up learning many hunting and tracking skills but, at the age of fifteen, became a jockey, then moving on to many other occupations, including the supervision of black slave crews. He was at heart a cowboy, and had several very successful partnerships moving cattle across the ranges, making good profits along the way, though he also diversified his interests including the transportation of cotton and other supplies.

It was the time of the Indian Wars and the troubles were increasing in northwest Texas, so in 1857 Goodnight and his neighbours joined Captain Cureton's Texas Rangers, where the skills he had learned as a boy were useful, acting as a scout and guide. So much so, that in December 1860 he led the Rangers to an Indian camp and took part in the raid, during which a white female hostage was set free.

The following year saw the outbreak of the Civil War and the Rangers were attached to the Frontier Regiment, but the end of his service came in 1864 when he returned home with the aim to rebuild the cattle business that he'd had before the war. Over the next few years, success followed success as he built up his business interests, and for one cattle drive in 1866, Goodnight built the first

chuckwagon, which of course became a well known asset for all future drives across the west. His operations became so successful that in 1871, he and a partner cleared a profit of $17,000, a remarkable amount of money for the time. Along the way he had also earned the nickname of "Colonel".

In 1876 he moved his operation to Palo Duro Canyon and drove out the buffalo to make room for his cattle. The following year he met up with the outlaw "Dutch" Henry Born to strike an agreement that illegal operations would be limited to the area north of the Salt Fork of the Red River, and away from the Palo Duro. He then went on to Denver to meet with a John G Adair from whom he had previously borrowed $30,000, and got an agreement that Adair would help expand the ranch. Goodnight spent eleven years building up the interest to an area of 1,325,000 acres with more than 100,000 head. He is reputed to have pioneered the use of irrigation and grew Armstrong County's first wheat crop. He invented a practical side-saddle for his wife, introduced Hereford bulls, before then experimenting with a cross between cattle and buffalo, named a beefalo. He is also reputed to have been the first rancher to use barbed wire.

In 1878 he again faced trouble from Indians as they left the ranges to hunt for much needed food, and Goodnight made a treaty with one of them, Quanah Parker, in which he promised two head every second day, providing they left the ranch in peace. The friendship strengthened and some years later led to Goodnight staging buffalo hunts for the braves.

He applied tough vigilante justice to the area with a strict ban on drinking and gambling on his ranch.

In 1880 he helped organise the first Panhandle Stock Association and became its first President. It was in 1887 that he sold his interest in the JA ranch as well as some others that he had acquired along the way, though he remained as manager of the JA until the following year, by which time he had built a house and the nearby town now bears his name. He had bought more land

and had a buffalo herd of 250 head as well as other livestock. The Goodnight Ranch was a major tourist attraction and the buffalo were shipped to zoos and even to Yellowstone Park.

He never had any children, though brought his cleaner's son up as his own, as well as providing boarding for college students. He and his wife opened Goodnight College in 1898 to provide youngsters with the education that he had never had, but she died in 1926 and it seems that as a result Goodnight fell ill, though was nursed back to health by Corrine Goodnight, a young nurse from Montana with whom he had struck up a friendship as they shared a common surname. The following year was his 91st birthday and Corrine gave him a present in the form of marriage even though she was only 26. It was two years later that he died in Phoenix having lived a very full life through an era of real frontier pioneering. Nowadays it would be impossible to emulate the lifestyle and I for one, am more than a little envious of Charles Goodnight.

Oh yes, the "Burbank of the Range" epitaph refers to the experiments he carried out on agricultural crops, with the assistance and encouragement of Luther Burbank, a pioneer botanist.

The stay in the lay-by was a good opportunity to stretch my legs and, as I walked around, a cargo train lumbered by on the railroad just a few yards away. It was incredibly long and carried containers marked up with Chinese and Korean names, rarely was there anything that was remotely Western. I thought back to an experience some years ago when I worked for an English company that had an American office, the manager of which insisted that Americans didn't like buying foreign goods. Well, here was strong evidence to the contrary. To give you an idea of the scale of these trains, I passed another a few days later. It was stationary and I measured it at just over a mile, with three locomotives at the front to pull it, and still consisted only of names from the Far East.

Later I arrived at the campsite outside Amarillo, set in Texan countryside of flat, wide-open plains and the wind made it a challenge to erect the tent properly. Once I had it built, a gust took hold and although I held tightly to one corner that I already had in my hand, the structure was shaken around like a box kite. Eventually I wrestled it to the ground, then managed to get some of my kit inside to hold it down though the exercise had warmed me up for it was still cold at only forty-five degrees. There was no rain forecast, so instead of using the tarpaulin to cover the bike, I used it for a blanket. Fatigue took over quickly and I fell asleep, but alas not for long. Unsurprisingly, the site was right next to the railroad and the constant long hooting from the trains, warning others of their approach woke me time and time again. Eventually night became day and the rising sun brought with it very welcome warmth.

The Palo Duro Canyon was only around forty minutes away, so after a leisurely breakfast of coffee and a bear claw, better known to Brits as a Danish pastry, I headed in that direction. I haven't ridden much around Texas, so I don't know what the rest of it is like, but the part around Amarillo was extremely flat, just like the Cambridgeshire Fens. The Canyons bring some three-dimensional relief to what otherwise would be fairly uninteresting countryside and, on paying the very reasonable $3 entrance fee, I rode on to the Visitor Centre and parked up. The view was magnificent with the deep gorge looking like it had been perfected for a film set; the reds and purples of the rock really smacked me in the eyes, but the craggy surfaces were softened with the dark green of juniper trees wherever I looked – well I think they were juniper trees anyway. It seemed like there were a lot of dead trees and grass, but it was Spring and a lot of the plant life had not yet woken up.

I learned in the Centre that this is the Nation's second biggest canyon and I was glad that I had seen it before the Grand Canyon,

which is of course the biggest. Americans are obsessed with size and love to boast about it whenever they can, but what the sign didn't say was just how much bigger the biggest is.

All the displays in the Centre were informative and entertaining, telling of the history of the canyon and the animals and people that had inhabited it. One exhibit illustrated no less than twenty-nine varieties of barbed wire and there was a video showing a 1916 film shot by none other than Colonel Charles Goodnight himself. The accompanying text told how the Colonel made friends with a lot of Indians and invited them to hunt buffalo on his land. I wondered if the Indians really regarded it as belonging to him.

The film was scratchy and it was, for the most part, difficult to make out what was going on, but Movie Producer/Director was yet another of Charles Goodnight's achievements.

Riding down into the canyon was a welcome relief, as it provided some twists and turns that the Texan roads hadn't yet offered and, after all, it's the twists and turns that make biking fun. It was also very warm out of the wind and eerily quiet when out of range of the noise of the other tourists, but of course as the morning wore on the number of tourists increased. There were cars, RVs and lots of mountain bikers, whom I suppose don't get much opportunity to climb mountains in Texas. I thought it funny that when I had parked up in a lay-by all the drivers going past stared at me intently, for some reason finding me more interesting than the scenery around them. The picture on the front of this book was taken at this lay-by.

Pulling into a café called "The Chuckwagon" (not much imagination involved in thinking up that name), I spotted another couple of Harleys, the riders of which were a married couple sitting in the shade enjoying a cold drink. We chatted for a while, mostly about the bikes and bike-related things. We never exchanged names, but the man told me that he'd had his bike, another Ultra Classic, for six months and had done around twenty

more miles than I had done in the last two and a half weeks, which made me feel all sort of grown-up. He told me that buying a Harley was very expensive in the Amarillo area and he could have saved himself around $1,000 by travelling to Wichita Falls where I had come from. I told him what I had paid for my bike and he expressed his surprise at the low figure, bringing Daytona Ron rising even further in my estimation.

After a while, we left the shelter of the Chuckwagon, them to go around the Canyon again and me to head to the Panhandle Plains Museum, which I had been told in the Visitors' Centre was a "must" as it was so close.

The museum is the biggest in Texas (Texans are even more obsessed with size than the average American) and really is impressive. It concentrates completely around life in the Texas Panhandle from modern day, back to early man 14,000 years ago, and made me think about who had really discovered America.

One of the first exhibits to catch my eye when I walked in was a stuffed buffalo, and I was interested to see that a female weighs about the same as the bike, fully laden, with me on top.

There were plenty of interactive exhibits too, as well as a reproduction of a western town using all original artefacts.

Rooms are dedicated to the way Indians lived, the changing life of the cowboy, oil drilling and refining, as well as one that contains nothing but displays of cowboy boots. Well, after all, it was an important part of life in the Wild West.

I have to say that having overdosed on culture and history, I spent far too long at an exhibit made up to be the front of a 1950s Ford Mustang, with a view of the open road through the windscreen. The push-button radio had cleverly been rigged so that when any of the buttons were pressed, a hit from the period would be played through the overhead speaker. Buddy Holly got a good airing that afternoon and the driver's seat was jealously guarded from any other punters.

It was however getting late in the day and I was feeling hungry. What I really fancied was a good pizza but, unfortunately, I could only find a *Pizza Hut* where the food was tasteless and the service diabolical, which is probably why there were so few people there. One by one, the customers finished their meal and departed, or simply got bored waiting and left anyway, leaving me completely on my own, apart from the half dozen or so staff. Just as I was finishing my lump of cardboard, the door to the restaurant opened and in walked something out of a Western movie: two tall slim cowboys in their Sunday best who had clearly not just driven a thousand head of cattle across the Texan plains. They were so physically alike, they must have been brothers, both in their thirties with brown hair, long drooping moustaches, and black hats with decoration around the crown that looked like a series of silver medallions. The one in front was younger and wore a blue denim shirt whilst his brother wore white, but both had button-down collars and not a crease in either of the garments. They also wore tight drainpipe blue jeans, again with not a crease and these were held up by black leather belts with big decorative buckles. On their feet they, of course, wore cowboy boots, but the younger brother sported spurs that jangled when he walked. It was marvellous.

As they sauntered to their table with the sort of walk that they must have copied from John Wayne, I couldn't see the older brother much, as the younger mostly obscured him, but I did briefly catch sight of something on his left hip. Could it be a six-shooter? I was praying that it was, but as the first man bore to his right to take up their chosen table, I got a proper view and it was unfortunately only a mobile phone. The museum had told that the cowboys' work had changed little, except that they now use modern tools such as 4x4s, satellite navigation and mobiles, and here was living proof, as though this were a roving exhibit from the museum.

They took their seats and for the first time I noticed that there was also a boy with them of around twelve years old, but dressed in contemporary clothes, topped with the ubiquitous baseball cap.

I remember my father giving me my first electric razor; it was an old one of his, but it was somehow a token of recognition that he now saw me as a man. I wondered if there was an age that boys would be given their first cowboy hat, and if it carried some sort of similar recognition. I'm sure if they lived on a working farm it would be long before they got their first razor

They looked over the menu as anyone would. I couldn't imagine the two men eating anything other than rice and beans, or cow pie, so what on earth could they be doing in Pizza Hut, and had they really dressed up for the occasion?

After a few minutes a woman and little girl joined them at the table but, despite my best efforts, I couldn't hear what they were talking about. I'm sure it would have given some clue as to why these two were appearing in "National Dress" though I suspected that they must have just taken part in a Rodeo or something similar.

I paid my bill and walked outside, trying to remember if I had seen rice and beans on the menu but, before pulling away, I noticed that the pickup truck they had arrived in had a trailer on the back designed for livestock. I could see that it was empty, but indicated they had been doing something very cowboy-like. The immaculate dress, complete with spurs can't be everyday clothes for working men.

The sight of these two cowboys really made the day and could have only been improved upon if they'd have been sporting a set of Colts or Smith and Wesson's, but I guess they are pretty-much an unnecessary accessory in this day and age. I can't envisage some tall black-clad "Quickdraw" coming into the restaurant demanding to settle differences the old-fashioned way, with one or both of these two characters, and I doubt that Hollywood would go a

102

bundle on a script titled "Gundown at the Pizza Hut car park". Progress I suppose.

There was a lot more to see in Amarillo; indeed the town is on Interstate 40, which for the most part follows the old Route 66 so the town plays to some extent on the history and nostalgia of it, with a Route 66 shopping district. Unfortunately, I had been told by the fellow Harley riders whom I had met earlier, that not only was there a cold front due to hit the following afternoon, but in two days there was likely to be snow! This was my cue to head south again and I checked the KOA map to fix a target for the following day. The town of Alamogordo in New Mexico seemed reachable in a day's ride, and promised some more interesting countryside once I was out of Texas. I also looked to see what nightly disturbances I was likely to experience at this new venue and, sure enough there was something that could qualify, the map showed that it was right next to the White Sands Missile Range. I hoped it wasn't live.

It took one hour forty minutes to drive the very uninteresting inch and a half on the KOA map to the Texan border. The only highlights were seeing a handful of bikers enjoying a Sunday ride, a few farm smells (something that had been surprisingly lacking on the trip to date), and the sight of several thousand head of cattle waiting in a pen to meet their fate. At last though, I crossed the State line into New Mexico and another international time zone.

Immediately there was a subtle change to the scenery, with trees alongside the road and grass a shade or two greener. Another small change was the different arrangement of the traffic lights with the clusters now being horizontal instead of vertical. The green arrow for filter lanes was on the opposite end of the cluster to that which I would have expected, and I waited like an idiot for the lights to change at one junction when they already had.

Joining US70, the wind started to get up but the weight of the Ultra kept things steady. This road was pretty remarkable for the fact that it was undergoing major road works, though you may think that there is nothing special about that. You may well encounter UK roads being dug up pretty much every day of your life, but in the UK it tends to be done, at most, a mile or two at a time. US 70 was being transformed into a modern dual carriageway, but being done big style, eighty miles of it in one go. You can imagine the manpower and equipment needed for such a project and I passed several plant "yards" and big RV parks purely for the workers. It seemed like an awful lot of Americans live their lives out of their RVs and are, I suppose, the modern day gypsies or the settlers heading across the plains in their wagons for month after month. I met a guy in Daytona who called himself Bandit and he spends almost his whole life living out of his trailer, going from bike show to bike show in order to make his living from servicing other peoples bikes: a really nomadic lifestyle.

You can also imagine what eighty miles of roadworks would do on English roads as it equates to just short of 70% of the M25. It would be chaos, but on US70 it was no problem because there is so little traffic. So I naturally wondered why so much was being spent on this major improvement.

The only difficulty the work caused me was the occasional dust storm with the plant churning up the dirt, and the wind whipping it into a cloud, but it was a minor hindrance and I had plenty of opportunity to enjoy the gently undulating scrubland around me before stopping at the little town of Elida to take on fuel.

The Ultra petrol tank has a chrome, hinged flap that hides the black plastic filler cap underneath, and it had become a ritual to unlock the flap, remove the keys and then take off the plastic cap and place it on the saddle, where it usually sat quite happily until the task was completed. I had done this, and was filling the tank when a gust of wind like a solid wall came down the street carrying grit, sand and dirt, hitting me and nearly sucking the breath from

104

my lungs. It lasted only a few seconds but had me pulling the visor and chin guard down on my helmet to keep all the dirt away from my face and eyes. I didn't notice that it had blown the filler cap off the saddle until I had finished refuelling and I found it several yards away, broken and mangled after being run over by a vehicle leaving the garage. Realising a new one was necessary I asked the cashier where the nearest HD dealer might be and was told that it would be Roswell, sixty-two miles away.

The name of Roswell may seem familiar to you, as it is the town where aliens are supposed to have landed in 1947, but I was unlikely to have the time to do any alien-spotting that day. She went on to say that Roswell had suffered a major fire the night before, being fanned by the wind, apparently resulting in fifty-seven homes being destroyed. A lorry driver also cheerfully added that the wind further south was incredibly strong and would likely blow me over, but I could see nothing for it other than to put what was left of the filler cap back in place and continue, checking that the fuel was not leaking and hoping that the wind would have let up by the time I got to Roswell.

Despite the fact that I had filled the tank to the brim, there wasn't a sign of spillage and I gently increased speed bit by bit, feeling under and all round the tank for wetness with my ungloved left hand.

The wind was nothing like that which had hit me in Elida, and I wondered what had caused that gust. It was an extraordinary force and I can only liken it to being caught by the exhaust of a jet engine, which I experienced in my RAF days. Could it have been the downdraft from something flying overhead, like a spaceship maybe?

Despite the mishap with the fuel cap, I was glad that I had refuelled at Elida as there wasn't a single petrol station before Roswell. Not surprisingly though, the Harley dealer was closed on Sundays so was of no use whatsoever.

However I was now happy that there was no spillage, so I rode on and felt confident enough to use US2: a slightly less direct route but one that looked like it could offer more.

If you look at a map of New Mexico it is fairly obvious that there are not many towns but there is a whole lot of desert. Desert means that there is nothing to stop the wind when it blows and it was building up again, hitting me on the right side and making me lean into it, to keep a straight line. It was pretty constant though and I had time to take in the surroundings, noting just how barren they looked. It was again scrubland but drier than the land I had passed through earlier. The grass, where it grew, was scorched and no plant seemed healthy. There was an occasional horse or cow in the nearby fields trying to find enough to eat and there were plenty of dried-up streams and riverbeds. From time to time there would be a farm that had good irrigation systems, so the soil would seem fertile with plenty of lush green grass and crops, but they stood out as a rarity.

Blowing across the road were occasional tumbleweeds, adding to the visual impact of the barren desert. When I was a boy, my mother and I used to joke about the Western films that always had a dust storm and tumbleweed blowing across the set. It amused us to comment on whose job it was to throw on the prop and how it was instructed in the script. It's funny how such obscure things can remind you of your past.

Some thirty-five miles later, in the town of Artesia, I turned right onto US82 and the wind now hit me from the left. I thought, A change is as good as a rest I suppose, and at least I'm wearing the tyres evenly, now leaning over the other way to keep in a straight line.

Leaving this town, it was most noticeable how different the desert was. It was mile upon mile of real desert, with almost nothing growing. Even the junipers were struggling for life in this rocky terrain, but it looked lovely, as it was so unspoilt. The colours of the rocks were deep red, brown and purple with

everything in between. There were no big cacti as appear in the movies, but there was a low-growing purple variety, with spikes on them that looked mean enough. Despite the unspoilt look of the terrain, it was not territory where I wanted a breakdown, puncture or any other mishap to come my way, and although the road was surprisingly busy, I decided to get through it fairly quickly. In front of me was a 4x4, the driver of which seemed as keen to make progress as I did. He also seemed to know the road well and sped along at a respectable rate, so I tucked in behind him.

After many miles, fifty at least, hills began to develop and along with them were the signs of water, as the juniper trees became taller and stronger. The road meandered through a valley, usually only a few hundred yards wide, displaying the early signs of spring with light green grass and buds on a variety of well-developed trees. Cattle, sheep and goats grazed on the grass, the fields benefiting from small and gentle streams. There were even a couple of orchards with signs outside their entrances advertising cider for sale. The road incline was gentle and the hills went on for miles with the dark green of the junipers getting stronger as the trees grew thicker and higher, covering more of the hillsides. The terrain was so different from the desert just a few miles back and was beautiful because of it.

Eventually the incline increased and we were into the Sacramento Mountains land, the junipers giving way to spruce and pine trees. I was still riding without gloves and I watched the temperature gauge drop thirty degrees in forty-five minutes. Higher and higher we went with the 4x4 in front being my guide as to how sharp the oncoming bends were. The harder he braked, the more I knew I had to, yards before I got there. Eventually we were high enough to see the white stuff I had driven south to avoid, still lying under the fir trees where the spring sun had not yet found it. It really was getting pretty cold.

I lost my escort at the small village and ski resort of Cloudcroft, where I refuelled again, as well as putting on my much-needed

gloves. The village looked pretty and I decided that I would come back and explore another day.

From here, the road descended steeply on the other side of the mountains, the sun was in my eyes making me concentrate on the twists and turns, but blinding me from the sight of the White Sands National Park in the distance.

It probably only took half the time to descend as it had taken to go up into these mountains and the KOA was easy to find on the edge of the town of Alamogordo that nestles at the base of the mountain range. I booked in and Ken, the owner, gave me his standard talk on what to see and do in the area. We only talked for a few minutes, but in that time it became obvious to me that he was one of the most interesting attractions. He knew so much of the history of the State and of the way of life of the local Mescalero Apache Indians.

I made it an objective to speak with him as much as I could whilst I was at the place.

CHAPTER FIVE
NEW MEXICO AND A GOOD OLD BIRD

If questioned, I would guess that many British people wouldn't know if New Mexico is actually part of Mexico or part of the USA, and the answer is that it is American soil though it was indeed once Mexican.

As with all the United States, the Indians of course inhabited the land first; the tribe being the Folsom Paleo some 10,000 years back, but eventually the Anasazi took over when they fled their own lands to the west because of floods around 850 years ago. They became known as the Pueblo Indians by the Spanish explorers because they lived in villages similar to the pueblos at home and evidence of the tribe can be widely seen.

The Pueblo way of life was threatened by the Apache and Navajo who came from the north and, whilst some of the differences between the tribes were sorted amicably, there were also times when they were not. Things hotted up when the Spanish introduced horses to the Indians, but then as the Spanish moved into the territories, they brought with them soldiers, settlers and priests.

In 1598, an exploration engineered by Don Juan de Oñate, arrived at the point where the Río Chama and the Río Grande meet, and he made camp at the Pueblo village of Yungueingge, which he renamed San Garriel del Yunque. The town was destined to become the first Spanish capital of New Mexico, but it was the territory's third Governor, Don Pedro de Peralta who founded the new capital of Santa Fe in 1610.

More and more Spaniards flowed into the area and the Indians were all but enslaved until 1680 when they revolted, killing large numbers of the settlers and driving the rest south to El Paso. It wasn't until 1692 that new settlers entered New Mexico but, in their absence, Utes, Navajos and Apaches, had raided the Pueblos giving them reason to now side with the Spanish. The Apaches in

turn were finding themselves under pressure from invading Commanches until the treaty of 1786.

In 1824, New Mexico became a Mexican territory and then in 1846, during the American Mexican War, US troops led by General Stephen Watts Kearny occupied the area and it became American territory. It wasn't until 1912 that it became the 47th State and here endeth the history lesson.

There are actually quite a few tourist attractions to visit in the Alamogordo area and, with the town being so close to the White Sands Missile Range, it is not surprising that there is a Museum of Space History. Whilst it was not the Kennedy Space Centre, the entrance fee was less than one tenth of that at Cape Canaveral, so seemed worth a visit. There were a few external exhibits consisting mostly of different missiles, but most of the museum was within the four storey "Golden Cube" as it's known.

I took the self-guided walking tour, which started by taking a lift up to the fourth floor and descending to each level below, via ramps.

The Centre is very proud of the links that it has with Cape Canaveral and that it's a back-up site for Space Shuttle landings, even having a replica runway to the one in Florida. In the early days of the program, the Shuttle had to divert to White Sands as Cape Canaveral was suffering from heavy rain or, as the Weather Channel insists on calling it, "liquid precipitation".

All of the videos being shown in the museum about space travel were very interesting though time consuming, but I particularly enjoyed one that showed various astronauts' activities in the Shuttle, so much, I watched it twice.

Not surprisingly there were a lot of exhibits focussing on missiles, as opposed to space travel. At the end of the Second World War, captured V2 rockets were brought to New Mexico along with some of the top German scientists, who opted to continue their work in the USA. The Americans greeted these men

110

with open arms and they were treated as heroes, following much publicity of the progress they made with America's missile defence systems. Their children grew up as American citizens with one even becoming the coach for a local football team.

The range history dates back to before the post war times, as it was the place that the first atomic bomb was tested and there are several books available on the subject, including one titled "The Day the Sun Rose Twice" which can be seen for sale at many outlets in the area. I read somewhere that, if you wish, you could actually visit the testing site, though there are only two opportunities each year and it seemed surprising that if the site is open to the public at all, those times should be so limited. All visitors are apparently escorted as a convoy, I daresay to ensure that perverted souvenir hunters don't walk off with half the rocks in the area. I wouldn't be surprised if all visitors leaving the site are made to walk through a dark room, and anyone glowing in the dark is made to empty their pockets.

Viggy, whom I shall tell you more about later, told me that there was only enough plutonium for three bombs. Having done one test, dropped a bomb on Hiroshima and then, days later, another on Nagasaki, the supply of plutonium was exhausted, but of course the Japanese didn't know that, so surrendered anyway. With so many people killed by these weapons of mass destruction, it was fortunate that it achieved its aim and brought an end to the war in the East. Otherwise so many civilians, many of whom were women and children, would have died in vain.

My father had a horrendous book with photographs of the victims of the bombs, some still alive and suffering from the terrible burns and mutilation that the weapons had inflicted upon them. I believe that it was an American book, but it served to remind people of what we are capable of doing to our fellow man, much as the German Concentration Camps have been kept as they were. Not by a Nation proud of their behaviour, but as a people

bearing up to the responsibility by attempting to prevent it happening again.

Riding around Alamogordo, it didn't take long to realise that it is not much different from other towns that I had seen, with the exceptions of Mexican influence in some of the buildings and the presence of a high number of Mexican restaurants. I love the food, even though so much of it looks as though it has been semi-digested when it is put in front of you. It also made a welcome relief to the omelettes and veggie burgers I had been surviving on, though hot and spicy breakfasts did nothing for my digestion.

One interesting point I did notice whilst touring the town, was that the roads were very slippery, even when dry. My rubber-soled boots would slide over the road surface when stopping at lights, which was very disconcerting, and it was a day or two before I realised that it was down to the dust on everything. The area was extremely dry and there were fires raging in the hills, though I never saw any smoke, let alone flames. It was possible that the dust was a result of the smoke but, as the wind was blowing in the wrong direction, I thought it more likely that the strong winds I had battled through on the way down from Texas, had blown up fine dust from White Sands in the west.

Having spent a couple of hours exploring the town, I decided to take a ride and, looking at the map, I saw what promised to be an interesting round trip, past the Mescalero Apache reservation and up US244 to visit Cloudcroft again.

The notion that the Indians are downtrodden and underprivileged is a very old fashioned one. Yes, of course, there are Indians who are poor, as there are Whites, but the Mescaleros are very successful business people, owning forests, timber mills and even a casino. It made me smile to think that the Apaches are making money from the White Man's greed, when it was that which robbed them of their traditional lands and ways of life in the first

place. The Indians originally greeted the White Man, expecting him to respect the land and the resources that nature provided. It was quite some time before the real Indian wars started and, only after the Indians saw how their lives were being destroyed, did they react.

There wasn't much to see as I rode past the reservation, so I continued upwards and the ride into the mountains was fantastic fun. There were bends in the road and the scenery was like many other mountainous areas, covered in trees and sometimes a little snow. The road surface was fair, though there were a lot of cattle gratings, some of which were preceded with warning signs and some not. All, however, were quite a bit lower than the road, meaning a big bump as the front wheel hit the metal. I found the best way to deal with them was to brake just before entering the grid, and then accelerate at the moment the front wheel crossed the threshold, causing the bike to sit up a little and minimise the thump.

It was about sixty miles to Cloudcroft and once there, I had a good look round. It was, as I suspected, a quaint and picturesque little village on top of a mountain, but I spotted the village museum, which I thought would be worth a visit so pulled into the car park. There didn't seem to be any other visitors there and I walked up the path, past the staff parking area and a pickup with a personalised plate saying "Viggy". I wondered what that stood for but didn't dwell on it. The sign on the building told me that the museum was open and, when I walked in, I met the man himself. He was around six foot three, in his sixties, big in build and most definitely in voice. He had a royal blue shirt, a beige waistcoat and matching trousers that were held up with a leather belt embossed with his name. To add the finishing touch, he sported a cowboy hat festooned with small enamel badges, souvenirs of every State, museum and anywhere else he had been to. He peered out from under bushy eyebrows and behind lightly tinted glasses. He loved the opportunity to go into showman mode and his enthusiasm was

bouncing off the walls. He asked who I was, in an accent that I would guess originated from the northeast of the country, and then if I was in a hurry. With the benefit of 20/20 hindsight, I regret saying that I wasn't.

Viggy launched into his presentation, starting with the explanation of the three jars of bear grease on the counter: one with blood and the others without. He told me how the Indians could use them for forecasting weather and how the previous owner: a Caucasian whose name I forget, accurately forecasted an earthquake and one year, the day that snow would fall several weeks beforehand, but there was no mention of how many times the man got it wrong. He then got very animated about an old washing machine, accompanied with an explanation of how lye soap was made: a pretty unpleasant and smelly concoction for cleaning clothes and body alike.

Somewhere between ten and fifteen minutes after starting "the tour", we had not travelled more than eight feet from the door, which then opened and a married middle-aged couple came in. This dramatic increase in visitor numbers threw Viggy into confusion for a couple of seconds, but he then decided that "we" would all start again.

With every detail that was issued, my fellow male sufferer gave little noises or expressions of surprise, like an "Is that so?" or more frequently an "I'll be darned". Mrs "I'll be darned" suffered in silence as we painfully made our way toward the back of the museum. It was a journey of no more than fifty feet but took nearly an hour, though it wasn't the exhibits that took the time, but the explanation of Viggy's role in acquiring them. All the way I was having flashbacks to the scenes from "Airplane" when the passengers were attempting to kill themselves rather than listen to someone's life story. I was ready to stab myself with track from the model railway, or attempt drowning in bear grease, and me a vegetarian!

During the torture, he also told us that he was continually looking for a rich sponsor and asked if, by any chance, we had the ear of Bill Gates. I'll be darned (hereafter to be called IBD) gave the expected laugh and we all replied that we didn't. The big man turned to me and said, 'Do you know who Bill Gates is?'

IBD gave another grunt of surprise, though this time I think it was for real. I confirmed to Viggy that I was aware of Mr Gates' presence on the planet and he said, 'Well I just thought you may not have heard of him "over there".'

Frankly, I couldn't think of any reply and let the comment pass.

The tour progressed. We passed exhibit by drawn-out exhibit, with intimate detail of Viggy's input to them all. To give the man his due, he seemed to have put an awful lot into the place in the four years he had been there, and I'm sure that the museum would not have been half as well stocked without him. I would just have preferred to hear more about the exhibits themselves and not the detail of their more recent acquisition.

Eventually, Viggy led us out of the back door and, from this position, gave us a lecture on the other exhibits and buildings that made up the rest of the quite large site. He had insisted that we take our cameras with us, as he "knew" we would want to take a picture of the tree stump that Eisenhower had carved his name into, as well as IBD wanting to take a picture of his spouse sitting on an old tractor. He was the tour guide from hell with jokes to match.

Maybe, I thought, I'll be able to make a run for it and get straight to the bike from here, but Viggy seemed to read my mind and his parting comment was, 'It's the same way out as you came in.'

I think I saw Mrs IBD's shoulders drop a little at that point, though her face continued to carry the fixed smile she had acquired somewhere along the way. We all scurried away from our guide, though they chose a different route to my own, and I

plotted another escape attempt by watching for when they went back through. Hopefully, Viggy would pick on them again and I could slip past unmolested.

However, it seemed that I was not the only one with that plan and eventually I gave up waiting for the IBDs, so ran the gauntlet. Viggy was talking to one of his colleagues but, as I attempted to leave, the colleague drew me into the conversation, giving Viggy the opportunity to get started again. Meanwhile, the IBDs tried sneaking past, but the man was far too good for them and blocked all of our exits by placing his huge frame in the doorway. Taking out some photocopied maps and placing them on a counter, he launched into a monologue of other sights to see around the village. After pointing each of them out on the map, he walked over to some photographs displayed on a wall to show us what they looked like, giving great detail before walking back to the counter and his position in front of the door. There were about twenty of these photographs and I could see another hour being lost so, on his second journey, I took a sidestep to my left, which put me within touching distance of the door. Although he was walking with his back to me, Viggy spotted my new position as soon as he turned around and, despite only having worked though a few of the photos, he suddenly changed tack. He walked back over and took up a position next to me, so close that he would have had to move for me to open the door. I could tell he was closing in for a kill and he was rattled that he could no longer head me off.

He made his move. 'Now, how would you all like a souvenir of your visit to Cloudcroft?' he enthused.

Well, none of us were going to fall for that one! We all stayed silent, but Viggy wasn't going to be put off. He pointed to some shelves a few feet from us and started listing all the items for sale, particularly focussing on a commemorative medallion.

IBD stayed silent, but I saw this as my chance. I rocked forward on my right foot, leaving my left where it was, and leaned

forward to indicate I wanted a closer look. Viggy took the bait and took the two steps necessary to get to the shelves, in order to pick up the medallion. As he moved forward, I rocked back again, and then with another little sidestep, secured a position right in front of the door, completely cutting him off from it.

He knew he was beaten; I could see it in his eyes. He temporarily gave up on me and turned his attention to IBD, for his spouse now had her nose very firmly planted in a small recipe book. He commenced working through the complete range of commemorative coins, medals, badges and books on offer, with explanations of what they were and how interesting IBD would find them, but the prey had taken on the look of a new punter at a fine art auction, hardly daring to move a muscle in case he became the proud new owner of a Rembrandt that he didn't want or couldn't afford.

At one stage, Viggy tried to bring me back into the game and held up a badge saying, 'Look, you could start collecting them and put them on your hat like me.'

The thought of it filled me with horror, which I think Viggy picked up on, and at that point wrote me off as a lost cause. He focussed his complete attention on IBD, looming over him and wearing him down with his enthusiastic foghorn voice.

Great, I thought, I can enjoy this, because as a wise man once said "Everything is funny when it's happening to someone else". Then after a minute or two, I felt I couldn't watch any more of such suffering, and started making signs to leave. There were lots of ways I could have done this, like doing my jacket up and putting on my crash helmet, but I chose to take my keys out of my pocket, making sure they jangled as I did so.

Viggy knew what the action meant, but attempted one last shot at me by trying to push the $5 commemorative medallion into my hand. I apologised and truthfully said that I couldn't carry any more stuff on the bike, in fact I'd had to throw some things away already. I could see that Viggy wasn't going to let me go that easily

but, just as he was about to speak again, Mrs IBD looked up from her recipe book and said, 'Oh yes, you must be very short on space.' Bless her!

I left the building almost running, and reached the bike in seconds. I was free. Another museum employee arrived as I started the engine and we had a conversation about motorcycling for a few minutes before he walked away. The IBDs had still not appeared and, for all I know, they are still there, maybe even as exhibits with Viggy giving great detail on how he snared them "one day back in 2002". Still, it's every man for himself in my opinion.

I didn't sleep well that night. Maybe it was the guilt of abandoning the IBDs; perhaps it was that I was finding my bedroll uncomfortable, or it could even have been the dreadful din of the trains blowing their whistles as they approached and travelled through the town. In the morning my right eye hurt a little when I got up and, within an hour, it was giving me serious pain. Being a "roughy-toughy" biker, I of course complained bitterly and by early afternoon was demanding a doctor. Ken and one of his staff: a young lady called Zoë, organised me an emergency appointment and a taxi to get there.

As I half expected, the receptionist and nurses were concerned that they could not immediately call on any medical insurance, even though I had a perfectly good credit card and, whilst I was almost crying from the pain, they filled in a multitude of forms before I got any treatment. The problem was something called iritis which, I was told, was fairly common and very painful. Yep, I knew the last bit of that.

The treatment consisted of five minutes or so with the nurse and about ten with the doctor, but set me back $63 for their time, and another $9 for the eye drops. Frankly, it was worth every cent and was my just punishment for the previous day's abandonment. I ought to add that I had to go back for a check-up two days later, for which I wasn't charged.

118

Zoë was so concerned about me that she sent her fiancé round the following morning to check on how I was, and we started talking about various things. Paul was a very young retiree and, during the winter months, he and Zoë came down to New Mexico for the sun. They were more snowbirds. He told me that Ken and Judy were looking to sell the campsite, which I thought a shame as less people will have access to Ken's incredible memories and stories. On the other hand, he would perhaps finish the book that he has been writing about the hard life of a young Apache girl, whom he had the pleasure of knowing when he was just a boy and she was an old lady.

Paul also owned a Harley Sportster that he had built himself, and was planning on building another in the near future, so that he and Zoë could go on rides together, for they both like being on the front seat and therefore needed one each. We talked about my Ultra for a while and, during the conversation, he asked what I'd paid for it. I told him and he also felt that it was a good price, putting Daytona Ron well and truly on my Christmas card list.

The eye problem meant that I had to stay longer in the town than I had planned, and I also wasn't fully functional because I couldn't wear contact lenses. I had some prescription sunglasses with me but I couldn't wear them for long with the Roof helmet as it's so tight. Fortunately, the delay also meant that I could steal more of Ken's time and hear so many of his wonderful stories. He had been a banker for twenty-nine years and, when he was asked to move towns for company reasons, he and his wife Judy decided to look at other options. An estate agent mentioned that the KOA campsite was on the market and within two days they were running it, though that was twenty years ago. The demands on Ken's time were great, so it was difficult to talk to him for more than a few minutes at a time, but all of those minutes were completely fascinating. He grew up knowing direct descendants of

Geronimo and learned many Apache ways of life and survival in the desert. He told stories of how the White man treated the Indians, how they continuously betrayed them and what the Indians thought when it happened. He knew of the guerrilla tactics of the great Apache warriors and the rituals they would perform before going into battle. He had studied the history of the State and the legends of the local gunmen and heroes such as Billy the Kid and Pat Garrett. The man was fascinating, but the stories are his and it is not my place to repeat them, except for one charming example perhaps. Ken told me that a great number of the early New Mexico settlers and soldiers were Irish, and were often heard to be singing a particular song, the lyrics of which included "Green grows the grass in Ireland". The Mexicans heard the song being sung many times and distorted the first two words; the result was that all the White people became known as "Gringos".

He also paid me the huge compliment of letting me read the unfinished manuscript of his book, titled "Song of the Nightbird". Ken described the book as the story of a young Apache girl's life during the post civil war period in New Mexico. I hope that he finishes it and gets it published soon, as it is sad but delightful. I think that if he were to have storytelling evenings for the young campers, he would likely find more adults attending than kids.

Since writing this book I have noticed that Ken did indeed finish the story and it is available through Amazon. As you would expect from what I have already said, I would recommend it, though keep a handkerchief nearby to catch your tears. ISBN-10: 188132587, ISBN-13: 978-1881325857.

The extended stay also gave me the opportunity to ring Daytona Harley Davidson to check whether my licence plate had arrived. Unlike the UK, in the States the plate licenses the individual person, so had to be applied for when I bought the bike.

Fortunately, the dealership now had it and could send it to me on an overnight delivery. Thus I was able to dispose of the temporary plastic-covered paper licence plate and fit the metal one with my own number of 05773E. It came complete with the word "Florida" and a little picture of an orange on it, but I was a little disappointed to see that the plate did not carry the inscription "The Sunshine State" as I had seen on so many other Floridian vehicles.

After three consecutive nights on the bedroll, my back was complaining, so I experimented in trying to make it more comfortable, finding that if I propped up the pillow to make it higher and did something similar to the area behind my knees, there was no strain on my back at all. I normally sleep either on my back or my left side, so on rolling over to the left, all that happened was the "hump" below my knees just tended to push the lower half of my legs off it. It was fine, and guaranteed the rest of my camping nights to be more comfortable. Not content with that, I gave some thought to the saddle soreness problem, which was at its worst when I was riding in jeans and it was hot. I had already established that a good quantity of talcum powder made things less sticky, but needed to provide more padding. At Daytona I had seen that Jim had a saddle-shaped cushion that seemed to be full of a kind of gel, so it took up the shape of whoever's backside was on it, though I had not seen these for sale anywhere that I had looked. I hit upon the idea of empty carrier bags stuffed into my back pockets and looked forward to trying it out on the next long run.

There was still one local attraction that I had to visit, which was White Sands National Park, just a few miles out of town. In his book "Made in America", Bill Bryson talks about Americans calling things exactly what they are, such as "blueberries", "sidewalks" and so on, so guess what White Sands is. It's 240

square miles of the stuff, but unlike any beach you may compare it to, this sand is gypsum. Normally, gypsum is dissolved by water, which may come into contact through rain or rivers and it is easily washed away. This process is actually what formed White Sands, as the gypsum is washed down out of the mountains into nearby Lake Lucero, but the lake has no rivers leading away from it so the gypsum can't escape. During dry periods, the water evaporates leaving beautiful gypsum crystal structures, which are far from being white. The strong prevalent winds from the southwest break down the structures, which start a domino effect as they hit each other. The process continues and the chunks of crystal bump into each other until, some miles later, the result is small grains of sand, scratched white from all the collisions it has experienced with others. The grains build into piles, the leading edge of which is protected by all the grains behind it. Only very strong wind will actually pick up the sand and blow it about, but the normal fairly brisk wind will cause individual particles to bump their way up the pile, maybe dislodging others along the way, until they reach the leading edge and fall over it. Due to this action, the pile builds up into dunes and progresses as a body, with the wind, year by year. There is no defined distance that it will travel each year, as it depends on how strong the winds are and how wet the weather has been as the sand has to dry out in order to be light enough to be blown forward.

Whilst plants will speed up the drying by drawing moisture out of the sand, they actually slow progress as they provide a barrier to movement. The dunes are usually much higher than the plants and swamp many of them, though there are some that adapt. The Soaptree Yucca can extend its roots by up to thirty feet so that the leaves stay on the surface of the advancing dune. The problem for the yucca is that when the dune moves on, the extended root system can't support the weight of the plant, so it collapses and dies.

Other species that have survived to reach the top of the dune, "capture" the sand with their roots so that they remain on top of a pedestal after the dune has gone. Unfortunately, many visitors have not resisted the temptation to vandalise the area, and have carved their initials, names, and so on into the hard sand captured by the plants. Much like Mr Eisenhower on Viggy's tree trunk.

Many of the animals in the area have adapted to the environment too, and have evolved a white colour to their coats as camouflage, though as they are mostly nocturnal creatures there wasn't any opportunity to see them. Having said that, most evenings there is a "sunset tour" around a specific area of the Park, and I joined as a lady Ranger led us round a well-worn path.

One girl noted a hole in the sand and asked her what it was. The Ranger casually advised that it was most likely the home of a rattlesnake, and that we shouldn't put our hands into it. Well I didn't have to be told twice, or even once for that matter.

The main event of the tour was the sunset itself, as it can be dramatic when the evening light hits the white sand, though that day there were unfortunately too many clouds to make it interesting. It was just as well, for I still had another day to go before I was allowed to wear contact lenses again, and was therefore driving with my prescription sunglasses. It seemed like a good idea to leave before dark so that I could see where I was going, and I headed back to town past Holloman Air Force Base. Despite having been in the RAF for twelve years, I am not particularly excited by the sight of aircraft, but I got my first look at a F117A Stealth Fighter as it took off and climbed rapidly out of sight, and it was actually very impressive. To be honest, I didn't know then that this was the official numerical code. I saw the number on a postcard of the jet, back at the campsite shop.

I had been in Alamogordo for five nights and it was time to move on. Regrettably, I didn't get an opportunity to say my good-byes

to Ken and Judy, as they weren't on duty the morning that I left and headed northwest to Arizona and the Grand Canyon.

I had contemplated taking a less direct route to visit a town called "Truth or Consequences" just to see what it was like. Apparently the original name for the place was Hot Springs but in 1950 a radio show bearing the name of the children's game was broadcast from there, and the town enjoyed so much publicity, the residents decided to rename the place after it. As they say, "Only in America!"

Instead I went north on US70, then on to US54, and had one eye on the weather around me as heavy rain was forecast and I had got kind of used to keeping dry. Despite the risk of rain, I couldn't resist diverting into a side road that had a sign announcing the "Three River Petroglyphs". Ken had told me that petroglyphs are drawings scratched onto rock faces by the native Indians and there were lots of them in the area. This particular site dated back 800 years and was attributed to the Jornando Mogollan Indians.

Befitting the ancient place that it was, the only noises were of the occasional distant birdcall and that of the other visitors to the site, but there was so little background noise that even their slightest and quietest conversation seemed amplified as it broke the peace. The drawings were spread on rocks along a path and up a hill. Whilst some of them were hard to make out, others were very clear so it was easy to see the patterns or outlines of birds and animals.

Despite there being a Ranger at the entrance, the site is pretty much unprotected, and it seems unlikely that people of the same mentality who carved their initials in the pedestals of sand at White Sands, had not also left their mark on these stones, adding their own petroglyphs to those that already existed. It would have been impossible to tell them apart and I must confess that for us heathens, when you've seen one petroglyph you've seen them all, so I fired up the beast again and headed back toward the road.

Just as I left the car park, I got my first (and only) sight of a roadrunner; it looked just like the famous cartoon character and, quite appropriately, ran across the road in front of me. I wondered if such an incident carried superstition and was something akin to a black cat running across my path, though to be honest, I can never remember if black cats are supposed to be lucky or not.

Back on US70, I marvelled again at the scenery with the Sacramento Mountains immediately on my right and the San Andres Mountains further away to my left. It was quite incredible how the terrain changed every few miles, despite it being a desert. Rock changed to sand, sand to rock, or the colours of each shifted slightly or completely, working their way through all the autumnal range. The plant life too can alter dramatically as the availability of water and shelter changes, or the hardness of the rock and sand varies, allowing roots to take hold. The scars of the road, railway, telegraph and fences were almost unnoticeable with thousands of square miles of untouched natural treasures around me. I never got the chance to think the desert was boring along the route. It was a beautiful, beautiful place – absolutely beautiful.

Twenty-seven miles after the petroglyphs, I turned left at Carrizozo and onto US380. There were black clouds all around me and a little patch of blue overhead, which followed me for eighty miles, so I guess that answered the question about whether the roadrunner was lucky or not.

Shortly after the turn, the road took me through a place called The Valley of Fire where the rock was as black as coal but the plants seemed to find it very agreeable. Alongside the road, there are frequent hollows in the surface, giving the vegetation well-received shelter from the wind, and I looked down on a multitude of bright green yuccas, along with the contrasting dark green of the juniper trees, all being set off with the black backdrop. After the pale autumnal colours of the desert, the spectacle was

stunning. It was akin to how you might find sudden and loud noise after being in a very quiet place for a while. The noise would assault your ears, and here, the sudden strong colours assaulted my eyes. Alas, like the rest of the desert vistas, it didn't last for long, and the road continued taking me on past little in the way of human habitation.

One noticeable contradiction to that was a Rock Shop, the first of many I was to see over the next few days. It seemed quite enterprising to be able to sell something that is freely available everywhere, but some of the formations and internal secrets of the items are hidden to those who do not know where to look. I was also intrigued to see that they advertised a rock known as Trinitite, which no doubt occurs naturally, but I had seen in the Missile Museum that it was also the substance formed at White Sands due to the A-bomb test. Did they have the glow-in-the-dark version, I wondered? With the patch of blue still going my way, I didn't feel inclined to stop and ask.

On long distance rides, most bikers do a variety of things to pass the time. I believe that quite a few of us sing to ourselves, as long as we don't have a pillion rider on intercom to suffer the misery. I spent a lot of time thinking about things, but also liked to air my vocal chords when out of a built-up area. This ride gave me the opportunity to really sing out loud and, after I had exhausted all the Eagles numbers I knew, I moved on to America's "Horse with no name". The opening words of the song struck me as being so relevant and I blasted them out at the countryside I was passing. Fortunately, nobody was about to hear my tone-deaf attempt at "I've been through the desert on a horse with no name, it felt good to get out of the rain". I started thinking about my mount and decided it wasn't such a bad old machine after all. Perhaps I should name it, though, to be fair, I had dropped the tag of "Great Big Ugly Beast" in favour of the shortened version, "Beast". I decided to keep with that, unless something else much better

came along. I guess it's a little strange naming a machine, but certainly not uncommon for bikers who develop relationships with their mounts.

Around midday, I crossed the Rio Grande with no pomp or circumstance, not a sign of any tribute to John Wayne and, in fact, I didn't even notice a sign saying that it was indeed the Rio Grande. To be honest, at that point it wasn't all that grand anyway.

Picking up Interstate 25 north for only nine miles, I then continued the journey west on US60. In the distance were the foothills and peaks of the San Mateo and Gallinas Mountains; the foothills looking an off-white whilst the mountains behind were black. The road took me between them, and the colours didn't seem to change that much, the black lightening just a little to a deep purple.

Coming the other way were nine Harleys: the biggest pack I had seen since Daytona and we exchanged salutes, with outstretched arms and palms facing down.

Suddenly, the vista changed to an enormous plain covered in long grass but still with mountains all around. It certainly wasn't desert any more; it was good grazing land and was no doubt benefiting from streams and rivers generated from the mountain rain. The weather was still holding out for me though; in fact the only time I got seriously rained on all day was when I took a wrong turn, resulting in a thirty mile detour. I could hardly expect my lucky roadrunner to have anticipated that little faux pas.

That is not to say that I didn't see the "liquid precipitation" all around me; often I drove on wet roads and often I could smell the rain. In a part of the world where the temperature and dryness mean little natural odour from the terrain, it seemed that my olfactory senses had heightened, much like the desert had intensified my perception of colours before The Valley of Fire. The smell of the rain was like the strongest perfume. Hell, I could sometimes taste it!

Toward the end of the plain was a National Radio Observatory, listening for any extra-terrestrial sign of life. The whiteness of the dishes could be seen for miles but, they seemed so miniscule amongst the surroundings, they were no more offensive to the eye than the many RVs I saw making their way East.

A little before passing the State border I stopped for fuel at "Fred's Garage". It was now pretty cold, despite being only mid afternoon and I was glad to get the chance to put my buff neck-warmer on. As I paid for the low octane petrol, the man himself told me that the last customer had come from the direction where I was headed, and had told him of snow and hailstorms; in fact, the weather was diabolical. I gave a cheery grin and told Fred that I wasn't worried because of my lucky roadrunner which, for some reason, seemed to finish the conversation fairly abruptly with Fred edging toward a back office. I was right though. I saw snow falling on one side or another several times, but none fell on me. Good old bird.

I'm sure that my first impressions of Arizona would have been different if I had passed from Texas directly into the State; not that this is possible by road, as New Mexico sits squarely in between. New Mexico describes itself as "the land of enchantment" and I understood why. To me, the first few miles of Arizona were "interesting" but not spectacular.

The two natural features that were almost immediately obvious were the red rocks that rose vertically out of the ground, much like a small-scale version of Australia's Ayers Rock, and there were lakes. Lakes, of course, meant water, irrigation and more grazing grass, so there were also more cattle and horses than I had seen for some days, but there was nothing like the grandeur of Monument Valley, the place with amazing rock formations used in so many westerns.

I picked up US180 to head northwest to the town of Holbrook, which I had seen from my map book had a KOA. It was getting very cold again, and I was considering trying one of the log camping cabins available, which are double the price of a tent site but considerably warmer. However, entering the town from the south, one of the first things I saw was the Moen Kopi Motel, advertising a daily rate of $18 (plus the inevitable tax of course), which was almost cheaper than staying in a tent, even taking my 10% discount into account.

Over the years, I have travelled widely with the RAF and with the jobs that I have had too. People often comment on how lucky I have been, and I always reply that one hotel room is pretty much like another. Well, the Moen Kopi put pay to that theory as it was very basic, but to be fair it did have an en-suite bathroom, a TV with Weather Channel, a bed with clean sheets and, most importantly that afternoon, a heater. That's where the luxuries ended but to me it was fine. At $18 it was a bargain!

The manager bestowed on me loads of detail about local attractions, as well as recommendations on the bar next door and the restaurants in town. All I wanted right then was heat and I beat a retreat to the room, only to have the manager knock on the door again half an hour later, this time with bike-oriented newspapers and a sticker proclaiming that I had been to the apparently "world famous" Winners Circle Bar, next door. It was a very kind gesture and, after such generosity, it seemed churlish not to at least have a look at the place, so after warming up I wandered to the pub. It was fine, with good service and good beer, the only problem was that people kept on buying me drinks and I knew that I had some writing to do. It wasn't long before I could feel the drinks taking effect and I headed back to the Moen Kopi.

I can't deny that in the morning I wished I had left the bar a little earlier and, although I wanted to do some writing, it really wasn't an option at that stage. Instead I spent the first half of the day just

wandering round Holbrook, and I would have described it as a "one horse town", except that I couldn't find any horses. It was Easter Saturday but it was still cold, so when I got back to the motel, I booked in for another two nights, which would give me the opportunity to get some writing out of the way. You know, some people may find writing easy, but for me it isn't. You may well have guessed that already. I suppose it's like cooking in some respects; you can have the finest ingredients available, but you need a recipe to hold it all together and you need the skill to make it work. I knew that I was getting excellent ingredients, but there was no recipe and I hadn't trained in the skills. Oh, and I can't cook either.

As it happened, months later I was in my local Harley dealer in Newmarket (Black Bear Harley Davidson) and I ran into one of the Fenlander Chapter members, a really nice guy who has been biking for years. He asked me where I had been, as he hadn't seen me around for a while. I told him about this trip and he exclaimed, 'Oh, you must write about it.'

I said, 'Well actually I am, but I'm no author.'

To which he replied, 'That's alright, most of the people in the Club can't read.' So perhaps I should dedicate this work to the illiterate members of the Fenlanders Chapter.

There was another job to complete whilst I was staying at the hotel. I had bought three aerosol cans of silicone waterproofing compound to spray the tent with. Stringing the nylon structure over the shower curtain rail, I emptied two tins over it and the last on the flysheet, allowing the minimum time I dared between each coat. The smell was overpowering and I was getting high on it. I think if someone had come in smoking we would likely have blown the place up and, if the tent was still going to leak, there was nothing more that I could do.

Despite my best intentions, I really found it difficult to concentrate and my progress was slow with the writing, until I

eventually gave up and turned to the TV. A news report told of further terrible weather in the Deep South, where I had been such a short time ago, and the area had suffered no less than twenty-six tornados in the last couple of days. That bit of news made me feel very, very lucky.

As a side note, I met the owner of the motel and he told me that the place was actually the first motel built on Route 66. He had not owned it for long and is slowly restoring it to its original glory, though he admits he has some way to go. It was quite a coincidence that I had chosen to stay at such a notable hostelry, though I had realised from my walk that the town was on this historic route, as there were copious references to it in the shops, as well as articles in a freebie paper.

He also told me of one of the local attractions: a National Park known as The Petrified Forest. As the morning weather was once again beautiful without a cloud in the sky, I headed east for thirty miles to the site of the National Park where the forest is situated – an easy ride along Interstate 40.

The Park is an odd shape; in the north it is a rectangular block around twelve miles wide and ten high, with chunks taken out of its southeast corner. In the centre of the south side of the block, there is a strip about a mile wide and heading south for five miles, before opening up in three further steps, allowing a twenty-five mile drive with some detours if desired. I stopped at many of the parking places en route, to admire the scenery and take photos, as the views were spectacular. Firstly the outlook was of the Painted Desert with vivid reddish-brown hills below the plateau I was on. It was so hard to get any idea of scale without a reference point and, in the photograph I took, the hills could be a few inches or a few miles high. About half a mile further on is Pintado Point where I suddenly got the impression that the world was a very big place. A nautical friend told me that on a calm sea with the eye six

metres above the water level you can see 4.9 miles to the limit of the horizon. On this plateau I could see much further; not only was the desert floor stretched out in front of me, with the Navajo reservation to the left and the Apache reservation to the front and right, but also the San Francisco peaks formed a backdrop 110 miles away. Some view! This area of Arizona also boasts the cleanest air in the United States, though even here there is pollution carried by the wind from the west.

Another half mile further on, the view changed, allowing me to look at the side of the plateau I had been standing on and see the different layers of rock with the now familiar colours. The exception being the surface layer that is volcanic and displays a shade of sparkling emerald green atop of a black background. I am sure that the layers would look different as the weather changed, diffused light offering a less dramatic effect, but there was still not a cloud in the sky and so the full colours of the rock layers were evident.

And so the journey went on, passing different scenery, some of it very similar to that I had now seen so many times, and others quite different. One area called The Tepees was named because of their mostly conical shaped rocks, the sizes varying, but all of them with the striped effect from the layers. The road took me down between them and, in places instead of the Tepees, the rock changed to form another plateau with the surface looking like the loose grey skin of an elephant. The texture looked creased and expandable just as the animal skin would be.

There were plenty of opportunities to look at more Pueblo buildings and more petroglyphs. The signs at a place called Newspaper Rock stated that it wasn't known why the drawings were made, but I'm not sure there had to be any deep significance. Perhaps the Indians made the drawings simply for fun, or perhaps they were vandals like modern day graffiti artists. Whilst I considered the possibilities, I experienced the first English accents I had heard for weeks as two people carriers carted the owners

from stopping point to stopping point. Their voices cut through the air like knives through butter. It was a bit of a shock as I had become accustomed to American accents and I better understood how the man felt who found a Pizza Hut box on the rubbish dump in Nepal. I had been quite unexpectedly bought back to a culture that I had escaped from some weeks hence, and got an insight as to what my accent must sound like to Americans.

Whilst I was keen to get on to the forest areas, I stopped to see something called the Agate Bridge, which is probably the most impressive site in the place. There was a tree across a gully but it was petrified into solid agate and is quite some lump of stone. Being 110 feet long, the weight was likely to make it crack and break so, in the earlier parts of last century, it was supported, and more recently a concrete plinth built underneath. I believe it was the biggest single stone there, as the forest areas are not complete trees but petrified logs. In the middle of the 19th century there were huge quantities of these remains, but the Santa Fe railroad passes by very near, so trains used to stop to facilitate tours that would allow people to take all they could carry. Admittedly stone is heavy and each individual would probably not manage much on their own, but the effect of thousands and thousands of individuals all leaving their mark has reduced the forest to its present state. Even today the theft continues. Despite written and verbal warnings as the visitors enter, and even a questioning by a Ranger as they exit, people remove a ton of petrified rock each month! What is even worse is that it is both possible and legal to obtain the rock through private local sources, whether the object of desire is a small chip or a huge tree trunk costing thousands of dollars. Nevertheless, people still risk prosecution for these chunks of stone, which I guess are likely to end up on mantelpieces or in garden rockeries.

I took the opportunity to walk a laid-out trail, if for nothing else than the exercise. In some areas the path went over pebbles

that, on closer inspection, turned out to be little chips of petrified wood, though I could not see how the chips were formed and if they were made before or after the wood was petrified. The trail also had many logs and a few tree trunks that looked as though they had fallen after the petrifying process, and then split into the logs when they hit the ground, much as I suppose a stick of Blackpool rock would break if you let it fall over onto a hard surface from a standing position. Except of course that these sticks of rock didn't have Blackpool or even Arizona written through the middle of them.

The literature given to me when I paid the entrance fee said little about the petrifying process and I was keen to find out the cause, so I did a little research on the subject.

During the Triassic period, 200 to 250 million years ago, this area of Arizona was close to the Equator, but what was then the landmass of Pagea, separated to form the continents that we know today. Tremendous climatic changes took place, causing trees to die or be knocked over and carried away by floods. Many trees rotted away but some were buried by layers of sediment. Volcanic ash was carried to the area from the many volcanoes that existed then, and added to the layers. The rain and ground water dissolved silica from the ash and carried it through the logs, replacing the cells and crystallising as mineral quartz, but combining with iron and other materials to create the intense colours that the fossils display. The colours in the logs are brilliant but the patterns reflect the original grain and rings of the tree.

The drive was a pleasant way to spend Easter Sunday, but I left the park with the sun setting and returned to Holbrook.

CHAPTER SIX
GETTING MY KICKS

The Manager of the Moen Kopi had told me about Meteor Crater, which I would be passing on my way west along I40. He also told me that when he'd last visited as a boy, the five mile road leading to it had been extremely rough. I had developed a real hatred of the "R" word but decided to risk it anyway and, as it happened, the road had been resurfaced so was as good as any I had travelled to date. It was mid-morning when I hit it and the main car park was almost full, but even a bike the size of the Ultra can usually be slotted in somewhere, so I was soon in the queue for the entrance.

Tourists were absolutely flocking in and the line moved slowly, largely due to the majority of people wanting to pay by credit card and the pay booths only had a somewhat unreliable radio link for a telephone system. When I got to the front of the queue, I realised that the desire to pay on credit was probably due to the extortionate $12 entrance fee, so I followed suit, slapping my Visa on the counter.

I climbed the steps that led up to the crater rim and looked down at the hole in the ground. Yes, it's a big hole at 570 feet deep, nearly a mile across and has a circumference of over three miles. It's also an old hole as it was formed when a giant meteor weighing millions of tons hit the earth 49,000 years ago, but when all's said and done, it is still just a hole in the ground.

The crater was apparently used to train Apollo astronauts, as "the topological terrain so closely resembles that of the Earth's moon and other Planets". From where I stood on the crater rim, it was hard to understand why. The bottom was pretty much flat and looked no different from most of the rest of the desert it was situated in, but despite my cynicism as to the real reasons for the training location, I have to admit that I'm no expert. To be fair to the place, the $12 fee also covered entrance into a small space museum and a short tour a hundred yards or so out along the

crater rim, the rest of it being closed to the public. Okay, now I've been fair so I'll say that I still think the $12 was a rip-off.

I should perhaps mention that most of the natural attractions I visited on the journey were State owned and mainly National Parks. They offer excellent value for money as the usual system is to charge for the vehicle, not for the occupants, and usually motorbikes got in at reduced price. Meteor Crater, however, was a privately owned enterprise and it showed. Not that this seemed to worry the thousands of people flocking in that day.

I rode back to I40 and headed west to the city of Flagstaff, a town that I remember hearing of in the movies, and very much wanted to see before heading on to the Grand Canyon. From Holbrook to Flagstaff was only a ride of about 100 miles, so it was going to be an easy day and, to make it even easier, I used the cruise control whilst on the Interstate. I was getting quite used to the feeling of handing control over to the automatic pilot now, being better able to anticipate at what stage I needed to retake command to cope with any approaching traffic or road conditions. When travelling on quiet, straight roads it was a useful tool, meaning that I could adjust my position on the bike more, causing less fatigue and providing potentially longer riding days. However, it did feel odd when the road suddenly inclined and the throttle grip automatically turned, to give the engine more gas in order to maintain speed up the hill.

Following the main route into Flagstaff, I stopped at a motel; the rates were acceptable so I booked in. The manager told me that my room wouldn't be ready for half an hour, so I waited outside leaning against the bike, which I had coincidentally parked alongside the room I had been designated. The design of the motel was similar to many others as the rooms were on three sides of a courtyard that was otherwise open to the road. I had bought a cold Pepsi from a vending machine and, as I sipped from the plastic bottle with the fizzy stuff bubbling in my mouth, I heard the

familiar and haunting sound of a train whistle. It appeared on tracks just the other side of the road and, if the wind had been in the right direction, I could have spat at it and hit it.

Within a couple of minutes of the first train, another trundled past, the whistle lamenting its slow progress and I counted the carriages on them both; the longest of the monsters had eighty-three in all. I checked that I had the earplugs I had brought with me but not used to date, as I could see it was going to be a long night.

Then from nowhere appeared an Indian. He wasn't wearing traditional dress with a feather in his hair, but jeans and a lumberjack shirt along with heavy work boots. He weaved his way toward me waving his arms as he went. I wondered what I should I do. The guy was clearly making for me and it was impossible to tell if he meant trouble. Should I try and form a circle like the wagon trains in the films? It would be difficult on my own and not enough time anyway. Unlikely as it may sound for a Navajo Indian, the man stopped just in front of me and introduced himself as Roger. He stood in front of me swaying and then leaned forward. Lowering his voice, he told me he was drunk and hadn't been home in three days, though I'd had a shrewd idea that he had been on the pop as his breath was a higher octane than any petrol I had been able to buy in Arizona. He enthused about the bike for a few minutes, walking around it and waving his arms as he went and then tried to cadge a few dollars from me. I asked him if he took plastic and he was good-natured enough to have a laugh before he zigzagged off again. I'm not an uncharitable person but I wasn't prepared to give the man more money for booze. Besides, he probably had a woman waiting somewhere and wondering if he was still alive.

Once all the kit was in the room, I rode toward town looking for a Harley dealer and a fuel filler cap, but within a couple of hundred yards found a Victory Motorcycle dealership instead. If you haven't heard of Victory Motorcycles, it isn't surprising; a

company called Polaris that has been around since the 1950s makes them. It is better known for snowmobiles and, more recently, quad bikes. It wasn't until the late 1990s they started making motorbikes. As may be expected in the USA, Victory motorcycles are V-twin cruisers, just like Harleys and Indians.

The guys in the dealership were very helpful, informing me of the nearest Harley shop situated to the west of Flagstaff, and even phoned to confirm that the place was closed, as it was a Monday. I asked if it was because it was Easter Monday but they showed surprise, as it is not a Bank Holiday in the States. We continued chatting for quite a while about biking things and, just before I left, one of them expressed his condolences for the death of the Queen Mother. It was a sweet gesture and, whilst it took me by surprise, several other people along the way also expressed similar sentiment. In general, Americans really respect our Royal Family and, to some extent, are envious that we have one.

With nothing else to achieve, it seemed like an opportunity to see if there was anything of the original Flagstaff still standing and, sure enough, there was. The Visitor Centre was located in the old railway station, which was described as a "Revival Tudor Building", and looked like it had been lifted out of England by some great tornado and dumped in one piece in the Arizona town. Although it dates from 1926, it was actually one of the more modern buildings making up Old Town and, as I wandered in, my first impression was that it was still a station and I wasn't sure if I was in the right place. Looking round, there were racks of leaflets advertising all the local attractions and I scanned them quickly looking for information on the history of the town. Finding none, I walked over to the counter that was once the ticket office, and spoke to the girl behind it. Just as I was asking her if she had anything on the Flagstaff history, another train rumbled past demonstrating that whilst the building may have been defunct as a station, the track was still very much in use. Naturally, the driver felt the need for long blows on the whistle and completely

drowned out my voice. I paused, waiting for the silence to return and I could see from the girl's face that she was very used to the interruption. When it was safe to talk again, I made a comment about how loud the trains were, to which she agreed and told me that 134 pass through Flagstaff every day: a fact which told me that one night's stay would very definitely be enough.

The leaflet the girl had given me explained that Flagstaff was one of the last areas of the continental USA to be settled, not counting the Indians who were there first, of course. The United States won the 1847 war with Mexico and, along with victory, came huge new lands including the area of Arizona north of the Gila River. The rest of the State was added when the USA purchased it from Mexico in 1853.

Explorers and settlers ventured into the new areas and eventually, in 1876, one group of young men camped near a spring and stripped a pine tree to act as a flagpole for the 4th of July celebrations. The camp, Old Town, was on the route of the Santa Fe Railroad (didn't I know it) and became a supply base for the construction gangs in 1882. The railroad built a depot half a mile to the east of the camp and so the area of New Town developed. Unfortunately, fires destroyed it in 1886 and 1888, leading to the many new buildings being built from masonry.

The leaflet set out a walk around the old buildings, now known as Downtown, and I walked around it a couple of times, enjoying the sights and reading the plaques on the walls. The area is similar to many thriving modern places around the world, full of cafés, bars and tourist shops, complete of course with the inevitable Irish Pub, though it didn't seem to me as though the town had quite "made it". I can't really tell you why that was; maybe because the place was fairly small and there was incredibly heavy traffic around it, whereas many modern towns would have designated it as pedestrian area. Despite the traffic and the trains, the place had a unique charm because it was different, so I enjoyed the walk and reading what the original uses of each of the buildings were.

Nowadays, travellers and tourists are attracted to the city because of the skiing, the Grand Canyon and other National Parks in the area.

The guys at the Victory dealer had suggested that I might like to divert into the Parks of Wupatki and Sunset Crater on my way north to the Grand Canyon. They told me that the road was good and the place was definitely worth seeing, so in the morning I left Flagstaff behind me and headed up US89, to turn right onto the thirty-six mile loop road taking me past the two National Monuments.

Sunset Crater is situated on the southern edge of the Colorado Plateau and the guide book told me that, according to tectonic plate theory, the ground I was standing on was moving at about the same rate as fingernails grow: an interesting but fairly useless fact. In 1250 the volcano had performed its last eruption and coughed out its last cinders, which were red due to the iron content and gave cause to its name. This volcano is not the only one in the area however, and is purely the most recent in the history of the San Francisco Volcanic Field. In fact, all the hills and mountains visible from the point were once volcanoes. What I found most interesting were the rock formations, caused by molten lava oozing out from cracks in a hardened crust. The shapes looked like spines of some prehistoric reptile that had fallen into a gully and been trapped there, eventually being petrified, as had the trees in the forest 100 miles to the east.

Driving along the road, there were woods on both sides though sometimes just volcanic rock, black and razor sharp, but often within these areas there were little patches of greenery. Even the smallest patches of soil supported trees that had made a bid for life, roots seeking out whatever moisture and sustenance they could from the terrain. Like the drive through The Valley of Fire, their green colour made a colourful and striking contrast to the blackness behind. I drove on and, quite suddenly, came to the

edge of the woods where the road descended into the Painted Desert, familiar hues of red and brown replacing the black rock, with the fir trees being exchanged for junipers (though I still don't know if they really were junipers). There were not many bends in the road and I enjoyed the cool breeze as the heat had built up during the descent from the hills. One bend caught me out a little. There was a small hill to my left and suddenly a left-hander took me between that hill and another to the right. It woke me up, as did the spectacular view of a snow-capped mountain in front of me that I took to be Humphrey's Peak, the highest point in Arizona.

I passed up the opportunity to look at more Pueblo dwellings as the Grand Canyon was still some distance away and I didn't know what other sights there were along the route. After heading up US89 and then turning onto US64 there were a couple of chances to stop and buy local Indian crafts, from bows and arrows to jewellery and dream catchers. I took a brief look at the offerings and, although the prices of the items were considerably less than I had seen in the gift shop at the Petrified Forest, the tourist paraphernalia didn't tempt me. Instead, I took the opportunity to look at the view around me. Behind me were high mountains and in front was the very beginning of the Grand Canyon, relatively narrow at this point, but I could still see the Colorado River at the bottom, hundreds of feet down.

Perhaps I shouldn't have taken this preview of the great natural phenomenon, for when I got to the south rim of the main part of the Grand Canyon, it didn't have the effect on me that I had hoped for. There is a high chance that you will have seen the place for yourself, for in 2001 alone, the best part of four million tourists visited it, so I hope that you will understand when I say that it was certainly impressive and there aren't any words that can do it justice; but because I was expecting something dramatic, the visual impact was less than it might otherwise have been. I think the other problem I had in trying to appreciate the sight was that

there was nothing to give it scale. I knew the average distance across it was ten miles because the guidebooks told me so.

At Meteor Crater there was a six foot cut-out of an Astronaut at the bottom to show how deep it was and, whilst it wasn't very clear to the naked eye, I could make it out and it helped me to appreciate just how big the hole was. The Canyon is eighteen miles at its widest and 6,000 feet at its deepest, but I needed to think of places that I knew of that were around ten or eighteen miles apart to really appreciate the size. For all I knew, the Colorado River at the bottom was no more than a little stream, but the fact that a raft trip through the Canyon can take over two weeks really helped to put it into perspective. The thought that the river had carved the Canyon, struck me as being completely amazing, though there are others formed in the same way. One of them: Glen Canyon, lies further upriver in Utah but is now beneath the waters of Lake Powell, created by the building of a dam in the 1960s.

The first European to see the Canyon was a Spanish explorer named Francisco Vásquez de Coronado on an expedition to find the Seven Cities of Cíbola, the legend being that they were incredibly rich and wealthy. Cíbola turned out to be only pueblos belonging to the Zuni people and there were no riches. From there, Coronado dispatched a small contingent to the west and it was these soldiers that were the first western eyes to behold the spectacle. It is hard to imagine what they must have thought as they first encountered the Canyon. They cannot have failed to be astounded by the sheer size and beauty of the place but, as it also blocked their path, there must have also been a tremendous feeling of disappointment. Even now, when the geography of the Canyon is well known and mapped, it takes three days to cross from the higher north rim to the canyon floor, and then up to the top of the south rim by foot. To those soldiers it was an impossible obstacle.

I would have liked to visit the north rim myself because when I had met Steve and Chris in Florida, they had told me that it was even more beautiful than the south rim. Unfortunately, it was still springtime and that part of the Canyon wouldn't be open to the public for another six weeks.

At the east gate is a tower, designed in the early part of the 20th century by Mary Colter, a well-known architect of the time. It's an interesting building with many features reflecting the native Indian influences of the area, including drawings throughout the structure. Halfway up, it is possible to walk out onto a flat roof and get a better view of that part of the Canyon, either the correct way up, or if you wish, upside down as there are periscopes built into the walls to give a different perspective. Inside and on the top floor, I made use of the telescopes looking out of the windows and was lucky to see condors flying around, with outspread wings, coasting on the thermals.

Having made the journey to the Canyon, I took the opportunity to stop at most of the viewing points along the way, though at times parking was difficult even for a bike. Although it was still spring, tourists were flocking in and I was glad that I had not made the journey in summer.

It was getting to be late afternoon when I headed south again, this time down US180, which does a dogleg to head in the general direction of Flagstaff. When I stopped for fuel, I was shocked to see that the high-octane grade was now over $2 a US gallon and I decided that, as I had been enjoying cheap food, so could the bike. I fed it low octane and paid the attendant my money, wondering if the high price was due to him doing a great impression of a band member from ZZ Top.

I was heading back toward Flagstaff as I wanted to see if the Harley shop stocked the fuel filler cap. Not surprisingly, they didn't and also told me that if I were to order one it would take about a week to come. I didn't intend staying anywhere for a week

so that clearly wasn't an option and I would just need to keep trying dealerships along the way, hoping that I would get lucky at some point. Whilst at the shop, I asked what the cost of a headset would be as I was tired of my singing voice and felt that I would like to listen to the radio as I travelled. The answer came back as a staggering $180, not for one of the special crash helmets with earphones and microphone built in, but just for a headset. It seemed that I would just have to carry on singing.

There were a number of KOAs along the way and I thought that I would just keep riding east until it got towards dusk. It was purely by chance that this meant that I got to the town of Seligman. I'd never heard of the place until I saw on the map that it had a KOA, and I didn't realise that it was situated at one end of the longest bits of Route 66 still in existence. The campsite was outside the town and I could easily see it was also very close to the railroad so I drove on. No doubt there would be some cheap motels in Seligman and, as I entered, I couldn't help but notice that the residents really knew how to make use of their connections with the old highway, as there were an abundance of tourist shops and references to Route 66. After cruising up and down the main street, a task that took about two minutes, I stopped at the Aztec Motel and was pleased to find, not only were the rates very good, but the room was probably the best that I had stayed in on the whole trip. Wanting to take a wander up and down the main street to see the tourist shops that were still open, I rapidly took everything off the bike and threw it into my room.

One of the first places that I came to was Angel and Vilma Delgadillo's barber shop, or at least it used to be the town barbers, but now Angel has laid down his scissors for townspeople and only picks them up for tourists. Instead, the large shop has almost been completely given over to Route 66 memorabilia.

Angel is of Mexican origin and, despite being past retirement age, he positively bounces around like a kitten chasing a ball of

wool, hardly pausing for breath as he jabbers on about whatever comes into his mind. He is also a completely charming man. As I walked through the door, he was inviting another tourist to sign his guest book but turned to me to ask where I was from. I told him England and he excitedly asked me if I knew the Sogga magazine. I said that I didn't and he looked disappointed. He asked me the question again and I decided that, without his Mexican accent, the word was probably Soccer. Apparently, in this tiny Arizona town I had discovered a football supporter, but I told him that I still didn't know the publication, and that I wasn't really into the sport.

This time he looked confused and followed up with, 'No Sogga, Sogga.' To which I finally got smart and realised that he meant the SAGA magazine.

Now I could tell him that I did indeed know of it but wasn't yet old enough to subscribe. My answer was irrelevant and he was already reaching into a drawer to retrieve a copy. He advanced toward me with a look of triumph across his face. 'Do you know who is in here?' he asked.

It didn't take too much working out and my fellow tourist was joining in with, 'I do, I do.'

Angel ignored her and opened the dog-eared magazine, thrusting it in front of me whilst he grinned from ear to ear. There he was in full colour, sitting resplendent in his barber's chair. He was extremely proud of his part in the article, which told of the great upsurge in interest of the old Route 66 and rightly so. Angel is an extraordinary character who has probably been largely responsible for this upsurge, as buses flock into Seligman and no visit would be complete without a stop at the Delgadillo's barbershop.

I asked him if he was free to give me a haircut, to which he replied that he never did it for free. For an instant, I thought he had misunderstood me, but that was only part of his act. I was soon sitting in the chair in the corner of the shop, as Angel

snipped away, spinning me around to the point where I was almost dizzy and still jabbering as he did so. It is strange how barbers like to talk so much as they do their work, but with most of them it is a two-way conversation. I could hardly get a word in and, instead of talking, I studied the walls, which were covered with a lifetime's mementos of his trade. Business cards, photographs, drawings and all sorts of other paraphernalia covered this little area, and I am confident that Angel would have had a story for every one of the items. Whilst I couldn't keep up with the flow of the things he was telling me, partly because I really was beginning to get dizzy, I did understand that Angel felt the new interest in Route 66 was due to people craving a simpler life. He felt that things had become too busy and complicated and I thought it would be hard to find anyone busier than this man.

He had finished cutting my hair and again spun me round, this time so that I could inspect the back of my head in the mirror that he held up. It was of course completely fine; I wouldn't have expected anything else from a man that had been making his living in such a manner for most of his life, and I nodded my acceptance. I then heard an electric motor starting and, before I had a chance to work out what was happening, Angel was vacuuming my head and shoulders to remove all the loose cuttings. Not with some special device, I should explain, but with a normal vacuum cleaner, hose and attachments. This was his *piéce de résistance* and I'm sure he loved the look of surprise on my face. Without a smile to give away that he knew it was eccentric, he told me that as far as he was concerned, he owned the hair that he had cut, and wasn't going to let me take it with me.

Quite some time after writing this book, Pixar produced the film 'Cars', and then later the DVD was of course released. Along with the DVD came a short documentary about the making of it and what influenced the writers. Angel was interviewed as being one of the leading

enthusiasts responsible for the new life in Route 66 and my own belief is that the film's 'Radiator Springs' was based on Seligman.

I left Angel's barbers and walked on to The Route 66 Souvenir Shop, but the outside of this place was even more spectacular, though undeniably tacky. There were a variety of amusing signs all over the front of the building and, parked in the road, was a 1959 pink and white two-door Edsel motorcar, that I later discovered had an engine size of 292 cubic inches, or just a little under five litres. It was gleaming in the early evening sun and sitting on the rear fender were two mannequins: the female dressed in 1950s gear of a white cotton blouse, long white-on-black polka-dot skirt and matching scarf, whilst the male was made up to look like a young Elvis, complete in white suit with bellbottoms. A third mannequin had pride of place behind the steering wheel and was positioned leaning out of the driver's window with a Route 66 flag in its hand. Turning back to the building, I could see that it had an upstairs balcony made up to look like a Western saloon, with dancing girls and cowboys lounging about, all being more dummies of course. As the shop was just closing, I decided to come back in the morning.

However, as I was on the longest existing stretch of the famous road, it would have almost been a sin not to take the opportunity to ride it, and I therefore needed to book in for an extra night. I left the room in the morning to head for the office and carry out the task, but met my neighbour, a big Texan, sitting on a chair outside his room, enjoying the sun and sipping his early morning Budweiser. We passed the time of day, then he told me that he was a roving farm hand and had worked all round this part of the country. He should have been moving on but was going to be here for longer because of problems with his truck. He nodded his head to a big pile of scrap iron that had a wheel at each corner, and took another sip from the tin he was holding. The dog at his feet seemed to see the head movement as a sign to find some shade,

147

wearily getting to its feet, walking over to the truck and then flopping down again in the shadow of it.

The Texan asked me where I was from and I told him England. He replied that his folks were from England, so I asked from whereabouts, but he didn't know. The answer killed the topic.

I asked him if he knew Angel, to which he laughed and told me that everyone around there knew him. He then went on to say that every year the town held a street party but the Health and Safety people had stopped it happening, as the appropriate food preparation licences hadn't been obtained. As a result, the street party had been scrapped and instead, Angel had a private family party that he held in his shop. He couldn't help it if uninvited friends turned up and 'overflowed' into the street.

In a town the size of Seligman, it would be a shame for anything to spoil the community spirit.

After completing the paperwork at the office, I made my way back to the souvenir shop. The owner was busying himself with the task of hanging out the signs, parking the Edsel at the front of the shop and positioning the manikins for their daily duties.

Wandering round the shop, I couldn't help but notice the radio playing quietly, the DJ stating that the station it was tuned to was the Route 66 Golden Oldie Channel. It was another positive sign of the renewed interest in the old road.

The variety of the contents of the shop was extraordinary, and I was more tempted to hand over cash and credit card here than in any other place I visited on the journey. From witty number plates to replica petrol pumps, crockery, hats, and the list goes on. I settled for a pin badge and handed over the cash.

The owner of the shop was about my height at five foot eight inches, but he was a lot heavier and I suspect had invested a fair amount of his takings in whatever his favourite ale was. He had long brown hair tinged with grey, as well as a goatee beard. I passed comment on the props that he had in the form of the

manikins and Edsel, and he gave me a potted history of the establishment since he had bought it a few years back.

The Edsel was his pride and joy and he had been offered $45,000 for it, though he said it was worth that much to him each year because of the tourists that it attracted into his shop. He told me that the car was rare even for an Edsel and he used to take it to shows, always putting a manikin or two around it dressed in 1950s clothes to really set it apart from the other competitors. I asked him if he would mind if I took a picture of the shop and he told me that I could take as many as I wished, and even sell them if I wanted. He added that he was a professional photographer by trade, his claim to fame being that he had created around 900 different postcards of fat women on beaches and, if I had ever seen such pictures, the chances were that he had taken the photo. I couldn't disagree with those sorts of statistics and had no reason to anyway.

When I asked him why he had bought the shop, he told me that he came west as a boy, travelling with his parents and remembered doing the trip across country a total of eight times, having to go back at regular intervals to see his grandmother. When he decided that he wanted a change of career, he found by chance that this shop was for sale and has never looked back. He added that his appearance gives him the chance to dress up as General Grant and take part in town processions, though he liked to wear the federal uniform to work occasionally, and give his customers something else to talk about. I could imagine him taking a place next to the manikins and scaring the living daylights out of unsuspecting punters if they got too close.

It was time to move on and take the ride, but I thought that I would make the regular stop at the library for emails and pay off some of the accumulating credit card balance. A sign just across the road indicated that the library was down a side street, almost directly opposite, and I crossed the main road to find the place.

As I walked along the route, I noticed a house with a thin man standing on top, hands on hips and staring down at the roof. He was completely motionless and, for several seconds, I was convinced that the place belonged to 'General Grant', and the man was another dummy. It was only when I was walking past the building that the stationary figure moved, just a little, but enough to show that my assumption was incorrect. He was in fact a workman in chequered shirt and cowboy hat inspecting the task he was about to undertake. This in itself was of no consequence, but when I found the library didn't open until the afternoon, I walked back to see that two colleagues had joined him, standing on the ground, looking upwards and also apparently motionless. They had arrived in a battered old pickup, which was parked on the road and, as I walked by it, the pickup started following me. I walked past it without giving it a second look, but a few yards later I heard a slow "tick-tick-tick". I turned to see the driverless vehicle following me down the road, the sound being made by small stones in the tyre treads hitting the tarmac as it progressed. Honestly, I'm not joking, it suddenly took off at the same pace as I was walking, and straight down the road behind me. None of the workmen had spotted what was happening and I had to move quickly to avoid being run over by the renegade truck as it began to gather speed on the slight incline. I pushed against it for all I was worth, whilst walking backwards to avoid being crushed, though I had little effect and cried out to the three men.

Put yourself in their position. You're minding your own business, assessing the work to be done on a job and you're then aware of some foreigner shouting at you for help. Turning your head, you spot your car pushing the guy along the street and whilst the foreigner may be crying out for dear life, your car seems completely silent as it trundles along. The sight froze them to the spot, for far too long in my opinion! When one of them finally took action, it seemed to me as though it were in slow motion, though he was probably hurrying for all he was worth. It just seemed like

he sauntered out, walked down the road towards us, then calmly opened the driver's door and put the handbrake on. I didn't get a word of thanks or congratulations, but I guess I should be thankful that he didn't call the Sheriff and accuse me of trying to steal the old wreck. A little ruffled but not physically harmed, I walked back to the Aztec and got my gear on for the ride.

I was soon out on Route 66 and, as there was so little traffic about, I turned the radio on loud and searched for a strong signal. The first station that I found was the golden oldie channel and, within minutes of tuning in, the DJ had put on the Rolling Stones, though alas Mr Jagger, or Sir Mick as he is now, wasn't extolling the virtues of the road I was travelling, but was instead banging on about not being able to get any satisfaction. Ah well, it was just as good and, if it had been "Get Your Kicks", you probably wouldn't have believed me anyway.

The road offered little in terms of scenic beauty that I hadn't seen elsewhere in the country, except for the opportunity to visit the Grand Canyon Caverns, but hey, this was looking like it was going to be the hottest day since Florida, I was on a Harley, and on the most famous road in the world. What's a boy to do except ride? And that's exactly what I did for 101 miles, until the road surface suddenly deteriorated, but instead of coming back on the much more direct and quicker I40, I returned the same way. I did make one minor detour at the furthest point, into the town of Kingman, because I had seen a sign advertising a Harley Davidson dealership. When I found the place, I saw that it was a multi-brand outlet with a host of Japanese names alongside the American icon and I nearly didn't bother getting off the Ultra. However, as I was there it would have been silly not to ask if they had a fuel filler cap and I'll be darned if they didn't have two. This was proving to be a very good day.

I saw more traffic cops along Route 66 than on any other stretch I travelled in the USA. Coming out of Kingman, I caught sight of a

black and white Harley with a helmet-clad man on top. It was now very hot and the shadow of the tree he was sheltering under gave him excellent camouflage, as the mottled effect of the rays of sun, that penetrated the cover, added to the two-tone colours of his bike. He was a speed-cop but didn't have a radar gun. In fact, I hadn't seen a speed camera in the country, but I suspect the guy could have told me my speed more accurately than the instrument on the bike. I couldn't help a glance down at it to check I was under the 35mph limit and then a look up at him again. Clearly I was not in trouble for he just gave me a friendly wave as I passed by.

Route 66 began its life in simpler days, long before speed limits were created. In 1857, Lieutenant Edward Beale travelled the west, surveying the land for the Government, and his route was named The National Trails Highway. Later, the road was renamed US66 and nicknamed "The Main Street of America" in 1927, taking in many local roads to create the 2,488 mile highway, crossing eight States as it meandered from Chicago, Illinois to Santa Monica, California. In those days the construction was dirt and gravel, sometimes with logs to keep the surface stable. There was less need for a good road surface then, as there were few cars, and those that existed were not the high performance machines of today.

In October 1929, the great stock market crash sent millions of investors into bankruptcy and kicked off the economic decline known as the Great Depression of 1930 to 1939. Unemployment rose from 1.6 million to 4.3 million in 1930, 12.8 million in 1933 and, at its peak, about fifteen million or 25% of the workforce. Exports plummeted, 86,000 businesses failed, 9,000 banks closed their doors and wages decreased by an average 60%.

From 1934 to 1936, a prolonged drought hit the farmlands of eastern Colorado, Kansas, Oklahoma, northern Texas and northern New Mexico. It exacerbated the effects that the intensive

farming had inflicted on the soil and caused severe erosion, as the wind literally blew the surface away, leading to the area becoming known as the "Dust Bowl". Failed crops, coupled with the Depression, prompted many desperate farming families from Oklahoma and Arkansas, nicknamed "Okies" and "Arkies", to make their way west along Route 66 in search of work in California's orchards, farms and vineyards.

As a side note, sitting here in 2002, there are interesting, though worrying parallels to the 1930s era. Stock markets are in complete turmoil since the 2001 events of September 11th and the continuing reports of accounting scandals in major companies. The events have caused countless billions of dollars to be wiped from the values of equities worldwide.

In central USA, fires rage through Colorado and there are parts of Texas that haven't seen rain in almost a year, causing the farmers to again talk about the 1930s dustbowl. In the north, there are even parts of Montana that are experiencing drought conditions, yet the Deep South has experienced such floods that the farmers there are suffering too. It seems that any lessons learnt from the earlier part of the 20th century are of little value now.

Route 66 was completely paved during the 1930s, providing much-needed work to thousands of manual workers. Then later in the decade, the build-up to World War II increased Government defence spending, meaning jobs for civilians and in the military. The Great Depression was over and many of the new jobs were created in California, causing a new wave of migrants to head west along the route. It was the main artery for the military too, transporting troops and supplies across country, and the paved road could hardly bear the strain of the demands placed upon it.

After the 1930s and early 1940s, the USA was in a mood to enjoy life. The war was over, people were more affluent, they had cars and fuel was cheap. Tourism flourished as families headed to the coast for holidays, and Route 66 was in its heyday. Towns grew

up along the highway with bright neon signs to entice the weary travellers to stop for food and drink, or perhaps even a bed for the night. Travelling the long distance across country was a tiring experience with no air conditioning, and the need for stops was frequent. Communities such as Holbrook, Seligman and Kingman reaped the benefit of the times but, alas, the good times were short-lived.

In 1956, President Eisenhower had a vision to build a road system such as he had seen in Germany during the war, and the Interstate Highways were born. A network of motorways was built across the country and, in the southwest corner, stretches of I40 were opened year-by-year, often in parallel to the old road and sometimes missing towns by a few yards. Local economies suffered greatly and many of their businesses collapsed. Motels, such as the Moen Kopi and the Aztec, deteriorated until their owners finally sold the buildings, perhaps lacking the foresight to know that one day the demand would again be there.

The Government finally decommissioned Route 66 in 1985; the signs that marked the route were removed and much of the highway fell into disrepair. While parts are still navigable, the existing stretch between Seligman and Kingman is unique.

It was 1987 before a small group of people formed the Historic Route 66 Association of Arizona. One of the main perpetrators was none other than Angel Delgadillo. Through the efforts of these individuals, the State of Arizona renamed the stretch of road that I was travelling, "Historic Route 66", and eventually the title was given to all remaining parts of the route.

I had no doubt that, in years to come, much more of the famous road would regain some of its respect and composure, bringing new prosperity to the little towns along the way.

The following morning I climbed back on the Ultra and headed for the motorway, feeling more than a little sorry to leave Seligman. The place may have been tacky but it had real character. Leaving

154

the town, I spotted something on the opposite verge; it was a prairie dog standing bolt upright and looking away from Seligman. It didn't move a muscle as I drove past and I wouldn't be at all surprised if the residents of the town had placed the little fellow there to greet all those approaching.

If you ever find yourself in Seligman and you spot the creature, standing motionless at the edge of town, please let me know.

www.onebritonebike.com

CHAPTER SEVEN
MAKING IT BIG IN NEVADA
AND LOW IN CALIFORNIA

The destination for the day was Las Vegas, again not a long ride, but it was getting very hot and the journey would be a sticky one. The plastic bags stuffed into my back pockets did seem to be making a difference, though I was sure they were also helping me to sweat.

After passing Kingman, I turned northwest on US93, which eventually led up into mountains with different scenery to any that I'd seen to date. Imagine a cake with dark brown chocolate icing when someone has patted the icing all over with a knife before it's set, resulting in lots of peaks and troughs. The cake has had a very light sprinkling of icing sugar which has settled in the troughs and some more that has been dyed green, halfway up the peaks. If you were to hold the top of the cake up to your line of sight you would see something very similar to the view that I had. The mountains were rocky and chocolate brown but a layer of almost white, older rock showed through toward their bases. The green came from a thin and patchy film of vegetation, and the road was so high that the vista stretched for many miles with each successive peak a shade darker than the one before.

The road descended over the Hoover Dam, which is responsible for turning the blue waters of the Colorado River into Lake Mead, an inviting spectacle in the intense heat. The Great American Tourist Machine was pulling countless visitors into the dam's internal workings, but I didn't feel inclined to follow suit; a brief stop to take my helmet off for a few minutes and have a drink was all I needed.

On the other side of the dam, the road snaked back up into the mountains before dropping again to the cities of Boulder, Henderson, and then my goal of Las Vegas. The traffic had got very heavy again, the heaviest I had seen since Florida and I wasn't enjoying doing battle with all the crazy drivers. On top of

that, it was easy to see the clouds of smog hanging over the area and I was filled with a great dread and apprehension. After all the stunning scenery and quiet of the last few weeks, I really didn't want to be there and wished that I had chosen a different route. However, as I only intended to stay in Las Vegas for one night to have a look round, I told myself it wouldn't be too bad. It may not have been ideal but I could stand pretty much anything for one night.

I knew when I was getting close to the centre of the city for, like so many others in the USA, the tall buildings leapt out of their surroundings, leaving no doubt as to where the hub of the place was. The difference with Vegas is that many of those buildings are unique in their design, making it so easy to recognise the skyline.

I pulled off the freeway an exit early in order to buy petrol and a map of the city. The card readers built into most petrol pumps in the Vegas area do not generally accept out-of-town credit cards, and this place was no exception. I went inside to deposit my card with the young black girl behind the till and, after refuelling, I returned to complete the transaction. In this time she had studied the card, spotted that my initials were M J and looking up at me with mischievous eyes asked, 'Are you Michael Jackson?'

'No,' I replied, 'He's whiter than me.' The joke provoked a hearty laugh and she replied, 'Ain't DAT de truth.' She was a lovely girl and, when I asked her for directions, she spent a few minutes sitting with me, highlighting motels and attractions on the map that I had bought. This was her break and she spent it helping me. I really didn't expect this sort of kindness in Vegas.

Finding a motel was easy, but I had such a feeling of foreboding about the city that I was planning the next day's escape route within a few minutes of arriving. Having gained all the solace that I could from my maps, I ventured out onto the streets and the Vegas Strip.

Within a short while I was completely and utterly fascinated by the place. Vegas is Orlando for grown-ups; it's one big playground full of countless varieties of ways to spend your money. I stood for a few minutes at the corner of Sahara and Las Vegas Boulevard to watch the roller coaster come out of the Sahara hotel and then, a few yards further on, disappear back into it again. Much like the sights at Daytona Beach, it seemed fantastic at that moment, but by the time I had walked the five miles to the other end of the strip and the pyramid hotel called the Luxor, the sheer design brilliance of the place had mesmerised me. If you've been to Vegas you'll know what I mean.

After stopping at the Treasure Island Casino to admire the exterior design of a pirates' galleon sitting in an island lagoon, I walked on to another called The Venetian. The bridge that took me over the road deposited me on the 2nd floor of the casino/hotel and the place was amazing. Not only were there gondolas outside the building but there were also more inside, taking people for trips on the waterway, built as the mock streets of Venice. The ceiling of the corridors was painted to look like sky with a few wispy clouds and hidden lighting completing the impression. It was a wonderful replica, though as I have never been to the real thing I have no idea how accurate it was.

I had originally been drawn to the hotel as it advertised an exhibition about "The art of the motorcycle" but when I reached the exhibition doors I didn't feel like going in. Instead I thought that I ought to at least put a few dollars into a one-armed bandit, just to say that I had done it. I picked one at random and put a $5 note into the slot for banknotes. It beeped at me to indicate that I had twenty credits and I worked my way through them, something that took longer than I expected, as I had a couple of small wins. Having finally disposed of the credits, I realised that I should have cashed a few quarters for washing-machines and phone calls if I needed to make them, so put another $10 in the slot as it was the smallest note I had. The machine beeped again and clocked up the

159

forty credits but I didn't really want to walk around with that amount of coins in my pocket. I decided instead to have two more goes, then take the coins and exchange most of them for notes at one of the cashier's booths, keeping a few dollars in quarters.

Now I've no idea why three different symbols gave me a winning line; it certainly wasn't shown on the illustration of winning lines at the top of the machine, but a winning line it was! Beep and chink followed beep and chink as the credit indicator counted upwards. It was exciting to have won, but was even better as I didn't know when the counter was going to stop. As it hit 300 everything fell silent and I didn't hesitate at all before hitting the button that instructed the bandit to cough up the $75. I'd made it big in Vegas!

I can completely understand why people then feel they've got to carry on pouring money back into the machines to see if they can replicate their luck, but I'm not daft. Winning this much was a good thing, and I knew when to quit and move on as there was still so much to see of the city.

The sights are endless but the highlights for me were to enjoy the fountain concert at the Bellagio and a couple of Newcastle Brown Ales at the Harley Davidson Café where, I must confess, I bought another pin badge. Many more of them and I was going to need a cowboy hat to put them on. Viggy would be pleased if he knew.

Vegas had its tacky side of course. Apart from the drive-through wedding chapels, there were countless groups of people, mostly Mexican, attempting to thrust leaflets advertising strip joints, topless bars and "friendly ladies" into the tourists' hands. They would flick the paper with their fingers to attract attention, though once I was used to this trick, I ignored the action, meaning they pretty much left me alone, preferring to concentrate on those single men who had reacted to the noise and had made eye contact. If they got someone to meet their gaze, they would try to

talk them into visiting whatever it was they were advertising, or get them to agree to call the girl advertising her number on the leaflet.

I had the radio on whilst I packed everything onto the bike in the morning, and there was a report about someone being shot dead in the night, whilst they stood on the corner of Sahara and Las Vegas Boulevard, exactly where I had paused the afternoon before to watch the roller coaster. This was a side of the USA of which I had seen precious little, but America is the land of the gun and even Wal-Mart sell them. Despite qualifying as a marksman in the Air Force I am very anti-gun, though it wasn't my country and I shouldn't comment but I'll say one thing. There are bumper stickers and signs in the USA stating that "if guns are outlawed, then only outlaws will have guns". I would respectfully point out that the more guns there are on the street, the more people on the street will get shot, as one Las Vegas citizen can no longer testify to.

However, Vegas had turned out to be much better than I expected and I left feeling very happy, though that may have been because I had an extra $75 in my back pocket.

With the feeling of being that little bit richer, US95 took me northwest and then a left turn put me in California and en-route to Death Valley.

The name of this place has the effect of causing apprehension and a little bit of fear – well it did for me anyway. As soon as I entered the National Park, the road began the descent into the low area of the valley itself. On my right was a hill that rose quite suddenly out of the terrain and had so many colours it looked as though someone had dumped a giant patchwork quilt on the valley floor. Just in front were two mounds, again like miniature Ayers Rocks, but they were brown and cream, like the colours of a Guylian chocolate. I stopped at Zabriskie Point to admire incredible scenery that looked like giant sand dunes with ripples

of colour through them, like one of the jars of coloured sands that are sold at seaside resorts. However, this vista was made up entirely of rock and the scale was enormous.

I'm not sure what I expected from Death Valley, but the name suggested to me that it was probably one of the most inhospitable places on Earth. Indeed, the pamphlet that I got when I'd paid the entrance fee described it as being made up of 3,336,000 acres (or around 5,200 square miles) of which more than 3,000,000 of them are wilderness. So if you read between the lines of that, there are 336,000 acres that are not wilderness. In fact they contain several communities, campsites, petrol stations, restaurants, a couple of hotels and, of all things, a golf course, so it probably wasn't quite what the uneducated tourist expected. To put the place into perspective for the British mind, Wales is about 8,000 square miles, so Death Valley is about 65% of its size. It's huge and can get very, very hot. The highest temperature ever recorded there was in 1913 at 134° F, or 57° C, and it is also extremely dry with the average rainfall being less than 50mm.

It is said that the valley got its name during the winter of 1849 when a party caught up in the California gold rush stumbled into it on their trek west, apparently on Christmas Day. The prospectors were known as the "forty-niners" and this particular group were the first white faces into the hellhole as, up to that point, the area had been inhabited by the Panamint Indians who were able to cope with the harsh and rugged terrain. The visitors attempted to find a way through the desert and mountains that hemmed the valley for a month. They were extremely short of food and water and were glad to find some refreshment on discovering Furnace Creek, naming it such due to the warmth of the water; a constant 83°F.

As they attempted freedom from the area, the wagon train broke up into smaller groups such as The Jaywalkers and the Bennet-Arcane Party, each with their own theory of escape. Eventually as one group left the valley, one of its members looked

back and said, 'Goodbye Death Valley,' and from that it is said that the area got its name. However it is believed that only one of the original visitors lost his life there, though I think the number would have been much higher had they made their trek through the Valley in the heat of summer.

Reports of silver and other precious metals lured other forty-niners to the area and, whilst there were strikes, none were large enough to sustain ongoing settlements. Even the main export of Borax wasn't strong enough to lead to a permanent township.

To the uneducated visitor, such as I was that day, the place looked like it could not support much in the way of life, though I couldn't have been more wrong. There are over 1,000 types of plant life, each of which has adapted to survival in the harsh environment. Some plants have developed outer skins that lose little moisture, whilst others have root systems that go down over twenty metres, or extend outward just under the surface to amazing distances.

Knowing that plants can adapt and survive so well, it is no surprise that animals can too. Rabbits, rats, deer, bobcats, mountain lions, coyotes and foxes exist, as well as many different types of lizards and a few varieties of snakes. The biggest native animal is the Desert Bighorn, which is a type of goat, but there are also wild burros that are descendants of escaped animals brought to the area by prospectors in years gone by.

All in all, the place is teaming with life, though that is to be expected as Indians once made it their home and would have needed food resources. Indeed, there is still at least one settlement of Timbisha Shoshone Indians who live in trailers and adobe houses on a reservation.

One of the many mysteries of the Valley is the extraordinary Racing Rocks of the Racetrack Playa. These are not little pebbles, but boulders up to 700 pounds (317Kg) that make their way across an almost flat dry lakebed, leaving furrows in their wake. Whilst

some of these stones have only travelled a few hundred millimetres, others have travelled over 900 metres! A century of research has not conclusively established what drives the rocks or why some take a straight line whilst others meander over the harsh terrain. Nor has anyone ever seen them move, so they remain a mystery despite numerous theories as to the cause. One of the suggestions was that the rocks were simply moving down an incline over time, but this idea has been quashed as it has been proven that in many cases they are actually moving uphill. Other suggestions have included magnetism and ice sheets that form in the cold night temperatures. When the ice melts, it surges, being pushed along by the wind and therefore having enough force to displace the boulders. Despite many scientists devoting countless years to the quest, the research has been made harder due to the remoteness of the area and the fact that it is classed as wilderness, meaning that no permanent structure can be erected.

However, a Professor of Geology at San Jose University has come up with her own explanation of the cause. In 1996, Dr Paula Messina mapped the locations of the 162 rocks using a handheld global positioning device, and continues to map their positions on a regular basis. She has found that two components are vital to the movement of the rocks – and they are wind and water, the fierce winter storms bringing plenty of both in that particular area.

The surface of the Playa is a fine clay which becomes extremely slippery when wet but, in addition, there are bacteria which become active in the moisture and form long hair-like strands, which themselves are almost frictionless. Under these conditions, it becomes much easier to move heavy objects such as these rocks.

She was also surprised to find that there was no correlation to the distance or pattern, dependant on the size of the stones, with big ones sometimes moving further than their smaller counterparts. Nor was there a pattern with the shape of the boulders and the paths they took. Instead, it seemed that the pattern and distance of their advance was down to the

surrounding mountains in their particular part of the Playa. The terrain would cause different wind directions and turbulence leading to the different results. However, Dr Messina's theory is still just that – a theory.

On leaving Zabriskie Point and descending further into the valley, there were a lot of plants, and I could see that they followed the bed of a stream. Rounding a bend, the sight of one of the hotels hit me, with tall yuccas around it, and it strongly reminded me of the album cover of Hotel California, putting the Eagles firmly back in my mind, singing the title track. I have to confess that when I later got hold of a copy of the album I could see that there was little likeness to the scene I had witnessed but it didn't matter. The music was what counted.

I stopped briefly at the Visitor Centre to pay the entrance fee and noticed that there was a sign to say that it was 190 feet below sea level. From there, I backtracked slightly, in order to take the fork in the road that led to Badwater, and I passed an area known as the Artist's Palette. It was there that I became convinced that I had developed a food fixation, for the mountains looked more like ice creams with the veins of raspberry ripple and other such flavours running through them. There were two more miniature Ayers Rocks, but this time they were dark brown with green veins; definitely choc-mint I decided. Perhaps these delusions were caused by the long time I had spent queuing in a Ben and Jerry's in Las Vegas, or perhaps it was the heat. It was cloudy but the temperature was over ninety degrees and there was no wind. I was sweating heavily under all my armour and was glad that I had taken the opportunity to fill my bottle at the Visitor Centre, despite the awful taste of the water.

Badwater is the lowest point in the United States at 282 feet below sea-level but, despite the heat, there was a small pool of water. There were also signs requesting that people kept away from the edge of it because of a breed of snail living there, totally

unique to the place. Unfortunately, the signs weren't easily spotted, so many people were traipsing around the pond doing untold damage to the poor little creatures. Other than that there wasn't much to see, except that on the hillside behind was a mark to inform where the sea level is and, despite the low altitude and the heat, directly to the west were snow-capped mountains, which seemed to contradict the temperature I was in. I would have liked to drive without my Roof helmet, but California was the first State I was in where it was illegal to ride helmetless. The rules vary across the country and, in some States, is also dependant on age, giving more protection to young bikers with the enforced wearing of protective headgear. I therefore had to suffer a hot and sweaty head.

I couldn't drive directly west and had to go north first, along the road I had come from, before picking up US190 again. The route was much like an inverted horseshoe and, although it was far longer than travelling a straight line, it did at least afford me a stop at the town of Stovepipe Wells and a chance to take a photograph of the town sign, proudly stating that the altitude was five feet. Of all the unlikely places in the world, I was also able to check my emails at the hotel, as well as phone Scott Pinizotto at Indian Motorcycles to say that I would be on the weekly Monday tour in three days time.

When Tom Cunliffe wrote his book about his travels in the USA and his visit to Death Valley, he mentioned his concern for the air-cooled Harley engine and the work it had to do on exiting the place, climbing the hills in the heat, though he experienced no problems and neither did I. I would daresay that none of the other 200 plus bikers I saw that day, either on their way to, or from Death Valley suffered either, which goes to prove what a workhorse the Harley is.

Looking at the map again, the only KOA that seemed reachable was at Lake Isabella on US178 and about halfway to the Californian coastline: something that I really looked forward to seeing. It was an uneventful ride up out of the valley, apart from one incident of riding round a blind bend and hitting a rock with the front wheel, which had me wrestling with the handlebars as they made a bid for freedom. It's funny, but even if I had seen the rock earlier, I would likely have hit it, as I tend to stare at such obstacles making me naturally ride toward them. I also think that part of the reason I hit it was that I was feeling incredibly tired, and that was probably due to the fact that I couldn't stomach the water from the Visitor Centre, so hadn't drunk anything in quite a time and was dehydrated. A little further on, I stopped to have a good look at the tyre but could see no damage, and took a few sips of the foul liquid in the water bottle. I needed to fuel the bike anyway, so would stop at the next gas station to refill us both.

The hills leading up to Lake Isabella were quite a contrast to the countryside I had experienced for the last few weeks, because they were so green. It was like being in the lower Swiss Alps; the vegetation was so incredibly brilliant and there were even little Swiss-style chalets perched on the sides of the hills.

Booking into the campsite, the manager told me that they ran a bar and I was welcome to stop in for a drink if I wished. Campsites with bars were quite a novelty to me, the only other I had been to was the one at Key West, so I thought that after I had set up camp, I would have a beer with a few fellow campers. When I wandered into the little place, it soon became obvious that I was the only camper there, and that this was the usual watering hole for all the locals, only they weren't local; for every single person had come to live at Lake Isabella from elsewhere in the USA.

I ordered a draught Budweiser and took my maps out for a study of what route to take in the morning. I was just changing between maps when the beer arrived. The barman was around six

feet tall, in his sixties with swept-back white hair, a white cotton shirt and black lace tie. As he handed me the glass, he leaned forward and very slowly drawled, 'Excuse me Sir, but I detect an accent.'

There was a jukebox blaring out some country and western number behind me, so I copied his movement to ensure I could be heard, then truthfully replied, 'So do I.'

He smiled and asked where I was from, but I hesitated before answering. Along the way people had been guessing my origins; around half asking me if I was English and half asking if I was Australian, though one person thought I was a Canadian and another thought that I was Ossie Osborne in disguise. 'Where do you THINK I'm from?' I asked.

He thought for a second, then looked me in the eyes and replied, 'Germany.'

Well, as English accents go, mine is about as "accentless" as it can get and I think most people would say that they wouldn't be able to tell where in the country I was from. I expressed my surprise as I told him my heritage.

'Well, I've lived in England,' he said. 'And you don't sound English to me.' He sounded as though he really didn't believe me and I guess I was a little offended. A thought then struck me.

'Whereabouts in England did you live?' I asked.

'Liverpool,' came the reply. Well, that explained it! His whole understanding of how the English speak rested on one of the strongest accents in the country. We exchanged a few more nice words before he had to return to his bar duties, whereupon I continued with my beer and looking at my maps. That, of course, attracted the attention of all those closest to me, and they were quick to offer travel tips and advice on the best sightseeing routes. I found that I was also in possession of a magic glass, because as soon as it emptied, I found a full replacement sitting next to it. As nice a gesture as it was, after a few occasions, I caught the barman's attention and asked him not to let anyone buy another

drink for me. However, a while later, just as I was draining the contents of that glass, another beer magically appeared and I asked the barman what was happening. It seemed the manager was now also serving and the barman hadn't thought to tell him that I didn't want any more. I was now feeling the effects of the alcohol and didn't know which way to hold the map. Not that this was important as I couldn't focus on it anyway, and had long since given up trying. Instead, I was talking to the other customers and enjoying their company immensely. As I put the glass down for the last time, I found a small wooden disk next to the beer mat and once again asked the barman for an explanation.

'It's a token,' he said. 'Somebody else wanted to buy you a beer and, as you didn't want another, this token will buy you a drink next time you come in.'

Americans really are the most hospitable people I have ever come across. I asked the barman to thank whoever was responsible, but to return the token to them, as I was leaving in the morning.

I slept very well that night, but I'm sure it was because there was no railroad nearby!

Laundry, a late breakfast and a throbbing head meant that I didn't get to leave until around 11.30 the following day. I had planned a route that took me around the west of Lake Isabella and high up into the mountain roads again. The weather was clearer than the previous day and I could see more of the countryside that surrounded me. California; this bit at least, was the greenest area that I had been to. The trees were advanced well past the early green buds of spring, yet there were still spring flowers of yellow, pink and blue with dense cover on some of the areas benefiting from plentiful sunlight.

US155 took me higher and higher and became twisty; very twisty. The road was tucked right into the edge of the mountain, with sharp left and right hairpin bends making me lean the bike

over further than I had done before, and I was very out of practice. It was first and second gear stuff, with heavy braking before the bend, cautiously choosing the line, as I had no idea what was round the corner, then gentle acceleration through it, daring myself to put the machine just a bit further over than I was comfortable with. However, I wasn't too worried about the previous day's experience with rocks on the road, as there was so much foliage on the mountain, holding it all together. Despite my best efforts, I just couldn't get anything in contact with the road surface other than the tyres. Man, it was hard work but it was also great fun!

What I first thought was a squirrel ran across the road in front of me, but it was smaller, browner, and had a thin tail. I realised that it must have been a chipmunk and I didn't think that I had ever seen a real one before. Maybe another good omen, I thought. Hopefully it would be as good as the roadrunner.

The road still twisted its way up and into the trees, and then very quickly into low cloud that closed in around me, until the visibility became a problem and the road surface became wet from the condensation. Then on a small stretch of steep downhill, the red engine light in the instrument console lit up and stayed on. Luckily there was a lay-by at the side of the narrow road and I rode into it, switched the engine off but left the bike in gear. My first concern was to check the oil as I hadn't done it for a while, and wrestled with the push fit filler cap located too near to a hot exhaust pipe, though it checked out okay. The bike was slightly overdue its service, but apart from the red light it seemed like it had been running fine, so I climbed back on and pushed the starter button. There was the familiar "click click click" of a starter solenoid trying to do its job on power from a very flat battery. "Bugger!" was the first word that came to mind.

Ah well, I was on a downward slope at that moment so I could bump start it. I had been running with the spotlights on so switched them off, but because the bike was built to American

specification, the normal lights came on when the ignition did. It didn't even occur to me to pull the fuse for them and, at that time I'm ashamed to say that I didn't even know where the fuse box was anyway. I shifted the bike into neutral and, checking as best as I could that there was nothing looming up behind me through the cloud, I rolled out onto the road. Not knowing what might be heading my direction, I was fortunate that the bike built up speed very quickly and with the clutch in, I shifted into second gear and let the lever out again. Luckily the tyre bit on the wet road surface and turned the big engine over, making it fire up immediately. Well, that's a good sign, I thought, but then noticed that the voltmeter on the instrument panel was down to eight volts, when it normally indicated fourteen.

My mind went back to my first ever motorbike: a Honda CD175A and a problem that I'd had with the charging circuit. I could clearly remember the offending article as being the "selenium rectifier": an arrangement consisting of four orange plates, about two inches square, bolted together through their middle, but with spacers to keep them apart. In that case, the rectifier had packed up altogether and the result was that I could only run the bike for as long as the battery held charge, and this was looking to be a similar problem. I didn't have many options. I could stop somewhere and phone a Harley dealer to collect me from the top of a mountain, or I could drive on and make it to somewhere more convenient, hopefully as far as a dealership.

On I went, trying to use the brakes as little as possible, as well as using them both at the same time to give the quickest braking. This would limit the time that the brake lights were on and reduce the drain on the battery power. I could hardly get into second gear before I had to change down again as the road and weather conditions were so bad. Then, just as I thought that things couldn't possibly get any worse, it started raining. Bugger! I thought once again.

When I'd bought the petrol cap a couple of days before, I had also bought some HD rain repellent wipes which, according to the text on the package made the water on the windshield break up into smaller drops, and allow the wind to disperse them more easily. I had used them immediately and was therefore expecting to have little problem seeing through the screen. The problem was that I needed some speed for the wind to do its part and there was no way I could get any up. On the other hand, the road was so twisty that most of the time I was looking either left or right, past the screen to the approaching bend. I went into one particularly tight right-hander to find some bright spark had put a cattle grid right at that point. The wet and slippery metal girders of the grid were not what I wanted to see when leaning so far over and had to momentarily pull the bike upright again. I couldn't turn on the power when hitting the grid, as I had been able to do when in New Mexico, because it would have put me completely on the wrong side of the road, and needing to crank over even further to get me to the right side. Instead, I wound the throttle off and felt the double thud of the front wheel entering and leaving the grid. This isn't fun any more, I thought.

Eventually, the cloud subsided and the slopes reduced till there was as much flat ground as there were bends. By now the engine was missing and trying to cut out between gear changes and I kept the revs high when shifting up and down. There seemed to be an endless supply of chipmunks running across the road in front of me and I feared some major catastrophe. Eventually, I spotted a log cabin some way up ahead and it had a line of Harleys outside, all facing outwards and giving the impression of a bike shop. I saw the name over the door; it said "Crazy Horse" and I thought of "Krazy Horse Customs" in Bury St Edmunds where I'd had some work done on my Dyna back home. The choices of stopping here or trying to get to a main dealer in Bakersfield were going through my brain when I noticed that it was actually a saloon. So Bakersfield it was then.

Miles later, after at least forty chipmunks had run across my path, I came to a T-junction with two bikers sitting on the grass enjoying the sun. They weren't on Harleys, but I asked directions and they gave me a rough idea of how to get to the Harley shop as I gunned the engine to keep it alive.

I pressed on, another nineteen miles according to the sign pointing to the town, and took the exit they had told me of. Driving up and down the streets, trying to orientate myself, I couldn't find a likely pedestrian to ask the way. Then at a red stop light, the engine finally died with a completely exhausted battery. Embarrassed at my predicament, I started pushing the bike to the side of the road, when the owner of a passing Road King stopped and helped me get it to a McDonalds car park, telling me that he'd only had his bike three days and this wasn't what he wanted to see! Of course it wasn't what I wanted to see either.

His wife lent me her phone, and I called the dealership to ask for a recovery vehicle. I have rarely heard anything as sweet as the words that came back to me of, "I'll be with you in ten minutes".

The man was as good as his word. Rob, the Service Manager turned up in a battered pickup and, with incredible ease, pushed my bike up a portable ramp into the back. This was Saturday afternoon and we only had around forty-five minutes before the shop closed until Tuesday morning.

At the Dealership, they determined the problem was not the stator as they first thought, but was actually the battery, which hadn't been serviced when it should have been because it was only half full. Both Harley Davidson Daytona and Harley Davidson Wichita Falls should have checked this on the services, but obviously hadn't. To make things worse, the extended warranty didn't cover the battery and I would have to pay for it myself. I was however very glad that Rob and his team were able to react so quickly.

I left the guys the three cans of Coors that I had in my panniers and went through to pay the bill. One of the ladies in the shop area

asked me about the trip and, after telling her the story of what I was doing, she kindly invited me on a "Dinner Run" they were having that night: a trip of around 150 miles with the local Chapter. It sounded like a good idea and I rode off quickly to find a motel and dump my gear.

The Best Western was just up the road, but there was a terrific omen opposite it that I couldn't resist, in the shape of the Roadrunner Inn. Could my luck be returning, I wondered?

A little while later, back outside the dealership, there were somewhere between forty and fifty bikes amassed, all with the usual black leather uniformed owners. I felt a little out of place with my bright yellow Gortex jacket and two-tone silver and burnt orange Ultra. Still, I was sure they would make allowances for me as I was a foreigner and I parked the bike up on the opposite side of the road to the dealership. Crossing to the other side where most of the bikers stood chatting, I noticed something in the gutter and, picking it up, I realised it was a chequebook. It turned out to belong to the owner of the dealership himself, Mr Tex Thorp and I was glad to be able to return it to him, feeling I had done something to repay the prompt service I had received a little while earlier. He seemed to be very appreciative of the action too, or so I thought at the time.

Just a few minutes later, someone or other made the appropriate signal and all the bikers and their ladies headed back to their mounts. The sound of the stage-tuned engines was fantastic as we set off and it occurred to me that it had been a very long time since I had ridden in a pack. It was a lot of fun; I suppose it was partly the sight and sound of so many bikes out together, but also it felt good to be with people that were part of a supportive group that shared common interests. I looked forward to the dinner when I could meet them properly and hear their stories.

174

There were two good experiences on the ride. The first was the orchards of oranges with a perfume like incredibly strong honeysuckle that lingered for miles, making me breathe as deeply as I could to savour the aroma. The second was the Pacific Crest Wind Project: a wind farm with literally thousands of generators spread over the hills around Ventura, the blades spinning round in the strong California winds, though I've no idea if they made much noise because I was in the middle of so many modified exhausts. I had never seen anything on that scale and it must have been saving enormous resources in terms of fossil or nuclear fuel. Personally, I've never understood the objection that some conservationists have to this type of energy production, as it is cost effective and makes use of free fuel without the pollution.

The bad part of the ride was watching the voltmeter needle head south. When we reached the destination of the diner, I found Tex and calmly told him that I still had the problem.

'Oh,' he said.

'It's down to ten volts,' I further explained.

'That's not enough,' he replied, and walked away. Well naturally I wasn't going to let the bastard get away with that and went after him.

'Hold on, what are you going to do about it?' I asked.

'The shop's closed until Tuesday,' he told me.

'But your guys told me they had fixed it.'

'Well they thought they had, but the shop's closed until Tuesday and there is nothing I can do about it.' And with that he walked off.

I exclaimed, 'I shall put this in my book!' It sounded as pathetic then as it does now, but it was all I could think of to say.

As he headed through the door of the restaurant his last comment was, 'Well you do that.' He didn't even bother to look at me.

Frankly, I was disgusted and told several of the bikers there, none of whom were surprised at what had taken place because they knew the man. I wasn't so much annoyed that he wouldn't look at the problem until Tuesday, but I was by his attitude. If he had said that Tuesday was the earliest they would look at it, but they would make sure that I got to my hotel okay, then I would have been happy. Instead he walked away and that was not what I expected of the comradeship of a fellow biker. It certainly wasn't the attitude I would expect from someone riding in the same pack, someone I had returned their lost cheque book to, and was definitely not what I would have wanted from the owner of the dealership that had just worked on the machine. It stank!

I decided I had no choice but to head back immediately as there wasn't much daylight left. Some of the other riders showed genuine concern and one couple gave me their card with phone number. As I discussed the problem with them, another guy approached me with a menacing look on his face. I thought maybe he was a friend of Mr Thorp's (if he had any) and I was half expecting him to tell me to clear off now whilst I still could. He was a big man with biceps that would have matched my thighs, the mandatory bandanna and various tattoos adorning the exposed parts of his skin. As it happened, I had confused the aggressive look for one that was actually concern, and he told me that if they passed me by the side of the road, he would go home and get his trailer to ferry me to the hotel. This was the sort of attitude that I had mostly come across in my travels, not the likes of Mr Thorp's.

It was dusk and I was about halfway back when the engine light came on and the voltmeter needle headed further south. I was driving way over the speed limit, as the quicker I got to Bakersfield the less the lights could drain the battery, and I was glad to eventually see the exit from the Interstate to get to the hotel. At the bottom of the slip road ramp, the engine died and, despite my

attempt to make use of the remaining speed, I was in first gear and the tyre wouldn't bite on the road as I tried a bump start.

Whilst waiting in the Amarillo dealership, I had bought some stickers for friends in England. These had a variety of witty statements on them including one that said "I'd rather be pushing a Harley than riding a Honda". Strange, but I didn't find it so amusing as I put my weight behind the immense machine to cover the couple of hundred yards to the hotel. At least I didn't have to also cope with the weight of the luggage as I had removed most of it when I had checked into the Roadrunner. Once again though, the bike had very nearly made it to my destination with a dead battery, much like a faithful but dying horse taking its owner to safety, and I was getting to like the machine.

Though the bike was heavy the ground was flat, so with some effort we got to the hotel with total darkness approaching fast. I told Jo, the receptionist, that I would now be here for at least three nights as I recanted the evening's low points and, whilst I took the last of my belongings from the panniers, she phoned a friend of hers. The first I knew of it was when she knocked on my door, asking me to come to the phone and explain what had happened to Bill, an extremely experienced Harley rider. After Bill and I had talked for quite a while, he told me that he would be over in the morning with a battery charger, so that I could at least drive to the dealership and not be charged again for bringing me in.

Sure enough, in the morning Bill turned up with his brother Sam. Bill was a tall slim man in his mid fifties, but looking very good on it, with few wrinkles in his tanned face and grey hair tied back in a very short pony tail. He had a short goatee beard and wore dark glasses that he didn't take off through the entire time we spent together. I would guess that he was quite a lady-killer in his time. Sam was older, shorter, with more weight and less hair. What hair was on his face was a little unkempt and straggly and his voice was deeper than Bill's. A rough rasping voice that most country singers would be proud of – well the male ones anyway.

We talked as we took the saddle off the bike and connected up the charger to the battery and the mains inside the motel door. They knew the owner of the Harley dealership and again were not surprised at the way he had acted. They told me that if my bike was an older model they could probably have fixed it for me but alas they were no experts on the recent Harleys.

I felt that as these guys were helping me so much, I should be buying them a coffee at the very least, and breakfast if they wanted it, so we climbed into Sam's ancient pickup and drove the two hundred yards to a café, where we ate and talked for several more hours. Actually I didn't get to talk much myself, I just listened to the stories they told of their background, their families and their lives up to that point. I believe they actually just wanted to talk about their history to someone who was genuinely interested.

Both were Vietnam veterans, both had been in serious bike gangs, both had been heavily into drugs and Bill had served time in the State Penitentiary. It was a side of life that I had never really been exposed to and I found it fascinating to hear these true stories. Bill told me of times when the gang that he was part of had been "at war" with other gangs and as one of the hit-men he would have bombed their cars or been prepared to do anything at any time if the leaders had demanded it. He told me that he and Sam used to be in opposing gangs and would have killed each other without thinking about it, but now were the best of friends. They recanted many stories of drugs, murder, prostitution and gangland stuff that would make your hair curl.

I can't retell much of what they said as they are still wanted for some of the crimes, despite it being many years since they committed them. That gives some indication of the severity of their deeds.

However, they did tell me a couple of stories that didn't directly involve them. One was about a group of local bike enthusiasts that started a bike club, which wasn't in any way meant to be a threat to the gangsters as they were just people who

178

wanted to enjoy each other's company because they shared a common interest. Unfortunately, they made the mistake of designing and making a badge to attach to their leathers, and the gangs told them "Drop it or defend it". It seemed incredible that such an innocuous thing as a club badge could have got these innocents into so much trouble, but they were left with no misunderstanding of the possible outcome if they didn't comply. The group knew what it meant and, after some deliberation, they chose the former option. I was also under no illusion that Bill would have received some pretty horrific orders from his Bosses should the badge have remained, and I was reminded of the incident at Daytona when Carl had to remove his "colours". It was only then that I realised that none of the bikers on the dinner run wore any sort of badge to show that they belonged to a particular group and the rule was the same right across the States.

They also talked of the biker parties that frequently occur at Lake Isabella, where I had camped two nights before, and told me what the parties were like during their own wilder days as well as the more recent history. They were at one not so long ago and had camped up near to one of the real hardnosed bike gangs. They felt they were far enough away not to get drawn into anything but witnessed the return of a girl who had been sent off by one of the leaders to buy booze. As she was apparently using her own vehicle, she felt that she was entitled to use some of the money to put petrol in her car but the gang leader clearly didn't agree. Bill recanted how they nailed her to a tree, and held up his left hand whilst pointing to it with the index finger of his right. I hoped that they were exaggerating and it was her clothes that they nailed through. I asked him if he meant through her hand itself and the look on his face and slight nod told me that he did. The two of them had seen the frightening situation developing further so quickly broke camp and left. I asked him what had happened next but he told me that they didn't know. Again his face told me differently and I believe he had a good idea. It would have been

difficult for them not to know as it must have taken time to pack up their belongings and it was likely the situation would have developed quickly. I can't tell you any more than that because I don't know what they witnessed. All I can say is that it must have been pretty bad if they wouldn't enlarge on things after everything else of their past they had repeated.

The gang life had cost Bill his marriage, well one of them, with his wife telling him that if he loved her and their children he would leave them despite the fact that he had been running two houses, one being his official address and the other being a "safe house" where his wife and children lived. He was clearly sad about the loss and I wondered if he now saw his children but I didn't want to encroach on his private affairs so didn't ask. It was also evident that when he spoke of this episode of his life it caused him great pain as he was fighting back tears. When he and Sam talked of comrades they had lost in Vietnam, it prompted the same reaction and he told Sam that he would not be able to take part in a forthcoming motorcycle ride that was being held to honour the lost souls. Despite the havoc and mayhem that the man had caused to many people during his gangland days, I felt his anguish and I was sad for him.

On the other hand, Sam was a comedian. He told of the time he was invited on a blind date only to find that the woman really was blind. The relationship blossomed however and he married her. He smiled as he told me that he never had to beat her, he just moved the furniture around and he had a string of bad taste, though funny blind jokes that I have no doubt he tells in front of his spouse. I am equally sure that they were indeed just jokes.

As we spoke, people they knew came and went, adding their input and telling of the district of Oilvale, not surprisingly a place where there was at one time lots of oil business workers, but is now known as a rough white people's area. The KKK were active

180

and burn a giant cross on the 4th of July, though I am sure that Bill and Sam were not members because they would have said if they were.

Now they are reformed characters. Neither of them drinks and neither has touched drugs in years; in fact they are anti narcotics. Bill even quoted from the bible to me, pausing briefly due to a small sneezing fit.

He then brought the subject back to the happenings of the day before, sharing with me some of his own stories of Mr Thorp. None were complimentary. He then asked me what my book was to be called and I told him that I hadn't thought of a title yet. He smiled and said, 'I have a title for you.' I waited for him to continue and, still with a smile on his face, he said, 'How I got screwed by Harley but didn't get a kiss.' I thanked him but responded that I doubted any publisher would be interested with such a title. If you're reading this you will know that whilst I owe him a debt of thanks for his input, I didn't have the guts to take him up on it and instead made it a secondary title. I would also stress that it was not Harley Davidson that was the offending party but one of their agents.

Eventually we decided that the battery had enough charge and we made our way back, though Bill told me to hang on to the equipment "just in case" and return it via Jo the receptionist. I had greatly enjoyed their company and thanked them for their help and for their stories. Bill smiled as he shook my hand and said that I could use them if I wished, but they were still wanted men for some of the incidents, so would I please change their names. Well, even though I have given no detail of anything that they were involved with, I have respected his request.

It would be easy to be judgemental in regard to their lives and actions whilst in the gangs, but it is important to think of their experiences before the outlaws recruited them. They would have been no more than boys when they went to Vietnam, old enough

to fight and die for their country but not old enough to take a drink. The War raged between 1961 and 1972 at a cost of 50,000 US lives and one person out of every ten that served was a casualty. They saw terrible atrocities. Enemy tactics were often intended to maim rather than kill, so that casualties would become a burden on their colleagues. Both brothers had lost good friends and seen others disfigured in some way.

It was the time of Hippies and flower power. There was a strong anti-war movement in the States and most of the country didn't understand who they were fighting, or why. It was the first war that had televised news reports and every day Americans "back home" would be reminded of the monetary and human cost of it all whilst staring at the box.

Unlike now, when roads and bridges across the USA are named after the veterans, many of those that returned home then, were treated as evil perpetrators instead of the war heroes they may have rightly expected. Whilst the outcome would have been different for different people, it is hardly any wonder that some fell into a gangland way of life. These were good guys and I felt privileged to have met them.

CHAPTER EIGHT
BEAUTIFUL PLACES AND WONDERFUL PEOPLE

Things weren't helped by waking up on the Monday with a sore throat and a cold that I guessed I had caught from Bill. I phoned Scott at Indian and told him that I wouldn't be there until the following Monday because of the problems I had encountered with the Ultra. He just chuckled and said, 'Welcome to the world of American motorcycles.'

First thing on the Tuesday morning I arrived at the dealership, and good old Rob told me that they would look at my bike immediately, though that meant I had between two and three hours to kill. Killing time is a pain but it was a chance for a light breakfast in a small café whilst chatting with the only other customers, who happened to be an English couple, before heading for the library to check emails once again. It turned out to be an interesting experience because it was my first, and only encounter with Library Rage. I'd heard of Road Rage and Supermarket Rage but I hope this is the first recorded incident of the Library variety. Not surprisingly, it was something about nothing as two guys argued, quite vociferously, about whose turn it was on an internet station, calling each other names and so on, until the one who was clearly in the wrong gave up and left. You would think they would have more to worry about.

Back at the shop, Rob had the Ultra waiting with a new alternator but the insurance company was refusing to authorise the repair as they said Daytona had still not sent in the paperwork. I didn't feel much like coughing up for the work myself, as it was what I had paid out all those dollars for in the first place, so we tried again. A second call to them got us nowhere and the "Jobsworth" the other end told me that I was shouting at the wrong person. Well, I honestly hadn't started shouting yet and decided that I would save it for Daytona Harley Davidson, so we called them next. However the response from them was very impressive because they not only got the insurance issue sorted,

but also said that they would reimburse me for the battery and the tow charges. Thank you, Shelley!

The bike was overdue a service and, whilst I was grateful to Rob, I had no intention of putting any more money into Mr Thorp's pocket. Indeed, at one point the man walked past me with a smug grin on his face. I gave him nothing in response but instead drove seventy miles north to Vasalia. The dealer there serviced the bike while I waited, and the Service Manager shared with me the fact that they get a lot of people coming up from Bakersfield. I wasn't surprised.

Just as I was leaving he handed me a thick Harley newspaper and I flicked through it to show my interest. The first thing I saw was an advert for a device that warns when your battery isn't charging. It was a nice touch of irony to accompany me the two miles to the KOA.

I booked in for three nights as there were some National Parks in the area that I wanted to see, but I felt a little down in the mouth. The events in Bakersfield, coupled with the effects of the sore throat and cold were biting, as well as having nearly a week to kill before the Indian factory tour, so I cheered myself up by phoning Bea, the friend from Chicago that I planned to stay with at the end of the journey. She told me that she was flying down to Los Angeles to stay with a friend in a few days, so if I wanted we could meet up weeks earlier than planned. Despite LA being about a day's ride south from Gilroy, I liked the idea of seeing her and meeting her young son, so agreed that I would ride down straight after the factory visit.

A brief look round Vasalia in the morning was quite enjoyable as it seemed different to most towns I had visited so far. It had a town centre with shops and restaurants that were not only next to each other but were mainly independents, giving the place some

character instead of the identikit street look-alikes, made up from all the big names that were common elsewhere.

US68 took me northeast, out of the town and through acres of orange groves with the same perfume that I had experienced a few days earlier. The trees were short and, whilst many had no fruit, others bore so much that the branches were bent to the ground, often having dropped some of their load, resulting in oranges lying by the side of the road. There were signs advertising avocados, strawberries, walnuts and pistachios for sale too, though I saw no evidence of the trees. Despite the lovely aroma of the oranges I was suddenly aware how much smog was in the air, because it suddenly cleared, meaning mountains became visible to my right, the detail of them telling how close they actually were.

Joining US180, the road became steeper as it wound its way up into very green hills with different types of trees indicating that they were well past the beginning of spring. Flowers of mauve and yellow were everywhere and again it seemed like an Alpine scene. The road incline increased bit by bit as I headed into the mountains, and I tucked in behind a red pickup that was moving at a reasonable speed so that the driver would again give me advance warning of how tight the bends were. We got higher and my ears blocked from the effects of the altitude and my cold. I could see that there was low cloud up ahead and I couldn't help but glance down at the voltmeter and engine light but they were fine. When the fog hit it was quite sudden, and was so dense that all I could see on my right side were a couple of fir trees and then a white wall of the "pea-souper". I had no idea if the hidden drop past the trees was thirty or 3,000 feet and didn't want to find out.

At the entrance to Kings Canyon National Park, I stopped and added a sweatshirt and neck warmer to my layers of clothing, because, although the fog was patchy, it was extremely cold. After studying the Park map for a few minutes, I started the Ultra engine again; it seemed loud with the engine noise bouncing back

from the fog and rock. With it reverberating in my clogged head, I drove the short distance to the General Grant Grove and dismounted to take the fenced walk around the area. Even the smaller Sequoia trees were big. Their red-brown trunks were hugely broad at the base, narrowing quickly to a trunk that extended straight up with surprisingly few branches for such enormous trees and only a little green foliage on them.

Because of their thick bark, they are incredibly resistant to the forest fires that used to frequently sweep the mountains; though there are many examples where forest debris has accumulated on the uphill side of the trunk, providing extra fuel to fires, and allowing the temperature to become so high that the trees can't resist them. When this has happened, the fire has penetrated the bark and burnt the less resistant inner wood, hollowing the giant out. Usually though, the damage was not critical and the tree lived on, aided by the fertiliser that the fire had created through burning the logs and branches on the forest floor. The heat of the fire was also important to prompt new life as it caused cones from the giants to dry out and allow the seeds to fall.

As well as being so resistant to the fires, the high tannin in the trees' bark makes them unpalatable to insects, fungi and animals, and means that they can live to astounding ages of over 3,000 years, though even these ancient examples do not die of old age. Their weak point is their roots, which are extensive but not so resistant to attack. Eventually, the trees topple and sometimes break as they fall, but there was one fine example of a toppled tree named the Fallen Monarch, which had split and burned in the centre. Over the years this has provided shelter for early settlers, horses and probably Indians too, though the trunk has deteriorated little in this time.

With the roots of the trees so close to the ground surface, the constant stream of visitors has exacerbated the damage to living trees, and resulted in the authorities making the fenced pathway. In some parts of the forest the Rangers are permanently closing

186

off paths and undoing some of the "progress" that has been made over the last 150 years. Of course, there are always people who think that the rules don't apply to them, and I saw one man jump the fence so that his friend could take a photo of him next to one of the giants. I'm ashamed to say that I heard him speak, and that he was English.

I stood for a while and admired the General Grant, known as the Nation's Christmas Tree, though you'd need a lot of lights to get around the trunk which is as wide as a three lane road at its base. If it hadn't been fenced off, I think I would have given it a big hug!

It was April and cold; some of the roads through the Park were still closed from the winter snow, but it meant that there were few visitors, and it was much easier to appreciate the beauty of the place without distractions. There were a multitude of chipmunks running round the ground, unconcerned by my presence, and wherever I went I could hear the sound of running water, as the spring weather melted the snow and created little streams running down the hillsides. Unfortunately, I wasn't the only tourist though, and the sudden sound of a crying baby nearby seemed deafening.

Back on the road, I drove on to the "sister" area of Sequoia National Park, stopping only to take a photo at Kings Canyon Outlook. It was an incredible "chocolate box" scene of fir trees and snow in the foreground, with distant mountains at the back, their peaks covered with snow and cloud. I thought that this was probably the best time of year to visit the Parks, though the fog was closing in now and not even the extra layers of clothes were keeping me warm. It was also getting difficult to see the road although there was little traffic to worry about. When I stopped briefly to see the General Sherman, I could see the condensation from my breath and was keen to walk along the path to the tree as quickly as possible, especially as my ears were getting cold without the crash helmet. It is stated that the tree is the largest living thing

on Earth, but I could have sworn that I used to go out with a woman who bore the same title! Seriously though, whilst there are taller and wider species than this mammoth, nothing else has the combination of both dimensions, to give it its bulk.

I drove on, again with involuntary glances at engine light and voltmeter, but all were fine. Eventually, the fog started to clear as the road twisted and turned, occasionally splitting as it went past a tree or a rock before joining again; then after a few more miles the weather cleared completely. The downhill twists and turns became more interesting, particularly the hairpins and the steep incline meant I could look down before entering them, checking there were no nasties in store on the other side. I could also hear properly again so could better judge when to turn the power on. Riding with my feet in line with my thighs meant that the toes of my boots extended past the footboards. Going into a very tight S bend, I leant the machine further and further over, and my right boot caught the road surface, then the left as I put the bike over the other way. At last! A minute or so later another bend took my foot off the board completely and I could go back happy that I was handling the machine as it was designed to be.

I felt a little better in the morning, as the fever had gone, though the cold was still thick. I sat at a picnic bench, maps in front of me as I planned my route for the day, and I became aware of movement a few feet to my right. It was a gopher that had just surfaced and was busy picking the grass and weeds from around the hole with its teeth. He disappeared time and time again with his spoils, and I thought that they must be for bedding. After a while he started pushing loose sandy soil out of the hole onto the area he had just cleared, until there was quite a mound of it. He didn't seem bothered by me at all, but I guess it was obvious to him that he could vanish down the hole quickly and I could hardly follow. I was more concerned than he was, fearing that he would bring the same sort of luck as the damned chipmunk had. Finally

he blocked the hole, I think, by using a plug of the weeds he had picked. It was an interesting interlude whilst I decided on the target for the day, fingers crossed that he was not as unlucky as a chipmunk. Well, nothing could be that unlucky.

Many people had told me how beautiful Yosemite National Park (pronounced Yossimitty) was and, although it was quite a drive, I headed in that direction. It was an uneventful ride up into it, though unlike the previous day, the altitude seemed to help my hearing for some reason. There was hardly any snow and the sun was warm, so I parked up for a quarter of an hour next to a river, just to admire the scenery and listen to the sound of the water. Looking round, there were all the things that you would expect: rocks, boulders and logs, but also the biggest fir cones I had ever seen lying on the ground everywhere. As I picked one up I was startled as I realised that it was crawling with small spiders, as indeed everything else was. The place was definitely not somewhere for an arachnophobe, though I guess was a great feeding area for birds.

A small waterfall gave me another reason to stop and take photographs, but it occurred to me that there might be bears about and I got a little worried. I then dismissed the idea, as I couldn't see what bears would live off at such a high altitude – it certainly wouldn't be spiders. Of course, it wasn't really that high and it was most likely ideal conditions for the animals, but it made me feel more confident to tell myself that the area was bear free.

The Park speed limits were much lower than it was possible to drive, so I couldn't enjoy the bends but was instead forced to enjoy the scenery, though it was not always pretty. One area had suffered a fire and the fir trees stood naked amongst scorched earth, their branches like withered limbs, which was the sort of scene that I had expected from the Petrified Forest. Some miles later, there was a tunnel through the rock and I have to confess that I was nervous driving into it, as the temperature had dropped

and there were road signs warning of icy patches. However, by chance I had chosen what was probably the best route into Yosemite itself, and emerging from the other side of the hole was like entering the Lost World. The view was absolutely spectacular with the most beautiful valley stretched out below and, looking down on it, I could see it was divided by the shallow and fast flowing Merced River with green fir trees all around. The cliffs each side were incredibly high, vertical, grey and craggy. To the right was the Bridalveil waterfall cascading unhindered to the valley below. It was stunning and one of many such waterfalls, though the only one that doesn't dry up in the summer, giving a clue as to the volume of water that falls during the period the winter snow is thawing. Anyone stopping for a better look, as I did, would get soaked from the spray long before they had walked to the foot of the waterfall, but the sight was worth it. The place was amazing.

Alas, time was pressing on so I reluctantly left Bridalveil, and went on down the road through the valley, which made a long loop up one side of the river and down the other, with two or three shortcuts across.

If you ever get a chance to visit Yosemite then take it.

Instead of exiting the same route that I travelled in, I took US140: a road that follows the river for miles providing lovely scenery all the way. I tried to compare Yosemite Valley to other places I had been, but couldn't. I've seen many beautiful wooded areas, some of course had rivers but, when you add in the boulders and the towering grey cliffs with the waterfalls, I can't think of anything comparable. I can't say that I preferred it to the deserts of New Mexico or that I didn't. It was different, like two good meals or two good films. I could enjoy them both without preferring one or the other, but it struck me as interesting that I enjoyed the desert by travelling through it and Yosemite was best appreciated by parking up to take in the view.

Since writing this book I have returned to Yosemite to get married! It must be one of the most beautiful places on Earth and is a terrific place to tie the knot. If anyone reading this would like details of how to go about it, then please get in touch by emailing me on johnmckay@uwclub.net and I will be happy to tell you. I will just add that I was nearly divorced before I was married after a little practical joke I played on Sharon leading up to our wedding. After a good ride out on my Triumph one August evening, we returned in good spirits and started talking about the wedding trip that we would take some months later. I have no idea where the idea came from, but I pretended that I had a confession to make to her in that there was another reason I wanted to get married in California. Naturally she asked what it was and I told her that it was State Law that she had to use the vows "Love, honour and obey". I'm not sure if I expected her to believe me or not, but she did and was very indignant about it. I continued the joke by telling her, with a deadpan face, that if she wanted to change venues I would completely understand. Whilst she was really upset at the prospect of using those particular words, she had her heart set on Yosemite.

I followed that up by getting Scott Belyea, a friend in California (who will be mentioned below) to email me and confirm that the State required this detail. As time went by, I got increasingly worried about what would happen when she found out and I thought it would be a good idea to tell everyone we knew about it being a wind-up, expecting someone to spill the beans. Unfortunately, nobody did and I didn't have the nerve to come clean.

The deception lasted for months with Sharon getting a bigger and bigger chip on her shoulder. Then, I returned home late one night in January to meet a Sharon with a big smile on her face. I asked her what it was about, and she showed me an email she had printed off from the wife of the Reverend we had booked to do the deed. Sharon had asked if it was at all possible to change the wording as we were foreigners and the email said that they hadn't used those vows in thirty years! I

191

couldn't take the pressure anymore and I meekly confessed to knowing that it wasn't law at all and I had made it all up.

My how she laughed!! ☹

Surprisingly, she decided that she still wanted to marry me so there we are. But guys... don't ever expect them to forget something like that because they don't!!!

I made my way back to the KOA to plan the following day's move, which I had decided would take me to the coast. I also had a dilemma in that campsites were cheap, especially those away from the sea and other glitzy tourist attractions, but I was increasingly finding that nobody else used tents in these secluded spots, so I was usually camping on my own in the designated area. I wanted to meet people, as it was they who were adding icing to my cake, most times at least. If I avoided the expensive sites on the beaches, then there was less chance of the interaction that I yearned for, and a lot of potential "gloss" would be missing.

After packing up in the morning, I decided to head west along US41 toward the coast. The route reminded me of Texas at first: flat farmland, but it was green and I could see more mountains in the distance. There were warning signs to say "speed limit enforced by aircraft" so I checked my mirrors to ensure there wasn't an F16 screaming up behind me with its reds and blues flashing. Of course there wasn't, and, after a few hours riding, I stopped for a meal at Mike's Roadhouse Café, another independent place. It had a spectacular collection of about sixty children's pedal cars, planes and boats around the walls; many of them were originals, and dating back I would think, to the fifties and sixties. Others were new and for sale, and here again was an example of the nostalgia trip that had seemed to be so evident in Seligman. Somewhere, probably in the Far East, there were people turning these metal reproductions out to satisfy the new

demand for them. The little red and battered car that I'd had as a child came back to mind, and I have to admit that I quite fancied a new one. It was a good job I couldn't have carried it or I would have been around $250 dollars lighter.

Immediately after the stop, the scenery changed again. The hills were very grassy, but brown, as though someone had crop-sprayed all the grass to kill it off. The only green was from the bushes at the side of the road, but they were desert bushes of pale colours and not like I had experienced elsewhere in California. With every brown hill that I went past, I got closer to the coast and I could feel the excitement building in my stomach. After all, it would be a major milestone in my journey, as the sight of the sea would mark my crossing of the continent. There again, there were still many miles to go and maybe the feeling was only the lunch that I had eaten.

The road surface changed for the umpteenth time and something in the tarmac made it sparkle like it was covered with a heavy frost, despite the temperature in the eighties. Then the traffic split left and right onto US101 and I completely misread my map, resulting in a very long detour. Eventually I got back onto the right route and was travelling up a steep incline, when I spotted an old VW camper on the side of the road, with hazard lights flashing and an open door over the rear mounted engine. I'd had one of the machines for a while myself, and felt duty bound to stop and offer assistance to the owners of the vehicle, who were latter day hippies, in their early twenties and looking like they had just travelled through a time warp from the 1960s. Having already established that the problem was a slipping clutch when the engine was warm, they were just letting the machine cool down before another attempt at making it over the crest of the hill. We chatted for a few minutes and they told me that they were on their way to the Giant Redwoods further up the Californian coast, as they wanted to see the big trees before they died, as well as experience reverse vertigo by lying on the ground looking

193

upwards. They were a nice couple and grateful for my concern, but assured me that they would be fine when the engine cooled so I pressed on, now feeling almost desperate to reach the coast. The hills now had such dense, dark and rich green grass they looked as though they were covered with baize from a snooker table. The road ended in a T-junction and I joined US1 to go north feeling how much colder it had got again, presumably as I was so near the sea. Leaving a left hand bend behind me I saw it at last, the Pacific Ocean. After 6,376 miles zigzagging across the country, I had now seen both coasts and for me the country had just got smaller, as had the world. I had a similar feeling when I first went to Australia. It had always been some distant and far off land, the other side of the planet, but when I had set foot on it, it wasn't so distant and never would be again. I guess that long-haul airline pilots must consider the Earth to be a very small place indeed.

I came across a National Parks campsite a few miles later and booked into it. I knew that these campsites tended to be very basic, sometimes without any facilities, but they were also extremely well priced. After paying for the night, the Ranger allotted me a position on a hill; so I set up the tent, ensuring that I wouldn't be rolling off my bedroll, and then headed back to the town of Cambria just up the road. It was a pretty place and by far the nicest, quaintest little town I had seen in the USA. As I parked up, two Harleys, a Honda cruiser and a Yamaha sports bike drove past, and all the riders acknowledged me with a cheery wave before stopping a little way along the road. I walked along to exchange greetings with the friendly people, and we swapped the usual information of how far we had come, for what reason and when we would be moving on. One of the guys had already disappeared into a shop, but emerged whilst I talked with the others and made a bee line for me. Scott Belyea was around my height but much heavier, though it somehow suited him and he looked very fit. He proudly took me over to see his own gleaming scarlet and black Ultra Classic, which was powered by an S&S

motor kicking out nearly 130 horsepower, as much as most sports bikes. I could tell how proud he was of his machine and the enthusiasm he had for it was evident in his speech. I could imagine him surprising a few of the Japanese bikers as he pulled away from traffic lights, leaving them to enjoy the wake of his loud exhaust note. He repeated some of the information the others had given, but then told me that they had rented a house in the town for the weekend, and invited me to join them at a local seaside restaurant. Although I'd had a big meal at lunch, it was an offer I couldn't refuse so, whilst they unloaded their stuff at the house, I headed down to the area of the restaurant. I wandered around the beach for a while, avoiding the marooned jellyfish and marvelling at the huge bleached logs and trees that had been washed up on the black sand. Then a short while later, I heard the bikes coming along the road, Scott leading the way and, as they drove past, he pointed ahead to the restaurant.

We hadn't really done any formal introductions until then, and sitting round the table was much like delegates on a course, each of them giving a short "presentation" of who they were and what they did for a living. I hadn't experienced anything quite like it at an informal gathering, and it was nice to get a crash course as to who and what everyone was. They neglected to tell me who was with whom though, and it took me a few minutes to work out that Ward and Phyllis were together, as were Scott and Dale, leaving Bill and the young attractive lady attorney, Corrie. I hoped for Bill's sake that they were a couple, but later realised that they weren't.

I had Scott on my left and Bill on the right. The conversation drifted around all sorts of things, but was mostly about biking. The team told me that they had planned a motorcycling holiday for the following year around the Alps, which for most of them would be the first time they had visited Europe. The holiday was an organised event and wherever the daily destination was, their luggage would be couriered along a direct route by van, waiting for

them when they got there; thus they avoided the frequent task I faced in getting all my kit stowed on the bike. As all the ladies were redheads, they had decided that the men would dye their hair to match, and I could imagine the group driving round Austria, getting noticed wherever they went because of their striking appearance.

I declined a starter and, whilst the others ate, Bill kept me entertained with stories about one of his previous jobs working in marketing for a big record company, the artists he met and the people he'd hung around with. The work had brought him into contact with various Mafia people and, as he spoke about them, he did a great impression of Marlon Brando in *The Godfather*. None of it was shocking, just informative, though he told me that he'd been naïve enough to ask one of the gangsters why his nickname was "Boom-Boom". The answer that he'd got from the individual was mostly a hand action as the Italian had made a two-fingered impression of a gun and then repeated his nickname. It seemed he'd had a certain reputation of sorting out disagreements in a very final way.

In turn, I told them a little of my travels, for we were all bikers and I hope they enjoyed the tales, though hearing about my experiences in the Deep South, Scott commented that it was a rough place where people go missing when an argument is being resolved. I wondered what Southerners thought of Californians, but I suspect it is probably that they are ruthless, hard-nosed, selfish people. What would they think if this group had befriended them, as I had been? I have to confess that after the incident in Bakersfield, I'd also expected a less warm and friendly experience.

The food was the best that I had eaten for several weeks and Scott chose excellent Californian wine to go with the meal. I had been very fortunate to meet with this bunch and probably wouldn't have done if I hadn't made such a cock-up of the map reading and stopped to help the Hippies earlier in the day. I was grateful to have been part of the cosy gathering, but when the bill

came and I wasn't allowed to pay, I wished I'd had a starter! To be serious, the generosity made me a little embarrassed. I had got so much from their company and at least wanted to return the compliment, so when Scott invited me to join them for breakfast the next day I accepted but, without mentioning it decided that I would pay for them all. As we left the restaurant, the big man even suggested that I could take a shower at their rented house if the campsite didn't have them and I think that if I hadn't already set up the tent he would have been offering me a bed as well.

I headed back to the State Park campsite feeling extremely happy. It was dark and quiet with not even the merest hint of a train, and the only noises were the Pacific waves on one side and bullfrogs in a pond on the other. I slept, very contented with the day.

As arranged, we met up at their house in the morning. It was an impressive building with beautiful ocean views and must have been built for a motor enthusiast, as it had three heated garages. They got themselves ready and we went into Cambria for breakfast where, once again, I was not allowed to pay, except for a token $5. I suppose I inherited the desire to pay my way from my father, and I remember an incident at my mother's 75th birthday party in Jersey. The usual argument broke out between my father and uncles as to who was going to pick up the bill, only to find that someone had already settled it. In my family, this was almost an act of war and an investigation started as to who had been to the gents and could have paid for it on the way. Of course, nobody admitted to it and suspicion grew to a level where there was serious disgruntlement. It was some time later that the waitress realised that she had presented the bill to the completely wrong customer and he had paid it, apparently not realising that it was over double what it should have been for his party.

I vowed that I would settle my debt with these Californians one way or another, but meanwhile the ladies wanted to put in some

197

serious shopping time as Corrie needed a hat for her friend's wedding. The sight of this leather-clad young lady stretching a cargo net over her new, wide-rimmed headgear, as she strapped it to the carrier of her sports bike, was quite bizarre. Her purchase was not enough for the ladies though, and we traipsed around the tourist outlets with Bill good-naturedly complaining that all the goods were available anywhere in the USA, so either wanted to go for a beer or a ride. I could understand his point of view, but I was more than happy to spend time with this group whatever they were doing. Whilst the ladies were looking around yet another gift shop, Ward wandered off to a hardware outlet, and Corrie cracked jokes about him looking for another hammer to add to his collection, which was apparently very extensive.

The morning passed quickly and I decided that I should start heading north. Ward's last words to me referred to an earlier event of the day, when he'd dropped his bike on start-up. He said, 'Don't do what I did. Remember it's metal side up and rubber side down.' It was a common Harley expression but I was sure that having had it passed to me, it was a curse and I should think about passing it on before it took its effect. I knew that I would have to wait though until I found bikers outside this group. I smiled and said my good-byes to the rest of the team and, as Scott shook my hand, he told me that as I would be passing their town in a few days, they would be very happy to have me stay. I knew he meant it and, as I headed out onto US1, I thought about how I had wanted to meet more people and that it couldn't have worked out better. They were a warm and friendly group that had made the stay at a little town all the more special for me.

My AAA map designated the road as a scenic highway and it was easy to see why. The Santa Lucia Mountains to the east were extremely green, and the mist out to sea diffused the horizon, so that distant pale blue water merged into the lighter sky. Shortly after leaving Cambria, I passed an old dilapidated lighthouse, set

on a rocky peninsular, with a broad splash of pink flowers clinging to the almost vertical surface of the craggy cliff below. It was a pretty sight and made it more bearable to be leaving the group back in the town.

The road was very twisty and the surface was good but this was a pretty, central Californian coast route, it was Saturday afternoon and it was unfortunate that it seemed that half the world was on the road. There were plenty of bikers about, but were obviously tired of acknowledging their fellow enthusiasts, so I got few return waves as I raised my hand to them. Progress was very slow in places and on one stretch I was reminded of an article that I'd read years ago, I think in "Bike" magazine, with the author expressing his views on caravan-towers. He was not a supporter of the pastime, and it seemed that his dislike stemmed from an occasion in the English Lake District, where a sign clearly indicated that the road changed to single track further on, and was not passable by anything bigger than a car. Some idiot with a caravan had chosen to ignore the warning and attempted to drive up the road, bringing everyone to a standstill as he blocked the route for several hours. In front of me on US1 were two RVs towing pickups, the drivers completely ignoring the roadside signs informing slower vehicles to use the lay-bys allowing others to pass. It seemed that neither driver wanted to lose his mate by pulling in to these rather short areas, so were happy to hold up everyone else rather than do a bit of leap-frogging. Inconsiderate sods.

It was hot and there was almost no wind; the only relief to the temperature being the strange and inexplicable cold spots along the route. Needing more than these as an escape from the heat inside my helmet, I pulled into a gravel lay-by on the coast side of the highway. Climbing just a few feet down from the road level, I could hardly hear the traffic noise; the predominant sounds became the sea below and the trickle of a small stream. Sitting down between the gorse bushes, I took my boots off and enjoyed the baking sun. It was good to look down on the golden sand of the

deserted beach and the gentle waves working their way up it. I had brought my notebook with me, but have to confess that I wrote little, almost falling asleep in the heat. Despite the heavy traffic just a few yards above me, it now felt like I was the only person in California and I had a private beach. It was just so comfortable taking in the rays and I was reluctant to move on, but eventually got back on the Harley and made my way past Monterey and Salinas to Gilroy.

Trying to find a fairly-priced motel in this part of the world was Mission Impossible, and the nearest campsite that would accept tents was miles away. I was keen to stay in the town because it is the self-acclaimed garlic capital of the world and I wanted to sample the delights of garlic ice-cream and garlic wine but, alas, could find nowhere reasonable. Giving up on Gilroy, I tried the nearby town of Hollister, apparently famous for the film *The Wild One*. Again no luck and I drove even further afield. That is when I had my first encounter with some traffic lights, the likes of which Bill and Sam in Bakersfield had told me about.

The road had sensors incorporated into it to operate the signals, but even something the size and weight of the Ultra was not enough to trigger them. As a result, on a couple of occasions, I sat whilst the lights went through their cycles completely ignoring my presence, so not lighting up on my lane to allow me to proceed. I tried rocking the bike back and forth, and jumping up and down in the saddle but to no avail. I must have looked completely stupid and eventually gave up, changing lanes so that I could drive straight ahead and double back to turn right, which I could do with no difficulty and still be legal. I daresay that most people wouldn't have bothered about the legal part, but I had a sneaking feeling that the law would lie in wait for bikers to fall prey to these lights and didn't want to find out that there was a hidden traffic cop somewhere.

Eventually, after driving an extra fifty miles or so, I ended up back in Salinas where I paid the same forty-five bucks for a hotel that I could have paid in Gilroy.

CHAPTER NINE
EASY RIDER

There was a time in the USA when there were more than twenty motorcycle manufacturers. Indian was the biggest and, some would say, the best.

The company began its life in Springfield Massachusetts in 1901, when a young engineer called Oscar Hedstrom designed an engine-assisted bicycle to be used as a pacer bike in the training of racing cyclists. The design was so good that it caught the attention of George Hendee, a local entrepreneur and businessman, and he invested in a manufacturing facility to produce the first Indians in 1902. This was a year before Messrs Harley and Davidson formed their company 1,000 miles away in Milwaukee.

The machines were relatively simple single cylinder models, but again Hedstrom's design proved successful and the sales financed a new model in 1903. This time it was a V-twin with a choice of a two or three speed gearbox, and rear swing arm suspension.

As part of the marketing of their brand, the company invested in racing machines and were often the winners at large events in the USA and Europe.

In 1913, Indian produced over 20,000 bikes and was the biggest motorcycle manufacturer in the world. It was also the year that they launched the Hendee Special: the first ever motorbike to have an electric start.

The partners sold their respective shares over the next few years and, although the engineering continued to be impressive, the new management was not. At the end of the Great Depression there were only two motorcycle manufacturers left in the USA, but Indian had been saved by their popular designs and not, it would seem, from the direction of their managers.

In 1940, the full range was restyled with the highly noticeable skirted fenders, which are one of the distinctive styling points, even on the modern machines.

The war years saw major military contracts for both Indian and Harley Davidson, but Harley was more successful at winning better commercial terms and, as a result, Indian was left with horrendous cash-flow problems by the end of the conflict. The management reacted with questionable decisions, resulting in their dropping much of their range, including a new shaft-drive V twin. They chose to replace these by emulating the British single cylinder bikes that were being imported, and the design team were faced with a mammoth task.

Cash poor and with a new design programme, they were forced to borrow heavily from a British company to fund it. Then in 1948 they dropped the mainstay of the range: the Indian Chief, to change over to the new single cylinder bikes. Unfortunately, the motorcycles proved unworthy to carry the marque in terms of design and quality of build, so they flopped. This prompted the financers to call in the debt in 1950 and effectively asset-strip the company by splitting it in two.

The resulting sales and engineering companies were sold to AMC in Britain, who owned the famous names of AJS, Matchless, Velocette, Royal Enfield, and a name that still strikes a note in my own heart: Norton.

Under the new owners, production of the Chief started again but in 1953 halted and, at that time, it was apparently forever.

A new hope arrived on the scene in the early 1990s in the form of one Philip Zanghi, with a plan to revive the plant in Massachusetts. Several years and millions of dollars later it was announced that his plans were a scam, and he was convicted of money laundering, tax evasion and securities fraud in 1997. Indian was "down, but not yet out".

In 1998, a Colorado court ruled that a Canadian company could own the brand, as long as they actually manufactured motorcycles under the Indian name. They made a partnership with a small firm called *The Californian Motorcycle Company* in Gilroy, and the result was *The Indian Motorcycle Company* in existence today. Again large amounts of money were invested, but this was a serious attempt at building a business, with several of the new company executives having actually begun their careers at Harley Davidson. Today the company boasts a range of what are really three machines, with the choice of optional extras to extend the range to a full complement of seven. The flagship is once again the Indian Chief.

The factory tour started at 1pm with nine of us following Rick, the "guide". I was disappointed by the tour, not because of the factory, but because of the tour itself. Rick appointed me "man at the back" due to my yellow jacket, which he could identify easily and know if we were all with him, as he stopped at various points to talk about the place. Unfortunately, he didn't keep up his part of the deal that he'd promised and as I was usually delayed in getting to these talks because of somebody or other who wanted to take a longer look at something, I missed out on the early parts of what he was saying and had to guess at it.

We were also not allowed to take photographs and, although it was a shame, it didn't surprise me. However, the paranoia extended further as Rick saw two of the other visitors making notes and got very worried that they were lawyers, though of course they said that they weren't.

He told us that when the new company was originally formed it had 700 employees, but has now dropped to 350, apparently because of the economic downturn. However, I would guess that, as the manufacturing processes were refined and new plant was brought in, the need for all those extra heads was reduced. It was probably just as well, for it seemed unlikely that the company

could afford so many people as it was only producing 125 bikes a week. The number was a little surprising as it didn't seem to reflect the number of dealers which was then standing at 200. They are spread across the USA and Canada, and I would have expected more sales, especially as there were three models in the range.

Of course they are not low-cost bikes; the cheapest of them was list priced at $17,000, with the top version of the Chief at $23,000, so they are not going to be snapped up by schoolboys with their first licence. Instead, the appeal would be to affluent Americans who aren't enamoured by plastic rockets and, in fact, around 60% of the output is made up of the Indian Chief, with the rest being split fairly evenly between the two other models. Mind you, this is what Rick told us and he kept on saying that he wasn't sure of the facts, so I may be telling you something completely untrue.

We wandered round for about forty-five minutes and all the staff seemed to be extremely enthusiastic in their duties, which certainly rubbed off on our little band, but the climax for most was seeing one of the Chiefs that was to be used in the next *Terminator* movie. I say one of them because a number had been ordered (again Rick wasn't sure how many), as the film script required the motorcycle to be destroyed and they would doubtless need some spare bikes during filming. Apparently Big Arnie had actually been to the factory some time previously and test-driven the machine, though of course he doesn't live all that far away.

I also liked seeing the manufacturing process, which can cope with eighteen bikes at any one time, no matter what model they are. None of the machines in production during the time of my visit incorporated a "home grown" engine, but that was about to change with the launch of the new Chief, the bike that Jim had test-ridden at Daytona. The gearboxes would, however, be made in Korea!

Something that disappointed me about the visit was that there was no handout to give facts and figures, the old and new history of the brand, or responses to frequently asked questions, which Rick couldn't answer. There wasn't even a coffee available as we waited to start the tour, or an opportunity to hand over cash in exchange for books and souvenirs, which made me think that they were missing a trick. If people were interested enough to come and see the factory, they should go away loaded with stuff that is going to remind them of the visit and, better still, get them talking with others about it. Maybe I was expecting too much, but some of us had travelled a long way for this, and "some of us" had hung around for a week so that we could do it. To me, it was like no thought had been given to the weekly event; it was more of an ad-hoc tour given to someone who was visiting the factory for other reasons.

I left feeling a little deflated and headed south, with the intention of making it as far as one of the KOAs close to the infamous town of Bakersfield. By the time I got there it had turned cold once again and I was very tired. I parked up on the slope outside reception, but before I had got off the bike, a tall, healthy-looking guy came over to me for a chat and we passed the time of day for a minute or two. I had to cut the conversation short, as the camp office was about to close and hurriedly booked in before returning to the bike in order to drive to the tent area. Everything was a little rushed and of course I was feeling very fatigued.

Then it happened. Ward's "curse" along with the effect of countless unlucky chipmunks hit home, and my left foot slid on loose stones just as I was about to pull away. Over we went, the world turning sideways as the weighty machine toppled me with it. On flat and level ground, we would have stopped when the bike rested on the crash bars, as did Ward's Road King, but mine was top heavy due to luggage and the slope was too much. The Ultra went right over onto its left side so that it was lying on the flat

section of the crash bars and the protective bars surrounding the pannier. I wasn't hurt other than a severely dented pride and, a second after I landed on the hard surface, I slid my left leg out from underneath the bike. I jumped up, hoping that no-one had witnessed the incident and tried to lift the machine, but with all that luggage it was just too heavy. The wheels were completely off the ground and were parallel to the sloping surface: a rather sad sight. I should perhaps have been feeling really upset, but I wasn't. It was a machine and machines can be repaired and, to be honest, I was too tired to be upset.

I went back into the office to get help and was lucky enough to recruit a couple of guys. With the bike upright again, I could see that the top fairing had been damaged by the loose gravel it had buried itself in, with deep scratches in the surface. More worrying was the little pool of oil that had collected on the ground and was dripping from somewhere underneath the primary drive cover. I rode around to the tent area and, leaning the bike onto its side stand, I checked again for the leak. There was only one drop this time and I started to believe that there might not be a problem.

I was praying that there was no damage as the nearest Harley dealer was my old mate Tex Thorp. Rather than give him any more of my money, I would have stripped the bike down and hauled it piece by piece on my back to Vasalia, barefoot and through alligator swamps if necessary, though in reality it seemed a better idea to have hired a van if I had needed to.

I set up my tent, with one eye on the primary drive case, and the guy that I had met outside the office before the mishap came strolling over. He was my favourite sort of visitor as he had a couple of bottles of Heineken in his hand. Eric and I talked for a good hour or so, which was good therapy after a relatively poor day. He was on his way home after a holiday with his grandmother and kids. We exchanged emails and phone numbers and he told me to get in touch when I reached Seattle, for I would be in for a "good home cooked meal". Another invitation I knew I couldn't

refuse. He left me somewhat lighter in spirits than when he found me, and I settled in for the evening.

Early morning, I packed up and rode thirty miles down the road before stopping at a diner to check for oil leaks. I stared at the ground for five minutes and was disappointed to see three little drops of liquid hit the tarmac, laying out a straight line below the primary case. The leak then seemed to stop, and I cleaned the bottom of the engine with some paper towels.

After getting some breakfast, I checked the ground and engine again but there had been no more leakage. The situation therefore seemed to be that if I had a leak at all, it was a small one and most likely from the primary drive. With it being so small, I should be able to do the 100 miles down to Huntington Beach and find another dealer in the Los Angeles area. I got back on I5 and kept an eye on the engine warning and oil pressure lights, as well as the gauge, but knew that I was unlikely to see anything amiss with them if there was indeed a leak from the primary.

The ride was completely uneventful and I was surprised by the high standard of driving around Los Angeles. The Interstate was quiet; there was little tailgating, and people used their indicators, not at all what I was expecting.

Beatrice had arranged to stay with her friend Debbie, and I had also very kindly been granted space on the living room floor: a particularly nice gesture as Debbie had never met me. I found my way to her place with no difficulty and Beatrice's son, a four-year-old Tasmanian Devil called James, greeted me as I walked up the path. He had never seen me before either, but there was absolutely no shyness in the boy, and he talked incessantly from the first minute we met. His energy was impressive enough, but more so was Beatrice's ability to cope with it. It is hard being a single mother, but when your son is continually hyperactive, it's doubly tough. However, he was a good lad and great fun to be with.

Beatrice is a lovely Belizean lady and, whilst I have spent a few weeks in her country, we actually met through a mutual friend in a village in Yorkshire, about as "Un-Caribbean" as you could imagine. Like many people from Central America, she left her home to work abroad, and having spent some time with the World Health Organisation in Albania, has now been living in Chicago for several years. This was a rare holiday for her and she was making the most of it, hardly out of bed when I got there late morning.

My host, Debbie, had booked the week off, but had been called into work, so Beatrice, James and I went down to the beach. It was nice to sit in the sun helping the boy to build sandcastles, though I did most of the building whilst he just dug holes in the sand with his spade. It's amazing how small children can find little pleasures so interesting for so long, then will suddenly lose interest and go off to do something else. In James' case it was trying to catch the seagulls or the fascination of watching two young lads get themselves ready to go surfing. Like in *Bay Watch*, there were the usual posers on the beach, and Lifeguards cruised by in jeeps. I kept waiting for David Hasselhoff and Pamela Anderson to appear but they didn't. I guess I was hoping more for Pamela Anderson but, the more I thought about her, the more I recalled a couple of the jellyfish on Cambria Beach. How strange.

I still didn't get to meet Debbie that evening, as she worked so late, or for that matter in the morning either, as I left the house reasonably early and went off to find the nearest Harley Davidson dealer. I left the bike with them for a while and, when I returned, they gave me good news. It seemed that they couldn't find any leaks and the drips were most likely from a spillage through the breather pipe, which of course I was very glad to hear. They were also kind enough not to have charged me for the inspection, but the sting in the tail came when they said that the fairing damage could only be repaired by replacing it, and it could take up to

sixteen weeks to get one. That was not a realistic option as I would be out of the country again by then, so I naturally declined the offer.

I left Debbie's place after a couple of nights and took the Interstate south to San Diego, but was careful to come off before I got as far as the Mexican border. My insurance didn't cover me outside the USA but, of course, the main problem was that I didn't have a passport. US70 took me through the town of Imperial Beach and I headed off to the beach itself, parked up, and walked down on to the sand to stand at the bottom left of the country: another corner done. The stop there was only a few minutes looking at the hill across the border, and the sprawling city of Tijuana, before getting back on the Ultra and rejoining US70. It was a nice ride with an enormous arched bridge taking me back on I5 heading north. Again, the view from the bridge was fantastic and looked directly into office blocks and skyscrapers.

The Interstate was no better on the way up than it was on the way down; in fact it was considerably worse. I hit the LA area completely at the wrong time and the traffic was the opposite of what it had been a couple of days previously. It was like being back in Florida with terrible congestion and maniacs prepared to risk anything in their struggle to get home. I practised finding the horn button with my thumb, though never had to use it, despite seeing two pickups belonging to companies in the extermination business. I switched the radio on and turned the volume up loud with the aim of advertising my presence to other drivers, though I don't know how many of them heard it in their air-conditioned micro-environments. It was stop-start driving for nearly sixty miles but, when the traffic moved, it moved quickly and added to people's frustration as they accelerated and braked hard, to ensure that they stayed that specific distance from the vehicle in front, where it is just too short for others to cut them up.

When through it all, I sped up to try and make up some lost time as I wanted to get to the nearest KOA at Bakersfield. I seemed drawn to the place. Along most of the route, the limit was 65mph, and I was doing eighty when I saw a bike coming up behind me. It went past doing well over 100 and I raised my left hand to acknowledge the rider whom I hadn't had a good look at. The motorcycle cop waved back and I was thankful he wasn't in the mood to book me, probably because it was getting cold and, as he was in shirtsleeves, he must have been feeling it.

Ten miles further on, I pulled into a petrol station and noticed his Kawasaki parked at the pumps. It was one of the garages where I had to deposit my credit card with the cashier before the pump would work and, as I walked into the shop, I was faced with the six-foot-four cop drinking a very large hot coffee. 'You must be cold,' I said.

'Yes,' he agreed, 'I'm going to put my jacket on in a minute.' He paused and then asked, 'Was that you I passed on the Ultra Classic.'

I admitted that it was, expecting an admonishment as to the speed I was doing.

'Oh,' he replied and then asked, 'Is that the 2002 model?'

Relieved at the way the conversation was going, I told him that it was a 99 bike and he said, 'I have one and I love it.'

The cashier was indicating that she wanted to take my card and for me to get on and pump the gas, so I hurried out to do it. The Cop followed me out a few moments later and started getting his jacket out of one of his panniers. As I finished pumping the gas, a BMW motorcycle pulled in and the Cop immediately strode over, covering the twenty feet or so with a few giant strides. 'Is that the 2002 model,' he asked and got a shake of the head in response from the full-face helmeted rider. 'Oh I used to have one,' he went on, and 'I loved it.' It would have been interesting to observe the sight of a pack of bikers coming in and the

212

conversation the Policeman would have had with each of them. He was certainly an enthusiast.

An hour later, I pulled into the KOA at Shafter, a little place near Bakersfield and, whilst booking in, a guy in his thirties came into the shop to buy a few things. He heard my accent and, after asking about the bike and what I was doing, he invited me to visit the airfield across the road, where he worked. He said that they had some really "neat stuff" and we agreed that I would come across in the morning.

I duly turned up the following day and found Tom, who immediately took me down to meet Don and Ron Massey: twin brothers who run one of the coolest businesses I have seen. The buildings they operate from were part of an air-training base for World War II, and are therefore considered historic structures. Inside them, it was partly museum and partly a renovator's workshop. Their office had radio-controlled planes hanging from the ceiling with all sorts of other memorabilia on the walls. In one corner of the room stood a perfect 1961 Triumph 650 Thunderbird, that looked like it had been rolled straight out of the showroom and into their workplace.

The Masseys' company specialises in restoration of all sorts of machinery but particularly aircraft, and the two brothers spent an hour of their time showing me around all the projects they were working on, as well as those yet to get to the top of the list. They had a WWII Stearman flight trainer, motorbikes of various ages, a 1959 GMC pickup, well on its way to being completely restored, planes, a Curtis fibreglass car, 100-year-old kerosene dispensing trolleys and all sorts of other goodies. It was like walking around an Aladdin's Cave of old and desirable machinery. The quality of the work they turned out was second to none and it was obvious how much pride they took in it.

Before I left, they introduced me to another brother, Ken, who operates a separate business nearby. Ken and his team work

completely with aircraft and used to specialise in the maintenance of crop dusters, but the agricultural method is slowly dying out as pesticides are banned, so they now build aircraft too. They showed me the two current build projects, the detail of which was amazing. Whilst the aircraft started as kits, these guys change just about everything and work with the latest high tech polymers and glass fibres to remould the structures, taking anywhere between five and ten thousand hours to finish the work! They told me of how one finished aircraft had crashed on its maiden flight through pilot error. It must have been soul destroying for them and the guy that funded it all.

One of the team asked me what had brought me to Shafter and another of the guys joked that, as I had a Harley, I had probably broken down. I told them that had been the case a week or so back and they asked me if the Harley dealer had got me to drop my trousers and lean over his desk. 'Funny you should say that,' I said and, after giving them some of the good and "not so good" details of my encounters with Bakersfield Harley Davidson, I was treated to a multitude of stories in return. None of them surprised me.

This had been a great and unexpected stop at a fantastic restoration business and was great compensation for the disappointment at Victory, but all these guys had work to do and as good as it was spending time there I didn't want to outstay my welcome. I also had chosen a destination of Fairfield for the day, which lies northeast of Los Angeles and was the home town of the Belyeas. So thanking them all for the time they had so generously given, I hit the road again and, after a few hours of riding, I arrived safely at Fairfield though couldn't find a campsite. I therefore reluctantly booked into another motel and got a stern reminder that this was still California and rooms were not cheap at a mere $55 a night. It was then that I hit on a very good rule of thumb when looking for motels in the States, which is to avoid any that include within their names, words such as "econo", "value" or

anything else that suggests a low price, as they are usually the most expensive.

I hooked up with Dale and Scott in the morning and they invited me over to their house: a beautiful very open plan design on the south side of Fairfield. Their hospitality was just the same and generous as it had been in Cambria, and they immediately offered me a room for that night, showing me where their washing machine was as well as their PC, in case I wanted to check emails. The warmth and generosity really was amazing.

Scott showed me around his collection of Harley Davidson memorabilia. Their house was like a shrine to the brand name and everywhere I looked I would notice models, pictures, clocks, calendars and so on, all associated with HD in some way. Pride of place on the wall was the printout from the Dyno tuning of his S&S motor, showing the power curves and stating the peak output was actually 129.7bhp. Unfortunately, the increased power did not do anything for the reliability of the Harley electrics and Scott told me of a problem he had experienced shortly after I had left them the previous weekend. Just like my Ultra Classic, his had suffered a stator failure and brought all the joy that a breakdown like that causes. Fortunately for the Belyeas, they'd had their friends with them who helped with getting the bike to a dealer where it was repaired whilst they waited. Before you ask, it wasn't in Bakersfield.

Scott had already made space in their garage for my bike, but I think he was embarrassed at having such a dirty machine parked next to his gleaming motorcycle, as indeed I was, so we connected up his hosepipe and I said goodbye to my prized insect collection. It was quite surprising how quickly the grime from thousands of miles washed away and a fairly respectable machine appeared from underneath.

The rest of the day passed quickly and we enjoyed an early evening meal at an excellent Italian restaurant, where the food and service were fantastic, despite it being incredibly busy. It was

good to see that Californians enjoy such service, as the fast-food places that I had been using along the way, most certainly didn't offer it. Even in the UK, the likes of McDonalds and Burger King have trained us to dispose of the food wrappings and return our trays, so saving on their labour costs.

Interestingly though, if the meal size defeats the customer in the slightly more upmarket places in the USA, and they should ask for a "doggy-bag", it seems to have become a common practice to present them with a flat-pack box. They are then expected to erect it themselves, as well as scrape their food off their plate into it.

The burger houses already expect the customer to dispense their own soft drinks, something that in the UK I have only experienced in the supermarket cafés, and I wonder what the next stage to the degradation of service would be. Perhaps it will be for the customers to cook their own food, but alas America has already sunk to that level, as one take-away establishment will happily prepare the pizza of your choice, but then it is up to the customer to use his own oven. However, the restaurant we were in was in no way lacking and, once again, I was not allowed to pay, something that was becoming very embarrassing.

The hospitality was further extended the next day when I was invited to join the Belyeas at a family party around eighty miles north. The idea fitted perfectly with my plans as the meal wasn't to be until the evening, the venue was in the direction I was headed and there was a KOA a few miles north at the town of Willits. It was also an opportunity for Scott and I to leave early and take the bikes for a ride, whilst Dale and their son Geoff, would come along in the pickup.

Scott led the way down I80 toward San Francisco with John Cougar Mellankamp blaring out from the speakers of his bike's sound system. Not that I could hear it, or for that matter my own engine noise, as the exhaust note from Scott's straight-through pipes with reverse megaphones drowned out everything. When he

216

starts the big engine up it measures around 2.5 on the Richter Scale and half of Northern California think that they're in for another earthquake.

It wasn't far to the city and soon he peeled off the Interstate, heading into downtown San Francisco with office blocks and skyscrapers all around us. He pulled up alongside some docks and, as I parked up next to him with his engine noise still echoing through my brain, I heard the comments of a young guy walking past. 'Nice bikes man,' he said. Scott thanked him and the guy turned his attention to me, or more specifically to my Roof helmet. 'Where did you come from man, outer space?' he asked, the emphasis on the last couple of words. I laughed and showed him the profile telling him that the design was based on an American football helmet. I had no idea if it really had been but the Roof passes a strong resemblance to the sports headgear. 'Oh,' he said, 'I thought you was from Mars man,' and he walked on. This was the best comment that I'd had on the helmet yet.

We stopped for a few minutes looking at the immaculate black and white tugs in the dock with a lone seal bobbing about between them, before riding on to the real tourist area. I bought us some breakfast at the "World Famous Buena Vista Café", though I had to confess that I hadn't heard of it, and Scott suggested that in that case perhaps it wasn't that world famous. Unfortunately, my lack of knowledge of the place said more about my ignorance than the fame of the restaurant.

We spent time in the sun, walking up and down the street vendors' stalls, and then got back on the bikes so that Scott could take me for a tour of the hilly city streets. I remember years ago, one of my father's favourite TV shows was *The Streets of San Francisco* with Michael Douglas and Karl Malden. We used to have to watch it every week, not that I minded as I enjoyed it too, but I remember the shots of those hills. If you haven't been to this city, I can tell you that the streets are exactly as they look on TV, and they are

great fun! On the uphills, my back was pressed firmly against the luggage strapped across the rear seat, and on the downhills my weight was on my arms and hands. The tour culminated in a drive down Lombard Street, the steepest and most twisting road I have ever ridden, where even with the throttle wound shut and in first gear, I had to brake all the way down. I was glad that I wasn't taking the heavily laden bike down it in the rain, as the surface looked like it would be treacherous.

As a teenager I had an Easy Rider poster on my bedroom wall showing Peter Fonda and Dennis Hopper, riding over a girder bridge and looking so cool on their big Harleys. Suddenly, we were heading north over the Golden Gate with the Pacific on our left and Alcatraz Island on our right. Peter Fonda was in front of me, or was it Scott, I couldn't be sure, but I knew that I was Dennis Hopper.

It was only fair that Scott got to be Peter Fonda as in the movie he has the coolest bike. Scott's Ultra Classic was so tricked out with after market accessories, that it made mine look like it was smuggled out of the factory door, halfway through production. Every time I looked at his machine I saw some bolt-on goody that I hadn't spotted before.

A brief stop on the far side gave me the opportunity to take a couple of photo's and, looking back at the bridge, I couldn't really understand why it was called the "Golden Gate". Red oxide primer brown would be more appropriate, but I guess if you see it in the setting sun, through squinting eyes and after a few beers, it may take on a more golden appearance. Regardless, San Francisco looked like a really great city and everyone I know who has been there tells me they think it is too.

We continued north quite some miles to a vineyard, owned by friends of Dale and Scotts' that I had actually met the previous day as they had joined us for the meal. Wes is a retired stockbroker and gave it up just a few years ago when he and Tootsie were lucky

enough to find the vineyard for sale. In that time they have learned an incredible amount about vine growing and dealing with the wineries that buy their grapes, but they have had to. Just talking with them for the time that I did, I learned a lot too and, whilst Wes seemed to be a little in awe of the journey that I had set myself, I had great respect for him and the dream that he had followed through. Wes and Tootsie have a pretty idyllic life, growing grapes on their sixteen acres of land.

They keep some grapes for themselves and presented me with a bottle of their own wine under the "Caldwell" label. As I sit here typing this, not very far up the road, in Oregon, I am sipping away at it. Whilst I don't profess to know anything about wine, I do like it and have to say that not only is the Caldwell wine excellent, but it adds a little something when you've seen the ground the grapes were grown on. I promised myself that when I got back to England I would buy a couple of bottles of English wine and send them to California, so that the Belyeas and the Caldwells could enjoy a little taste of East Anglia. There again, maybe they wouldn't thank me for that!

When we left Wes and Tootsie, Scott got away a few seconds before me due to traffic and, whilst I knew that he wouldn't drive too fast as I was following, I still opened up the throttle a bit to catch him. I didn't think I was going that fast, but after a sharp right hand bend there followed a sharper left hander, with a warning sign advising of a 15mph top speed. I don't know what speed I was doing, but going round the bend I heard the bittersweet sound of metal on the road surface. Now at last, I really was getting the big machine over!

The family party was excellent and took place in a restaurant not too far from Dale's family home. It was her father's 75th birthday and a good number of relatives had turned up to make it a very enjoyable event. I felt like a bit of an intruder for a short time, but everyone was so warm and friendly that the feeling didn't last for

long. I was made to feel most welcome but alas I was once again not permitted to contribute.

Scott decided to leave the restaurant a little early and we said our goodbyes, but when the rest of us left twenty minutes later, we discovered he was still in the car park with more bike difficulties. This time it was the starter motor, though he had half expected the problem, as the guys who had fitted the big, high compression S&S motor, had warned him that the unit was not man enough for the job. Although he had ordered an uprated starter, it didn't help with the immediate difficulty, and we weren't sure what the exact problem was. I was confident that we could get the bike running but Scott didn't want to risk a journey home with the bike in that condition. Fortunately, Dale and Geoff had come to the meal in their pickup so we found some sloping land and, with the use of some boards, we managed to get the Harley onto it. I had some lengths of rope in my luggage, which Scott used to tie the bike down, and we pulled the front brake lever back toward the throttle grip, wrapping insulating tape round to keep the front brake on.

My last view of the Belyeas was of them driving off in their pickup, with the big Harley in an undignified position on the back, and I thought back to the other Scott's words from Indian, "Welcome to the world of American motorcycles".

Whilst I didn't know it at that moment, this wasn't the last time I was to see the Belyeas, for they paid me the huge privilege of being the witnesses at my wedding in Yosemite.

www.onebritonebike.com

CHAPTER TEN
THE TOP LEFT CORNER
AND THE GIANT REDWOODS

The campsite was owned by Jerry, a keen motorcyclist and owner of a Honda Goldwing. He was in his element as there were loads of bikers passing through, on their way to a big meeting at Laughlin, Nevada, and he was attempting to talk to us all. Before I left in the morning, we spent half an hour or so swapping stories and recommending routes and he took pity on me when he saw my KOA map book, which was by then looking very sorry for itself with pages ripped and falling out. He replaced it with a crisp new copy and, as I watched the old one on its way to the dustbin, it was like saying goodbye to an old friend.

I looked around the town of Willets for a while. It was a nice, quiet little town, full of motels and restaurants, but best of all I found two shops selling second-hand music cassettes. I couldn't justify buying new ones as I only use CDs at home, and now I would no longer have to put up with my own tone-deaf singing voice for company. For less than eleven bucks I acquired:

J Giles Band – *Freeze Frame*
The Beach Boys – *All Time Greatest Hits*

And best of all...
The Eagles – *Hotel California*

Instead of going back onto US101, I headed west to the coast on US20 with the Hotel California tape blasting out of the sound system, and my helmet in open face mode so that I could hear the music properly. I couldn't help the huge smile on my face and I'm sure that motorists coming the other way must have thought I was crazy, as through the grin I was singing louder than ever.

The road led up into the Jackson State Park and there were good bends with smooth roads. It was second and third gear work, much less strenuous than the first and second stuff I had experienced further south and I absolutely loved it. By the time *New Kid In Town* had finished, I was getting metal on the road surface again and I told myself to slow down.

The journey through the forest was about thirty miles, terminating at Fort Bragg and on that day around half a mile of fog, before picking up US1 again. The coast seemed a little more rugged than that around Cambria, and it made intermittent contact with the sea, giving new and different views at frequent intervals. Every time I saw the Pacific it was like seeing it for the first time that day. Sometimes there were white-crested waves rolling up the beach, breaking on the sand with terrific force, and other times the sea was completely calm, as there were natural breakwaters protecting sheltered lagoons. As US101 is a quicker road north and south, there was little traffic and meant that I could enjoy the ride.

Some miles after Fort Bragg, I had to drive through roadworks and, although I had turned the music down a long way, one of the workmen could obviously hear it as he started bopping away as I drove past. There he was in his work clothes, fluorescent safety vest and white hard hat dancing up and down on the side of the road, and I so wished I had been playing the Village People's *YMCA*. After all, I was the biker, he was the construction worker and I'm sure that we could have found the other band members easily enough. Incidentally, I remembered that one of the other performers was an Indian but I couldn't remember what the fourth was, so I found their site on the internet. If, like me, you thought there were only four people in the group, you will be surprised to know that there were also a soldier, a cop and a cowboy. All characters would have been easy to find I'm sure, so we could have formed a Village People tribute band.

Shortly after that, the volume was up loud again and the local wildlife was being treated to the new member of the Beach Boys singing along to 'Barbara Ann'.

Twenty miles later, the road veered back inland to link up with US101, as Jerry had told me it would, because the coast was too rough to have a highway along it. The trees closed in again and, as the uphill incline increased, so did the bends. There were only a token number of signs warning of appropriate speeds; instead the preference was to indicate that the road was likely to be twisting for twenty-one miles. That meant I had to go into every blind bend as though it was going to be a really tight one. Most often they weren't, but occasionally I got lucky and they would be real humdingers! Now my confidence was up, it really was fun going into good tight S bends, flicking the machine over from one side to another as much as I could with the great weight of it.

There were a number of bikers heading south, probably all taking a long route down to Laughlin. We waved at each other with the exception of one chopped Harley rider coming out of a bend, who was wrestling with his ape-hangers. I think it must have been pretty tough steering the thing as it had a fairly serious rake angle on the forks, and his buddy setting the pace on another bike seemed to be riding a fairly standard machine.

Some way after being back on 101 there were signs for a scenic detour through the "Avenue Of The Giants", which was situated within an area in excess of 50,000 acres of Redwoods. The road was thirty-two miles long but only added a mile or two to the journey north and, in my view, had to be taken. It wound its way through awe-inspiring Giant Redwoods, some of them over 300 feet high, standing straight and upright. The route was sheltered under these huge trees and it was a welcome break from the afternoon heat. I parked in a lay-by for a while and just looked at the monsters. I felt tiny and insignificant in between them and I guess that I was, for like the sequoias I had seen further south in California, some of these specimens were ancient, having lived for

thousands of years. To me they were something very special and I could understand the respect that the native Indians had for the land. The occasional car went by but, other than that, it was completely quiet and peaceful. I thought of the young Hippies I had met near Cambria and hoped that their camper had got them to their destination. Looking up at the nearest trunks, I could understand what they meant by the reverse vertigo, because they seemed to go on forever. The other varieties of trees were struggling for the daylight because of the canopy way above them, and had grown at an angle over the road, as the space offered more sun. The forest floor was covered with debris and bright green ferns contrasted against the dark bark of the Redwoods. It was a lovely place to sit and do nothing for a while. It was calm and peaceful. Somewhere you could be alone with your thoughts.

Eventually I pressed on and, although there were plenty of opportunities to cut the detour short, I took none of them. The road was intertwined with US101 and the Eel River, making it look on the map as though they were plaited together. The glimpses of the water showed that it wasn't fast flowing but was the most amazing cobalt blue, no doubt rich with minerals giving it the hue. The banks were wide and flat, made up of white rocks about the size of large potatoes and it was yet another colourful, incredibly beautiful, unspoiled place.

Toward the northern end of the route I saw a sign advertising the "World Famous Drive Through Tree", though if the truth be known I think there is a more famous one at Legget, where US1 meets US101. As I hadn't stopped to see that tree I decided to pay the $1.50 for this specimen. It's a shame to see the trunk all hollowed out, but I parked my bike inside it and took a photo, more than anything to give the picture some scale. I touched the bark to feel the texture of the old giant and as a sort of "thank you" to the great thing. I didn't feel that I knew it well enough to give it a hug.

I found it difficult to take on board how old the trees were. An age of two thousand years was common and I thought that for the Christians amongst us, the older examples were saplings when Christ walked the earth. Somehow that seemed to give me some sort of scale of the history involved and shows that our brief time on the planet is very transitory indeed.

After an overnight stop at the town of Eureka, the plan was to ride on into Oregon on US101 again or, as it is called in this part of the country, "The Redwood Highway". Once again I got intermittent views of the sea and each of them provided a similar variation, as had the previous day's journey. I parked up at one and just sat on the bike to take it in: the sun was beating down, the sea was a deep blue and the beaches unspoiled. A few minutes later, a purple Road King pulled up next to me, and the riders dismounted. Steve and Cecelia, or CC as she likes to be known, had decided to take off for a few days from their home in Seattle, not that they both needed a holiday. CC, another stunning redhead, was just coming to the end of a six month break from her job as a Flight Attendant with American Airlines. It was a semi-forced temporary retirement due to the downturn of the industry after September 11th. As was customary, we chatted about bike things and swapped phone numbers and email addresses. I was glad of the interlude because, as I said before, it was the people that were making the trip so enjoyable; it was also a day where I didn't feel like driving too far anyway, but after a while we fired up and went our opposite directions.

All along this stretch of road were signs warning of elks crossing and they made me cautious. I had heard of several cases of motorcyclists having narrow escapes with the animals and, at the birthday party a couple of days previously, Dale's brother had told me of another incident in Canada. On that occasion, the biker managed to avoid a mother elk, only to have a direct collision with the calf following behind. The young animal was killed and the

biker thrown off his motorcycle hurting him badly. Alas that wasn't the end of his troubles. He then had to contend with a mother bent on revenge, and had to literally run around avoiding her for over an hour until another motorist came to his aid. I wanted to do no harm to elks, nor for them to do any to me.

The detour that was offered through the Prairie Creek Redwoods was even more stunning than the longer one of the day before. It may have been down to the light, but the colours seemed more dramatic and more contrasting and it didn't matter too much that it lacked the spectacular river views. Then I passed the State line and was in Oregon. I had heard several times that Oregon and Washington were beautiful, and the first impressions were that nothing I had heard did the place justice. The sea was now really wild, with huge monolithic dark rocks a few hundred yards out. The waves were smashing against them causing foaming white water round their bases and a misty spray above. On shore the foliage was rich and, on some of the rocky monoliths, there was even enough soil for trees to grow there.

Only a little way further into the State, I saw a road sign stating the presence of a natural bridge, so I parked up to take a look. A short, fenced path led down the tree-clad hill to a boardwalk where there was a view to the sight of the bridge below. There were actually two arches in the natural strip of rock that otherwise enclosed a little cove. The sea seemed much calmer than it had been a little way south, but there were several of the monoliths giving protection to the place. It looked like there was a path over the bridge, and I liked the idea of walking across it, so carried on past the boardwalk. It was a well-trodden track. As I made my way down the hill, the traffic noise disappeared behind me, to be replaced with sounds of the sea and an occasional bird. Even my footfall was silent as the forest floor was covered with the usual debris of pine needles and dead leaves. There was also a strange green gossamer-like material hanging from every branch of every tree, which looked soft, but was rubbery to the touch. Later I was

told that it was a form of moss, but it looked a little like the thin covering that stags have hanging from their antlers in the spring.

After a while, the path split and I opted for the much less used route down toward the bridge. As I got closer to the area, the ground got steep and I slipped on all the loose material. It served as a good warning because, further down, the slope gave way to an almost sheer cliff, dropping to the sea below. It was not particularly high, but a fall would probably have been fatal, either from hitting something on the way or through drowning. I took the rest of the descent very carefully, using the roots of the trees as steps and handholds and I could see that others had done the same.

Stepping out onto the first part of the bridge was easy and gave me a good view of a channel between the huge rocks further out. There was, however, a big step onto the second part and carrying my crash helmet made it impossible to climb up. As I intended to go only one way across the rocky strip, I stuffed my gloves into my pockets and put the helmet on. It was difficult to climb the ridge for it was high, there was a lot of loose earth on the rock surface and the bridge was only a couple of feet wide. Once I had got up the step, I could see that there didn't look like there was a path on the other side of the bridge after all and, in any case, the rest of the journey across it would have been far more perilous as it was so narrow. I stood for a moment taking in the better view that I now had of the channel and thinking how daft I was to have come this far. I was on my own and had I fallen I would have been in serious trouble with nobody knowing I was there. It was a completely stupid act.

It was a steep climb back to the bike and through the whole episode I didn't see another person, emphasising how silly it was to have been so reckless.

Again in the saddle, the road continued to Coos Bay, where I noticed that hotel prices were now much more reasonable as was

the price of fuel. Strange that petrol should be getting cheaper as Oregon law forbids customers to pump their own gas, so the petrol stations have to employ people to do it, just like the old days in the UK.

I had chosen to stop at this town because the bike was yet again due a service and, the Harley dealer there, was the last one for a long way.

As always, it was easy to spot motels in the town due to the familiar U-shaped layout, and one jumped out at me with en empty car park but a "Vacancies" sign illuminated in the office window. There was nobody there when I entered, but then a middle-aged lady came through a door at the back. She left the door open and I could see that the adjoining room was her private accommodation with a TV blaring out some awful daytime programme. There were religious pictures and statues dotted about, as indeed there was a crucifix on the wall above her desk in the office.

She looked at me disapprovingly; I don't know why. Perhaps it was because I had disturbed her viewing time or maybe it was because I was a biker, but to me the motel looked pretty much empty as nearly all the keys to the rooms were hanging on the board on the wall, so you'd think she would have been grateful for the business.

I booked in for three nights, giving me two full days to allow time to organise the service and write up a few notes and she begrudgingly handed me the key for the room closest to the reception office. I daresay to keep an eye on me.

Bright and early the next morning, I went to the dealership and they serviced the bike straightaway, though told me that I needed a new rear tyre, which would cost $170, plus fitting and tax. As cruisers are so common in the States, I thought that I would probably find somewhere else that could provide it cheaper, but I did spend some time looking round the shop and found the perfect gift for Scott and Dale, in the form of a model of an antique

Harley. Each of these designs is only made in one batch so is a "limited edition" and Scott had told me that he thought it would be fun to collect them. It wasn't enough to repay their kindness, but at least it was a start.

On the last night in Coos Bay, I walked down to a bar for a beer, which is something I wasn't making a habit of as it used up precious cash reserves. The first place I found was poorly lit and the only tables that had lights were the pool tables. I took one of the high stools at the bar, as I needed good light because I had brought my maps with me to plan my next week or two. I was covering ground quicker than I had anticipated and that meant that I had a few options open to me.

1. As I had an "open air ticket" to fly home, I could probably go back to England early, though that would have been a shame.

2. I had a friend in St Louis who I had promised to see if there was time and the city was only a relatively short way from Chicago, my final destination. This seemed a better option than the first.

3. As I was going to have reached three of the four corners of the USA, I could drive on to Maine and hit the last of them, but as I was to fly out from Chicago, the round trip to Maine and back would add something like 4,500 miles to the journey. The distance wasn't a problem, though there would have been some high mileage days and possible bad weather so far north. With the open ticket, I could, if need be, delay my exit date, though of course it wouldn't have been legal. I knew a lady in England who had visited the USA for five months on a three month visa and the only drawback she encountered was that if she ever wanted to return, she would have had to apply through the Embassy. I'm not normally one to flout the law, but it would have been great to be able to hit all four corners of the country. When I thought about this, I realised it was another completely daft idea. It would be fine

229

if all went well, but suppose I had some run-in with the authorities, albeit a minor one, or a traffic accident caused by somebody else. I would be a foreigner without a passport who had outstayed his visa and would almost certainly have found myself either in jail, or on a plane home. The Ultra would probably end up in a Police compound with daily storage charges being applied, and I would be helpless to retrieve it, let alone sell it. The 4th corner didn't seem to be an option.

I sat and thought about it all, changing between maps and trying to come up with other options. The place wasn't busy and it meant that I could think easily and clearly about the possibilities, though I made little progress. I was vaguely conscious of two men and a woman who came in and took up the seats to my left, the young lady being the closest but with her back to me. They ordered a pitcher of beer, drank it and then ordered another before the woman, whom I shall call Sheila, noticed my maps and asked what I was doing with them. The usual conversation took place as to where I was from, what I was doing, where I had been, which hotel I was staying at and where I was going.

One of the guys, Mike, had wandered off, so Sheila introduced me to the other, Brian, who I had thought was Dutch because of his accent, but was actually profoundly deaf. We exchanged a few words but I found it difficult to hold a proper conversation so I returned to my maps.

Sheila continued to hold a two-way conversation between us both, swapping over at regular intervals and taking a good gulp of her beer as she did. The conversation she had with Brian, half spoken and half signed, was completely different to what we were talking about, and the situation continued for some time as she told me about herself. Apparently she was divorced with two children, had recently inherited a considerable amount of money and, was a reformed alcoholic. I mentally questioned the last part

of that as Mike had temporarily returned and the three of them ordered another pitcher, along with tequila chasers.

I studied my maps as Sheila held another conversation with Brian, but when it was my turn again, she turned the map toward her by gently taking my hand in hers. This wasn't just a fleeting contact though, it continued for a couple of minutes as she suggested places that I might like to see en-route, whilst pointing to them on the map and volunteering to accompany me to the more local spots. She was now leaning forward so that her shoulder was in contact with mine and our faces were very close as we studied the book.

After another session with Brian, she turned to me and asked, 'Do you know something?' I shook my head slightly, shrugged my shoulders and waited for the follow up line, expecting another travel tip or information on places of interest. She looked me squarely in the face and said, 'You're completely fuckable.'

You know, alcohol is funny stuff, the way it affects your vision and addles your brain. This lady had a bad case of beer goggles. Seriously though, despite the crudity this was a huge compliment and to hesitate for more than a split second would have been very un-cool. I met her gaze and replied, 'Thank you. So are you.' Perhaps my response wasn't all that clever but it was the best that I could come up with at short notice and, after all, I was still in shock.

'Oh I'm not,' she said.

'Oh you are,' I replied. And so I found myself convincing her that she was for another couple of rounds of her denial. Well, what could I do? She actually was a good-looking woman and even if she hadn't been, I could hardly have told her so.

Brian got another stint of chat with her, in which time Mike had made his pilgrimage to ensure more beer and tequilas were ordered before it was again my turn for her attentions. This time, as she spoke, I felt her hand on my left knee and thigh as she again asked where I was staying and was I going back there that night. I

231

was completely truthful with her but it was obvious that she was having trouble distinguishing my motel from another one, a couple of hundred yards down the road.

And so it went on for another half hour or so, in which time she got friendlier and friendlier, as well as asking my room number and could she come and see me later. Well, my room number wouldn't have taken much working out anyway, as it was the only room with a Harley parked outside – so I told her. To be honest, I had no problem with agreeing to her visit either, because it was very obvious that before too long she wouldn't be able to stand, let alone find her way there. However, I did have some scary visions of the motel receptionist throwing me out due to a loud lady guest turning up.

At one stage, Sheila went to the ladies room and it prompted me to think that I could do with a visit too. As I headed in the direction she had taken a couple of minutes previously, I met her returning to her seat and she embraced me. It wasn't a short or long hug, but just long enough for her to give me a really passionate kiss with absolutely no sign of any inhibitions at all. Then, as quickly as she had grabbed me, she let go and headed back to her stool.

A few minutes later, Mike again returned, they had some more tequilas and he informed the other two of something in very hushed tones but making sure that Brian could read his lips. The next thing I knew, Sheila whispered in my ear that she would see me later but they were just going off to smoke some pot.

Well, I suppose you want to know if she turned up, and the answer is no, of course not. I would have thought that the cold Oregon night air probably knocked her out before she even got her smoke. On the other hand, whoever was in Room 34 at the other motel may be asking what he did to get so lucky.

There again, if she had have turned up at mine I wouldn't tell you.

The weather forecast in the morning was promising rain showers, but I could live with that so I set off north again, wondering if perhaps I should have stayed another night. It didn't seem like a good idea though, as I had got the impression that Brian was actually quite fond of Sheila and would be very jealous of her antics.

I turned the radio on and stuck in a new cassette that I had bought at Wal-Mart. The temperature was only forty-five degrees, but the Isley Brothers were crooning about the summer breeze blowing through their minds as I headed for Washington State. Despite the weather, the music was making me feel good and the grin was back on my face.

Sixty miles up the road, I stopped at the "World Famous Sea Lion Caves" and paid the seven bucks to get in. I hadn't been to the main area in San Francisco where the seals were, so the caves offered a chance to see the wonderful creatures. To me the entrance fee was worthwhile just to see the lift, which is now the only way down to the cave because the wooden steps to it were demolished some years ago. It was a 208 foot vertical shaft with a further gallery sloping down another seventeen feet, blasted out of solid rock around forty years back. The work took place over three years, because no blasting could be done when the seals were "in residence", so in real terms actually only took nine months to complete. In the height of the season, around 3,000 people a day visit the cave and the lift must be really worked hard. As one of the staff told me "It just keeps going up and down", though I'm not sure what else he expected of it.

The viewing area was set in a side lobe of the main cave, looking down on the seals from around thirty feet up. The animals do what you might expect them to do, sit around on rocks until a bigger seal comes along and pushes them off. It was a bit like watching managers in some companies all working their way up the chain, only to be knocked off by someone else.

233

The cave also housed various exhibits including the skeleton of a seal that someone had shot. I had heard on the radio there was a lot of this happening and it appeared that the culprits were shooting the animals just for the sport of it, despite being protected by law. Hopefully the perpetrators would be caught and dealt with accordingly.

However, humans are not the only enemies the seals have, as on the top of the cliff there was a sign indicating that whales can sometimes be seen on their migratory route, occasionally stopping off for a seal snack. There was no evidence of any whales that morning, despite the full larder of around 150 seals on a rock shelf outside the cave.

It was an hour well spent but it had started to rain again. Not heavily but big drops, the sort you can hear hitting the leaves of the trees and the ground. I wasn't too worried about it as the Weather Channel had only forecast showers, and, as I said before, showers I can live with. I made my way north, now taking more notice of the advisory speed signs for the bends and watching the raindrops hit the windshield. I couldn't see any difference in the way it ran off the screen even though it was treated with the Harley Davidson anti-rain wipes and I was doing reasonable speed.

As the afternoon progressed, the Weather Channel's forecast proved to be accurate as there were rain showers. The problem was that they were interspersed with heavy rain, very heavy rain and a few doses of hail for good measure. I had my visor open, partly to avoid it misting up and partly because I couldn't see through it with all the rain on the front. Water was dripping off into the helmet and soaking my neck-warmer. That, however, was the lesser problem as it had completely penetrated my leather trousers, boots and gloves. With every move of my feet or hands I could feel the water against my skin; it was cold and uncomfortable, nearly causing me to chicken out several times,

stop in some town and book into a motel. After three nights in one place though, I really felt that I needed to make some progress, but it was slow with such poor visibility. I stuck to the advisory limits religiously and was well below the maximum speed most of the way. Several times I got stuck in the Catch 22 situation of being behind a lorry that was throwing up spray, reducing the visibility further, but on the other hand, giving me something to follow. Sometimes the trucks moved so slowly that I wanted to overtake but couldn't because I couldn't see past the spray. Fortunately, the road was hilly and the up-hills often had crawler lanes for slow moving traffic, so I passed them one after another. The high point of the day happened during this and, through the drops of rain that had accumulated on my speedometer, I watched 17,140 miles being clocked up, meaning that I had doubled the mileage on the bike since I had bought it.

Eventually I reached the town of Astoria and crossed the bridge to Washington State. Now I felt I had made some progress and after 170 miles of really crap weather, the shelter of a nearby motel was too appealing to pass up. After unloading the luggage from the bike, my feet squelching in my boots with every step I took, I turned the heating up in the room and stripped off. My jacket needed a wash so it joined the rest of the washing in the guest laundry, I hung the leather trousers over the back of a chair near the heater, the gloves went on top of it inside-out, my boots promptly joining them. Then, after a hot bath, I discovered that I had completely cocked up with the boots, as the glue on the left one had melted, leaving the sole flapping round in the air. I pushed it back in place and put them both on a cooler surface, hoping that the damaged boot would repair itself as it cooled. Alas, in the morning I discovered that there had been no improvement, so was glad that the Weather Channel was reporting that the rain was on the way out. Switching over to a news station I heard that there had been a riot at the bike meet in Loughlin, prompted by a fight between two rival bike gangs in a casino. The result was four

235

people had been shot dead, over 100 arrested and SWAT teams were in control of the city. Quite amazing.

I applied a coat of the black liquid I had bought at Daytona to all the leather. It did another good job of removing the white stains you get when leather has been in the rain, and I was left with nice black bike gear again, but I now knew that it was no good for waterproofing. To make things worse I also had a left foot completely exposed to water being thrown up from the road and I needed to find a shoe repairer before more bad weather.

Carrying on up the coast, for many miles there was no view of the sea, just trees. I was deep into Washington State and there was little traffic, though I was surprised at how large some of the towns were, the main industries appearing to be timber and fishing. When the sea did appear it was a nice relief. The sun was shining now and the Pacific sparkled, convincing me that there was no more rain to come, for a while at least. After 200 miles of travelling that day, I turned onto US113 and then a few miles later onto US112, which led to the Peninsular. I stopped at the bridge crossing the mouth of the small Hoka River, again because it was a good view. The riverbanks and seashore were sandy and the vegetation above was thick and green. The sea was blue but the angle of the sun caused a silver tinge giving it a metallic appearance that motor manufacturers would likely give some fancy name. Away from the river mouth it was like a millpond but, as the comparatively warm river waters met it, the water swirled and was white-topped. What made the scene special was that twenty miles away across the water, the mountains of British Columbia were also white-capped, providing another chocolate box scene. They rose steeply out of the water, very dark but white on top, just like a pint of Guinness.

The speed limit signs along the road needed to be taken seriously on a bike. Pot holes on blind bends made things exciting and getting to Neah Bay, the furthest point on the Peninsular, a

slower than expected journey. Actually, it was not quite the furthest point but it could be considered so when on a heavy Harley. Some may argue that the top left is really the Canadian border and I still wanted to get to it before I could feel that I had hit that milestone. Once there it would unfortunately be a bit like Key West because I would have to turn around and go back the same way as I had come. It was to be the first part of the trip East and it felt like the journey home was looming. The thought depressed me greatly and I tried to put it out of my mind.

The route back to US101 was a little longer than the route I had taken after leaving it, and provided lots more bends to play on. There had been plenty of Harleys around all day, sometimes ones and twos and sometimes fairly large groups. The constant waving at all these bikers took my mind off the fact I was heading east and I really pushed myself into one or two of the bends. The force of the impact of the metal foot boards on the road quite alarmed me and I decided at this point that I had nothing to prove. An Ultra Classic should be given more respect and I would not purposely mistreat the bike any more.

The map showed that there was a shortcut by ferry from Port Townsend to Whidbey Island, and then a bridge back to the mainland, providing a saving of about 100 miles; so I headed for it. As it turned out it saved me little time, as there was a delay in the crossing of over an hour and a half, though there were several bikers there to talk with and that was entertaining.

On the trip across to Whidbey Island, I sat with Jackie, a lone lady biker who had left her husband at home to look after the kids, while she headed out on her Softail for the weekend. We swapped stories and she told me of her early days of biking in the USA, back in the 70s. Anyone riding then was considered an outlaw regardless of what they rode or what they wore. She and a boyfriend stopped at a Diner one day, she couldn't remember exactly where and, despite wearing fairly ordinary clothes and

sporting bright yellow helmets, they were treated as undesirables. They waited to be seated and could see that their presence was causing great concern, until a "volunteer" waitress eventually showed them to a back room, took their order, and left, closing the door behind her. Jackie's boyfriend opened the door but it was closed again almost immediately. He opened it again and again it was closed. When the waitress reappeared he told her that they wanted the door left open and the waitress replied that it was being kept closed for THEIR protection. It seemed the locals did not take kindly to strangers on motorcycles, but this was the era that Easy Rider was released. Maybe the film was a very accurate reflection on attitudes of the time or maybe it helped to reinforce them. Either way, the attitudes then were so completely different to those of now, where owning a motorcycle, especially a Harley, is likely to provoke a conversation with passing strangers with no difficulty. The very strange thing is that most of the people who want to talk about motorcycles are the older ones, who probably rode bikes in their youth. Were they all outlaws? I doubt it.

Whidbey Island is farmland full of agricultural smells as well as the sweet scent of the fields of flowers, which were mostly tulips. The blooms I saw were a mixture of yellow and red, a real splash of colour in all the farmland, and I was surprised at the strength of their aroma. I was also surprised that they were all mixed up together in the same field, and although I know nothing about flowers, I suspect the bulbs actually produced the mixed colours.

The real WOW of the journey though, was the trip over the bridge at Deception Pass. From about eighty feet up, I looked down both ways at stunning views. To the west was British Columbia, the islands in between and the Juan de Fuca Strait, and to the east was a small island and the American mainland. The sea was an opaque jade green and surged through the gap below with the tide, swirling around the rocks but with only the slightest hint of white water. I heard someone say that it was flowing at around

eight knots and there was more than one small boat taking a shortcut by riding the current through the gap. I walked along both sides of the bridge, taking photos, and my right sole followed the lead of the left, both flapping like flip-flops in reverse with every step and amusing many of the fellow tourists that could hear me coming from yards away.

I continued on to Blaine, the most northerly town on the coast and next to the Canadian border. It was another uneventful journey but I had a particular tune in my mind, and again, it wouldn't go away. It was sparked off by my flapping boot soles, which reminded me of someone I knew at college. The guy had a shoe heel that was falling off one day, and when he realised he burst out into the song, "You Picked a Fine A Time to Leave Me Loose Heel". Sorry, I know it's bad but it was his joke – not mine.

Arriving in Blaine, I drove out onto the dock, the furthest point I could make west. That was now the top left of the States crossed off the list and I had therefore travelled the breadth and length of the USA. It was a shame that I wouldn't make the top right corner, but there was no real agenda to the trip so it wasn't really important. With one last look at the Pacific I headed south to the KOA, southeast of Seattle.

CHAPTER ELEVEN
YELLOWSTONE

Finding a shoe repairer was surprisingly difficult in the area of the suburbs of southeast Seattle. The lady in the camp office had given me some possible places to look, but they had either moved, were closed on Mondays or, in one case, the shop was actually a Chinese laundry – an easy mistake to make!

Eventually I found one and, having explained the urgency to get the boots fixed, the man told me that it would take around three hours. That was okay because, just a block down the road, I had seen a motorcycle parts shop that advertised a good stock of tyres. I drove down there and they did indeed have a suitable rear tyre; better still, it was considerably cheaper than the price Harley had quoted, and lower still than another local company that I had telephoned. All in all, it still cost $200 including fitting and tax, though I smiled at the entry the owner had put against "Name" on the receipt. It simply said "English Dude".

After another visit to the cobbler, both the bike and I were suitably rebooted and I could think about calling the friends from Seattle that I had met along the way.

After some difficulty, I made contact with Eric, the guy I had met at the Bakersfield KOA, and we spent the evening and part of the following day together. Eric was a hardworking and enthusiastic young man, who was disillusioned working for people who didn't appreciate him, so he set up his own construction business. He has the appearance of someone who works manually: tall, very broad-shouldered and extremely fit. He gave me a really enjoyable tour of the city and, as we drove, he entertained me with experiences of his work life, stories of his childhood and teenage years, as well as some of the more infamous residents of Seattle. These started with the Green River Murderer: a serial killer of prostitutes of the area in the early 1980s, whom it was believed had died of cancer years ago. The recent discovery of the remains

of two more bodies and the advancement of forensic medicine had shown that the original suspect was not the guilty party, and the case has been reopened. This is Seattle's own "Jack the Ripper", an unsolved serial murderer that got its name because five bodies were found in the area of The Green River, South King County in Washington State, just south of Seattle. Over the years, the body count increased, then in 2001 one of the original suspects was re-arrested as his DNA matched that of the killer's.

It was late in 2003 when that suspect, one Gary Leon Ridgeway admitted to forty-eight killings and did a plea-bargain with the authorities. On agreement to plead guilty, he was promised that he would not receive the death penalty. He also agreed to help find some of the missing women.

Ridgeway fitted the profile that they thought the killer would display: that is a deeply religious man with a hatred of prostitutes, whose services he used frequently.

The man was born in Salt Lake City in Utah and it is said that his academic abilities were so poor that he'd had to repeat one school year in order to attain high enough grades to pass. At the age of sixteen he stabbed a six-year-old boy (who survived) and, whilst walking away, he laughed, saying that he always wondered what it would be like to kill someone. It seems that he gained plenty of practice for, whilst he admitted to the murder of forty-eight women, he boasted that he had actually killed more than ninety.

Eric went on to tell me about a local boarding house he had stayed in as a child. He can clearly remember how the garden was all dug up and he thought it very strange, but it turned out that the lady running the place was married to a man who had gone missing. As the Police suspected foul play, they came and dug up the garden but found nothing. Though it was later discovered that the lady and an accomplice had killed her husband, and ground up his

242

body in a meat grinder before dissolving it in a bath of acid. Gruesome stuff on what was otherwise a pleasant drive.

One of the most unusual sights I saw was only a roundabout; in fact it was the only one I had seen in the USA. I do wonder what Americans visiting the area make of it, as most will not have ever experienced such a thing. In England, I live near what was an American Air Force base and on it there was a roundabout, just so Airmen and their families could practice going round it before hitting the British roads.

I also wonder how in England they cope with going round it to the left, as I remember an incident when I was stationed in Germany on Harrier aircraft. As I said before, often on exercises, the "Harrier Force" would deploy to woods around Germany, and to do so meant the transportation of a great deal of equipment. This would be carried in long convoys of camouflaged lorries or Landrovers on the normal German roads. There was one particularly harrowing occasion when a novice driver leading a convoy went the wrong way round a roundabout. You can just imagine the chaos as every other driver followed him, with all the good people of the town abandoning the road and, some of them, their vehicles. It was probably a very worrying experience for all concerned!

I enjoyed the time spent with Eric, the local history he spoke of, and his impressions of England that he shared with me. He had never been to the UK and, if anyone ever mentioned my home country, it conjured up memories of Julie Andrews and a smoke blackened Dick van Dyke, dancing their way across the rooftops of London in Mary Poppins. My initial reaction was amazement as I couldn't believe that he had it so wrong, but then had to admit that my impressions of the USA were pretty much based on Hollywood and the country was nothing like I had imagined. I vowed to send him a postcard of the rooftops of Cambridge; it was

one that I had sent many people in the past and knew it was a lovely sight. There and then, I even chose the wording I would write on the back of it, it was simply "Chim chiminey chim chim, chim chim cheree".

Whilst still in Seattle, I had hoped to spend some time with CC and Steve, the two people I had met on US101 in California, but it was a bad time as CC was about to go on her first shift after the six months off. However, after I returned to the UK, she contacted me on one of her London trips and we had a meal together. What I found incredible, was that she told me that she and Steve were looking for a construction company to do some work, and I was able to put them in touch with Eric. So there were two sets of people that lived a few miles from each other in Seattle, whom I had met hundreds of miles apart in California, and I connected them in London. Small world isn't it?

Instead of the evening that I was hoping to spend with them, I spent some time with some fellow campers. Mitch had introduced himself as soon as I had arrived at the site, advising me of the best place to pitch the tent, what facilities were available, where to park my bike, etc, etc, etc. It was useful info as the camp office was closed.

When I told him where I was from, he replied that his wife's family was from England too. I asked him whereabouts and, after a short pause, he told me that it was "England, Germany or one of those places".

He invited me to his trailer where his wife, Katie, was sitting and making a patchwork quilt. They struck me as a fairly odd couple in that they seemed so different. Firstly, he was probably only about five feet six inches and very wiry in build, though I'm really not sure how tall Katie was because she never stood up the whole time I was there. I'm guessing she was a few inches taller and somewhat heavier in build, but as she was covered from the

chest down with the quilt that she was working on it was difficult to tell.

He was a fast-talking New Yorker with the accent to prove it, firing questions at a rate it was impossible to answer. No sooner had I opened my mouth to respond, than he fired off another at me or at Katie, or instead, gave his own opinion about whatever the topic was. I could picture him as a New York cab driver but, despite his size, he was actually a retired Marine and, more recently, a Highway Patrol Officer in Florida. I would have hated to have been stopped and questioned by him, as I would imagine it would have likely been a real interrogation and, although in his early sixties, he looked mid-fifties and owned a motorcycle himself, a Honda Valkyrie. It was soon clear that he was extremely knowledgeable about bikes in general, sharing his knowledge as he bounced each question off me and then answering it himself before I had time to draw breath.

Katie's accent gave her southern background away. As much as Mitch was blunt, she was gentle, her great passion being the patchworks, and I would guess that she was several years Mitch's junior. It was clear that she found Mitch's views different from her own, though this didn't seem to cause them any problems. She asked me if I had bought any "protection" to take with me on my travels and it was obvious she was asking if I had bought a gun. I felt a little sheepish as I told them of my flick-open truncheon, and the admission of not having a firearm launched Mitch into a monologue of how he had no less than three guns on board their trailer, including a machine pistol. He told me that he considered that he was the last line of defence of Katie, himself and their belongings and, as he did so, he took a revolver out of his pocket and deftly waved it in the air, showing he was well used to handling guns. It would have been surprising if he had not been considering his background.

He went on to tell me that he had visited London and whilst he felt that the British police seemed to have violence under control, I

should not feel the same way about the USA. Katie immediately intervened and pointed out to him that I had travelled 11,000 miles across the States and had not encountered any trouble. She felt that his upbringing in the Bronx had made him almost paranoid about violence, and to some extent she was probably right, though it can't have helped having an Armed Forces background followed by dealing with the lunatics on the Floridian highways.

Despite Mitch's overbearing way, he was a good-natured soul. They both were, and they were good enough to invite me to share a pizza with them, for Katie was a vegetarian too. However Mitch was caught out when he went to get it, because unbeknownst to him, he had ordered it from one of the chain of take-away places that don't cook the food so he had to coax the extra large piece of bread into their small trailer oven. It tasted fine though and it was a very kind gesture.

The evening was yet another example of how generous and warm Americans can be to total strangers, and a stark contrast to the story of The Green River Killer.

My route plan to travel east was through Mount Rainier National Park, situated southeast of Seattle, as it was one of the very few routes through the Cascade Mountains that avoid travelling on the Interstate roads. The map showed some possible minor difficulties, as a couple of lengths of the roads were marked as "closed in winter", but if the questionable part of US410 wasn't open, I should be able to travel south a few extra miles and pick up the open part of US12. I thought the risk of these extra miles would be well worth not having to travel on another Interstate and I set off early, in cold cloudy weather that was forecast to improve, though the cloud meant that I didn't have the morning sun in my eyes. Half an hour or so later, I started the ascent of the mountain with plenty of scenic views to glance at on the way. A while after that, I was travelling through a mountain village made up of a few

log cabins and I spotted a sign stating that the road was closed in fifteen miles. According to my maths, the junction I needed to hit before taking the southern route was another twenty-one miles so I took the decision to go on hoping that there was something wrong with my sums somewhere. Then about two miles later a chipmunk ran across my path, sealing my fate. Nevertheless I had now come so far that I carried on and found that the road was indeed closed because the whole Park was not yet open for the summer season. There was no choice but to retrace my steps, almost all the way back to where I had started from, costing me about 100 miles and around two hours.

As it turned out, it was to my advantage because, whilst most Interstates are not that interesting, this part of the I90 is absolutely breathtaking. Snoqualmie Pass allows a route through the Cascade Mountains with perfect snow-covered peaks on both sides, as though the white stuff had been painted on. I stopped to admire the view at Keechelus Lake, which got an extremely high WOW factor, but to be fair the sight of mountains was having less effect on me now. It's like anything else, you get used to it after a while.

Travelling on to the other side of them, I was surprised to find what was almost a desert and not at all what I expected in Washington State. I say almost a desert because it was somewhere between desert and scrubland and not very pretty. I hadn't seen desert for a week or two though, so it made a change, and there were occasional places that had been well irrigated giving plenty of grass for animals to graze on.

The road seemed to go through mountains all day, up and down, above and below the snowline. I passed into the Idaho Panhandle and was amused by the statement on car number plates. As I've mentioned before, in Florida the plates often proclaimed the State as "The Sunshine State" and in Texas the wording is "The Lone Star State". I later noted that Illinois

announced that it is "Lincoln's State" but Idaho's two words were simply "Famous Potatoes". Very agricultural.

The road through this part of Idaho is only a little over 60 miles long, and by late afternoon I was ascending the Bitterroot Range with the air temperature at sixty degrees. I had taken my gloves off because of the heat, but there were illuminated signs warning of icy patches. The chances of ice seemed extremely unlikely to me until I passed through areas in the shade of the mountain, and the air temperature dropped like a stone. The bike's temperature gauge wasn't quick enough to respond to the changes before I was out the other side of them, but it seemed likely that the drop was easily twenty degrees and, if you take into account that the ground temperature was likely to be lower, then icy patches were quite possible. I made sure that I was within the advisory speed limits through the bends and a lorry driver behind made sure that if I did come off, he was so close he wouldn't be able to avoid running me over. I sped up on the straights and, as they were generally uphill, it didn't take long to lose him.

A little while later, I was high in the mountains of Montana and, although the route was clear, the snow was piled up at the edges of the minor roads and in the gardens of the little settlements along the way. My direction was to the southeast, meaning that the houses on the right side of the road had an early dusk and benefited less from the warm afternoon sun, so the snow on their side of the road was deeper. At this time, the Clark Fork River was also on my right, its waters running very quickly and looking almost black. I was feeling cold but didn't want to stop before I had to, even to put my gloves on, so drove with alternate hands on the bars, whilst the other hung down straight to take in the warmth from the exhaust pipes. It was particularly easy to warm my left hand as the left exhaust runs close to the side panel, warming it nicely and putting my hand on it was like putting it on a warm radiator. I was glad that I was not driving to the west, as the reflection in the mirrors was just a red glow from the setting

sun and would have been blinding to anyone driving toward it. Whilst it looked like it was a good sunset, I wanted to get to wherever I was going and didn't feel like stopping to enjoy it.

I decided to stay in the town of Missoula, which was just out of the mountains and would likely provide a warmer place to camp, so I settled back to enjoy the rest of the journey with long sweeping bends, just right for riding one-handed.

The KOA was easy to find in Missoula as it was on the side of the town closest to the interstate. I found that the office was shut and I realised that I was back on Mountain Time, meaning it was therefore an hour later than I had thought. After completing the late arrival, self booking-in process, I found that I was setting up the tent in near darkness. It was feeling very cold now and I took a late shower to warm up before going to bed fully clothed. It was claustrophobic wearing clothes in a tight sleeping bag but tiredness got the better of the claustrophobia and temperature so I was soon asleep. Unfortunately, I woke early because the bitter cold had got to me, particularly my feet. I put on lots of extra clothes and looked at my watch, it was 6am so no reason to get up yet. However it was impossible to sleep any more as I was completely limited in movement and couldn't warm up either.

At 8am, the sun was beginning to work its way through the trees and light up the tent wall, so I reluctantly left the shelter of the sleeping bag and started breaking camp. The radio reported that it was thirty degrees outside but would warm up later and I turned on the bike ignition to check the temperature gauge. It sluggishly fought its way a little above twenty degrees, but the sun still hadn't reached the bike yet. By 9am it was well above the trees, the temperature was rocketing and I was taking off layers of clothes, like a stripper on piecework.

Back on I90, the scenery was of more distant mountains; again they were mostly snow-topped and looked black below the snowline. The land was fairly flat but every so often the road would come to the edge of a rise and the scene would be renewed

with more peaks. There is something really nice about heading toward mountains when they are snow-topped but far away, especially when it's hot. Further on I realised that the lower blackness was due to trees that looked suspiciously like junipers as they were sprinkled across the flat valley floor too. Shades of Steven Spielberg's *Poltergeist* with "They're back" went through my mind.

Driving along, mile after mile, at between 70 and 80mph with the cruise control on, I was for some reason thinking about what I would do if I broke down. There was little traffic so it may not have been easy to get assistance from passing motorists, though the answer was simple. I would just need to get to a phone and call the nearest Harley Dealer, and the hoardings along the route had advertised the proximity of them, so there was no problem there. I wondered what would one of the early settlers have done if their horse had gone lame, or thrown them and ran off. They could have been miles from anywhere and anyone, with limited food and water, and maybe hurt. If they had been on their own, they must have felt desperate and pretty scared. What survival expertise might they have had? I think it would have been a very lonely and risky business, travelling in those days. The expanse of the country is hard to take in until you have travelled it. It is just enormous and so much of it is remote. Mountains and deserts can really bring it home to you how alone you really are and also how vulnerable. The John Wayne movies with big cattle drives went through my thoughts along with the gigantic task of moving hundreds of cows over long distances. They were brave and tough men that undertook those adventures.

My goal for the day had been to get to the area of Yellowstone National Park, but the wind was getting up, and besides, I wouldn't get there until the afternoon and therefore wouldn't get much time there. It seemed a better idea to spend the night in the

town of Livingston and continue in the morning. I battled on through the wind, which wasn't bad most of the time, but then gusts would grab me and shake me around before letting go again, just like a cat worrying a mouse. When it had hold of me I tensed up and gripped the bars for all I was worth, leaning toward the sideways force and then as quickly as it had started the force would disappear and I was left having to revert quickly to an upright position. Sometimes when there hadn't been a gust for a minute or two, I would start relaxing and it seemed the wind could sense it, giving me a quick "slap" to check I was awake before relenting again, though it got my attention every time. Just a few miles before I reached Livingston and a warm hotel room, I spotted a sign with a limp windsock hanging from the top. It read "Gusty Winds". A warning too late.

The morning broadcast from the Weather Channel advised of a 30% chance of rain and, as I loaded up the bike, I saw the temperature on a big digital thermometer outside a shop, head down from fifty to forty-seven degrees. I commented on it to the hotel receptionist as I checked out, and she asked, 'You know what comes next don't you?' I looked blank. 'Snow,' she said. I asked her if snow was forecast and she checked the newspaper on her desk.

'No, but there is a 30% chance of rain,' she told me. This was pretty much the forecast for that very wet day in Oregon so I was a little dubious about the chances of staying dry, but I had to get on.

The wind was now blowing constantly from the west, and the weather looked worse in the east than it did to the south where Yellowstone lay, so perhaps south was a good idea after all. It was about fifty miles to the north entrance of the Park and there was little traffic, though around two thirds of the way there I nearly got wiped out by a motorist behind me, who wasn't paying attention to the road. He didn't notice that I'd had to brake because of the car in front of me suddenly stopping, and I had lined myself up on

the offside of the car, waiting for an oncoming bus to pass. There wasn't time to manoeuvre to the nearside and, looking in the mirrors, I became aware of the car behind approaching far too fast, then the nose dipping as the driver braked hard. It's not a nice feeling when you know there is nowhere you can go, and there is nothing you can do to control the events of the next few seconds. To put it bluntly, I completely tensed up and you could have cracked walnuts between the cheeks of my backside. Fortunately the offending driver steered his car onto the hard shoulder and came to a stop next to me. I didn't feel like expressing my anguish with his lapse of concentration, we all do it from time to time, and the situation was really caused by the guy in the car in front. Nevertheless I kept a close watch on my mirrors after that, and although he stayed a long way back, it took me the rest of the ride to the Park to relax again.

I checked with the Ranger when paying my admission fee, and she confirmed that the forecast said a 30% chance of rain. I really didn't like the look of the sky so asked if there was any mention of snow, to which she replied, 'No, just rain.'

Yellowstone is enormous and whilst it is mostly in Wyoming, it also straddles the two states of Montana and Idaho. It consists of 3,400 square miles (2.2 million acres) of true wilderness and was the World's first national park, having being founded by President Ulysses S Grant in 1872. If like me you have difficulty comprehending what the area relates to, it's a bit more than 40% the size of Wales!

It's different from any of the other parks I have been to for several reasons; the first being that once up to the top of the mountain, it is fairly flat, or at least the west side is. A good part of the east side was still closed during early May, but as the Park is enormous there was still plenty to see. The park sits on the Yellowstone Caldera, a super-volcano and the largest on the continent. The volcano is still considered active as it has erupted

several times in the last few million years and is capable of producing huge volumes of lava and ash, enough to block out the sun and cause a mini ice-age.

Another great difference were the hot springs all over the place, with steam escaping against a backdrop of the snow that was still very evident. The springs had formed pools with a soup of minerals making them milky white, yellow and red, though there were one or two blue pools, the shade of swimming pool paint. Walking near them was extremely dangerous as the surface crust is usually very thin and weak, but many people have ignored the warnings on the signs and in the literature. There have been far too many cases where they have fallen through the surface and been scalded to death and, as the terrain is also continually changing, new springs can pop up anywhere.

The odour of sulphur permeated the air, sometimes as strong as the "rotten egg" smell that every schoolboy would recognise, and sometimes fainter like a spent firework. Sometimes the smell was so strong you could taste it. The chemical also gets into the streams and rivers so that where rocks churn the water, the whitecaps are tinged yellow, as are the waterfalls.

Some years ago there was an earthquake in the Park and, despite all the wide open spaces, knowing that just below the surface of the ground was scalding water and chemicals, all potentially about to erupt around you or on you, must have been terrifying.

I drove on through the primeval landscape, enjoying it immensely as I had never been anywhere like it. Going around a left hand bend, I could see that some way up ahead something was happening, as the cars on both sides of the road had stopped and, as it looked like an accident, I slowed down. I could see that there was something black and tan blocking the opposite side of the road and I was very concerned, as I thought that it was bears. I wouldn't want a close up meeting with a hungry bear even if I was in a car, let alone on a motorbike, and I dropped down to first gear

ready to turn around. I drove on a little way and knew that I was unlikely to be able to do a U turn on the narrow road, so checking my mirror for traffic behind I started to brake, as it was getting to the stage when it would be too late. If the bears wanted to catch me, the short distance between us would cause them no problem, but I then realised that the animals weren't bears at all but buffalos, maybe descendants of Charles Goodnight's herd. There were five of them and they were wandering along the road toward me, unconcerned by the traffic around them. They were beautiful creatures, but the dark fur on their massive heads hid their facial features, and it wasn't until they were very close that I could make out their enormous and incredibly dark eyes. We passed each other with me travelling a little faster than they were, ready to accelerate if need be. The lead animal turned its head toward me as it walked and whilst it gave no indication that it was worried, I knew they were wild animals, basically a 2,000lb weight with horns on the front and capable of travelling at 30mph. A lot of people have been seriously gored by buffalo, and I even heard of one case of a man trying to put his young son onto the back of one in order to take a photo before Rangers stopped him.

I had several encounters with the animals that day, but most times they were quite skittish when approaching from them behind and went into a mini stampede. Whilst passing through road works I came up behind one pair that had two calves no more than a few days old, the colour of Jersey cows. Although they were already trotting along when I approached, the road suddenly got very rough with lots of loose stones and big ruts. I had no choice but to accelerate the few feet to the smoother road or I was at risk of being thrown off the bike. The animals reacted badly to the engine noise and really bolted, though fortunately they ran to the left, for if it had been the right I would likely have hit them.

Despite driving at a low speed, I was making full use of the road so that I could look as far round bends as possible to avoid more surprises. Leaving a blind right-hander, I could see that

there were crowds of people lined up along the right side of the road, with everyone looking to the left, pointing cameras and binoculars at something. It took me two glances to see what the great interest was and I couldn't believe I had missed the brown bears on the first look. There were two of them, only around 100 feet away, across a tiny stream and gorging themselves on what used to be an elk, or at least that's what someone told me it was later on. At that distance it was impossible to tell from what was left. I found a space to park the bike, which wasn't easy because there were so many cars, RVs and pickups already in the lay-by, and I got off to take some photo's. Even on full zoom, the bears' distance was too great to get a good picture with my digital camera and, by the time I had extracted the other, complete with zoom lens from the pannier, one of the bears had wandered off, probably to find the cubs that I had been told were nearby. The remaining animal seemed shy, for he kept his back to the crowd the whole time and whilst I did get a few shots, they weren't great. He continued eating for a long time, I am sure to the dismay of a few crows that were hanging around waiting for their turn at the carcass. Of course, it was no accident that the bears happened to be eating right opposite a big lay-by, as the Park Rangers had no doubt provided this picnic, and were also in attendance in case the bears felt like a spot of desert. In reality the animals were probably more sensible than some of the people there, and whilst they wouldn't have crossed the stream, I'm not so sure about all the visitors, if the Rangers hadn't been there to stop them.

It was a great feeling to have seen bears in the wild and I would have loved to have seen a few more of the hundreds of other animal species in the park. Time was ticking by though, and I still didn't trust the weather to be good to me, so after a few minutes I pushed on. There was a particular place I wanted to reach within the park and it was still some way off.

Old Faithful is over fifty miles inside the Park from the north entrance and I prayed that the nearby petrol station marked on the map would be open, otherwise I would be in trouble.

Fortunately, it was and so was the nearby café, so after a real fast food lunch that took an age to be served, I rode on to the geyser. There were lots of benches facing the natural phenomenon, and they were occupied by Japanese, Dutch, German and even a few American tourists. Oh, and one Englishman of course. I sat there with everyone else waiting for something to happen but Old Faithful just steamed away, sometimes a little and sometimes a lot. It was not the only geyser in the area however, and we were lucky enough to see one of the furthest neighbours erupt, spouting something like fifty feet into the air. All around the cameras clicked and whirred as people captured the event and waited patiently for Old Faithful to do its stuff too. In modern times it erupts around twenty times a day, spouting out between three and 7,000 gallons (14,000 to 32,000 litres) of water with an average height of 145 feet. The time between each eruption depends on the length of the last one and can be predicted with a good degree of accuracy. If the previous eruption took place for less than 2.5 minutes then it is likely to be around sixty-five minutes till the next one, but if it lasted more than 2.5 minutes it's likely to be ninety-one minutes. Apparently it has sometimes been used as a laundry and General Sheridan's men noted in 1882 that if cotton and linen garments were placed in the hole they would be ejected thoroughly washed whereas woollen items would be torn to shreds.

There were a lot of patient people that day, just waiting for that next event, but I could feel that the temperature was dropping again as there was a pretty unpleasant looking weather front coming in from the west. I didn't dare wait any longer and, as I climbed back on the bike, the snowflakes started to fall slowly, but the sky was threatening and I didn't want to hang about any longer than I needed to.

The snow was wet, closer to sleet than real snow and it obscured my vision as it fell on my helmet. I opened the visor to see better and the wet stuff stung my eyes and face. It wasn't coming down heavily though, and I could keep the windshield clear on the left side by wiping it with my left hand every minute or so. If this was the worst I had to face, it really wasn't much of a problem. The road that went to the east exit of Yellowstone was closed, so initially I had to take the same way back as I had come on the way in. Around ten miles away from Old Faithful was a turning leading to the west gate, which would have taken me down out of the mountains sooner, but west of where I wanted to be. I took the decision to press on, back to the north exit and, a couple of miles further on, I could see that the oncoming vehicles were getting whiter and whiter. First it was just their bonnets but then the roofs and the radiator grilles too. The sleet had changed to dry snow and fell more and more heavily, until I could hardly see ahead of me. I knew then that I should have taken the west exit when I'd had the chance, but if I was to turn around I would have to backtrack along the part that I had just covered, and there was no guarantee that the west exit was any clearer now. I drove on, now unable to see through the windshield as it was blocked with packed snow. I couldn't keep it clear no matter how many times I wiped it with my soggy wet glove and I had to peer round it. The car in front was going too fast for my liking but provided a good target to follow, just as long as I didn't drop too far behind and lose sight of its tail lights. Time after time, I wiped the speedometer glass to see how many miles I still had to go through this purgatory, and although the progress seemed painfully slow, the miles travelled up and the distance to go came down. That may sound like I was stating the obvious, but I really felt threatened in this weather. The roads were slippery, I had poor visibility and I was truly worried.

The vehicle in front of me stopped in a lay-by and I had to go on without it as a guide. Arriving at road works that I had passed

earlier, I was at the front of the queue and a man stood there with a "Stop" sign, as I gently came to a halt next to him. He looked a little odd in his appearance. He was tall, with a brown, waxed cotton full-length coat, hide gloves and his obligatory white hardhat. I could see that underneath the hardhat he had a red ski hood and, although I couldn't see his hair, his beard was ginger and he had incredibly bright blue eyes. With his sign on a long pole he looked like a cross between a "lollipop lady" controlling the traffic for school children, and the outlaw Josey Wales. I smiled and said, 'This isn't much fun is it?'

He smiled back and replied, 'Well, this is May, it's Montana and you're over 7,000 feet up. You're going to see snow.' I suppose he was right except that we were just inside Wyoming. He kindly wiped the snow from my windshield and then spoke to his colleague at the other end of the road works by use of a radio. The oncoming traffic had passed and he turned the sign to read "Slow" waving me on. Just after the construction work, I pulled over to let the cars behind me pass and give me something to follow again.

The road was now covered, except for the tracks of the vehicles in front, though sometimes even they disappeared under the white blanket and I could feel the rear wheel skip to the side here and there. It was difficult to compensate whilst peering round the edge of the windshield as I was very off balance, but was glad that I had a new rear tyre as I'm sure the tread helped and the bike pretty much corrected itself on most occasions. Where the road was completely covered, the drivers in front often lost their perception of the road edges and shifted toward the centre. More than once I found myself in the left of their two tracks and near the road centreline, making me perilously close to oncoming vehicles that were also tending toward the middle. It was very, very unnerving.

The scenery wasn't important now, though I couldn't see far anyway. I could still smell the sulphur as I passed the hot springs and taste again the pungency of the fumes. The bears were

nowhere to be seen and the elk carcass had only three crows perched upon the rib cage, they too apparently had had their fill and they sat hardly moving. Maybe it was the snow that had them so motionless or maybe they saw this as their chance for their own photo shoot, for there were still a number of photographers standing, talking and probably waiting for the snow to subside before leaving. They, of course, had nice warm vehicles they could climb into for shelter, though to be honest, I wasn't finding it cold despite the temperature gauge reading only thirty degrees. I guess the sheer effort, concentration and fear was keeping me warm.

Eventually, finally, it stopped snowing and the road reappeared. Descending the mountain, the temperature came up and, by the time I was back to Livingston, it was fifty degrees. It felt positively warm and good to be on the road again. Although it was late afternoon, I decided to head further east for an hour or so. The scenery was similar to the day before with distant snow-covered mountains, but they had somehow lost their appeal. I have seen a list of translations of the words that the Inupiat Eskimos have for snow, which totals thirty. I had a few of my own after that experience, though mine were mostly adjectives.

That evening was the only time on the whole trip that I had problems finding an hotel, regardless of price. There were concerts and conventions in the local towns that were attracting thousands of people into the area, and I was forced to ride around for a couple of hours before finding refuge. It didn't matter, but it once again brought home to me that it was a wise decision to travel out of peak season, for a lot of time could have been wasted otherwise.

In my warm motel room, I took out the maps for the usual nightly study; the flatlands of the Great Plains lay before me for the next couple of days and I was looking forward to seeing them.

Most of the way I took I90, which veered south after Billings and provided me with the opportunity to visit the site of the Little

Bighorn. I didn't remember seeing any movies about the battle, though I am sure that there must be some, and I doubt that the event is taught in English schools, it certainly wasn't in mine. Yet, there cannot be an English schoolboy who has not heard of it and that it was "Custer's Last Stand". Being ignorant of the events that caused the demise of Colonel Custer, over 260 of the soldiers under his command, as well as an undetermined number of Indians in the two-day battle, I was glad to learn about it.

The cause for the conflict was, of course, the complete disregard the white man had for the native Indians' nomadic way of life. Representatives of the USA Government signed a treaty in 1868, designating an area in eastern Wyoming as a reservation for Lakota, Cheyenne and other tribes, though it was done because it was believed to be "cheaper to feed than to fight the Indians". The agreement promised to protect them from all that would do them wrong, but the peace was short-lived because in 1874 gold was discovered in the Black Hills that lay in the reservation, prompting thousands of fortune hunters to ignore the treaty and pour into the area. At first the army tried to uphold the agreement by keeping the gold diggers out, then the Government tried to buy the hills from the Indians, but the tribes wanted the treaty upheld. The Lakota and Cheyenne started raiding settlements and travellers in protection of the lands that the white man had "generously" agreed were theirs and, in defiance, the raids extended beyond the borders of the reservation. In December 1875, the Commissioner of Indian Affairs set a deadline of January 31st for the Indians to return to the reservation or be treated as hostiles. Not surprisingly the Indians didn't comply.

There were actually three separate expeditions in the campaign against these tribes that were under leadership from Sitting Bull, Crazy Horse and other chiefs. General George Crook led the first from Fort Fetterman in Wyoming, but was defeated in battle and forced to withdraw.

Colonel John Gibbon from Fort Ellis in Montana and General Alfred Terry from Fort Abraham Lincoln in Dakota, were to converge on the Indians at the Bighorn River. General Terry ordered Custer to approach from the south and he himself would approach from the north with Colonel Gibbon's forces.

Custer and the 7th Cavalry of around 600 men found the Indians on June 25th and it would seem that he underestimated the size of the settlement. He divided his regiment into three battalions, each consisting of four companies. One company was assigned to guard the pack train, he kept five companies under his command and the other six were split equally between Major Marcus Reno and Captain Frederick Benteen.

Reno was ordered to cross the Little Bighorn River but he was hopelessly outnumbered and had to retreat to the bluffs back on the other side. Benteen joined him on orders he'd had from Custer, but Custer himself had taken his men north and was never seen alive again. It's unclear what his intentions were, but again he was heavily outnumbered and every man under his direct command met their doom. The Cheyenne Chief Two Moon recalled the battle later and said "The shooting was quick, quick. Pop, pop, pop, very fast. Some of the soldiers were down on their knees, some standing... The smoke was like a great cloud and everywhere the Sioux went, the dust rose like smoke. We circled all around him, swirling like water around a stone. We shoot, we ride fast, we shoot again. Soldiers drop and horses fall upon them".

It was a very well worded description I thought, and whilst the Indians were jubilant in the victory of the battle, they did of course lose the war to keep their traditional way of life.

There was a viewing point down onto the battle area and white stones represented the positions that soldiers fell, although there were none for the Indian warriors because their tribesmen removed their bodies, before the positions were recorded. Looking down on the hillside was like looking down on other battlefields

which have been kept as monuments to those who died in the conflict. There wasn't much to see.

Incidentally, the number of soldiers that died on those two days was slightly higher than the number of British troops that died in the Falklands war.

I took US212 on to Sturgis, the town where one of the USA's biggest motorcycle meetings happens every August. However this was May and the town had little to offer – well, nothing really. It was about as uninteresting as a town can be and it's hard to imagine what the place is like when hundreds of thousands of bikers have descended on it, let alone how Sturgis became the venue for such an event. I drove around it on the Saturday night that I arrived, and also the Sunday morning that I left, but could see nothing to explain it. No doubt there are books on the history of the motorcycle meeting, and how it has grown each year to something that attracts motorcyclists from all over the USA and beyond, but I didn't feel inclined to research the subject.

The bike was due yet another service and I had hoped to get it done there, but the Sturgis Harley Davidson dealer doesn't even offer maintenance. Incredible really, as it is such a big biking place. Instead, I headed down to the dealership's mother company at Rapid City and, on the way, had first hand experience of how dry the area was, for along the roadside there were fires, probably started by drivers throwing lighted cigarettes out of their windows. The weather was presenting such contrasts; it was extraordinary.

www.onebritonebike.com

CHAPTER TWELVE
THE END OF THE ADVENTURE

I struck lucky again and the dealership was able to do a service while I waited, another plus point for making the journey at this time of year.

I passed the time talking to other customers and to one of the staff, Tony, who told me of how in the 1970s he had been badly hurt in a motorcycle accident, and had lain for weeks in a hospital bed with a broken up body. One of the nurses persuaded another patient to befriend him, because he had been through a similar experience and she thought that he could help with the mental shock of it all. Tony reacted badly though, because the other patient was a Sioux Indian and he had been brought up to believe that all Indians were "lazy good-for-nothings". The Sioux didn't give up and eventually Tony allowed the man to push him around in a wheelchair, then help him on crutches, and finally progress on to accompanying him on short walks. He realised what a bigot he had been, but had a chance to repay the debt because, before he left the hospital, a black man was brought in with similar injuries to those he had suffered. Tony experienced first hand what it was like to have the offer of help rejected, for the new patient had been brought up in south Chicago, an area heavily populated by blacks. The prejudice against whites was all the man knew and Tony's advances were very unwelcome. Like the Sioux, Tony persisted and the result was very similar. He had then gained from knowing that he had helped someone, whose racial feelings had been altered, just as his own had been. Now his prejudices are a thing of the past.

I liked the story, but hoped that Chicago had changed since the 70s, as Beatrice lived on the south side and I was going to be there a few days.

Weather was still something that I was aware of as I climbed back on the Ultra. The radio had told me that there were blizzards

through Snoqualmie Pass, the place I had ridden through two days before, and the Deep South was again experiencing tremendous rain and floods. Fortunately for me, the part of South Dakota that I was now travelling through was forecasted to be cool and dry, so instead of keeping on the Interstate I joined US44 which ran almost parallel to the highway, but between twenty and thirty miles to the south.

The area is known as the Badlands and some of the terrain was really strange. It's situated mostly to the south of the Missouri River and has little quality soil, so little vegetation. The land has a thick crust making it harder for rain to penetrate and therefore exacerbating the lack of plant life and leading to the name of The Badlands.

The weird contours made me think that I was riding along the tracks of a giant printed circuit board as the land on both sides of the highway had been eroded, resulting in gullies and high points, like the legs of components that were sticking through the board but had been badly soldered. It was such a strange sight, but would have been great fun for trail and mountain bikes, providing as many obstacles as the rider would care to tackle. To add to the bizarre effect, the sky was amongst the most unusual I had ever seen. It seemed to be completely covered with cloud and there were lines and swirls in it that gave the appearance of a knotty piece of pine. On the occasions that the road took me below the "knots" I could see blue sky through them, as though the knots had been bored out of the wood.

In the better areas, it was farming land and I could again detect the smells that told me so. Sometimes there were fifty to sixty miles between the towns, so I would guess that the farms were enormous, with thousands of acres in each of them. I was aware of the distances between petrol stations too, and made sure that I filled up at every opportunity, which on one occasion gave me a

chance to look at something that I hadn't yet seen on my travels. For whatever reason they had chosen this venue, there was a group of adolescent boys at one of the garages, all wearing cowboy hats and practising their lasso skills, which were incredibly impressive. Admittedly they were only targeting stationary objects, such as posts and the handles of a cart, but the accuracy they displayed was amazing. They saw me watching, but didn't start a conversation and I didn't want to interrupt their fun, so after a while I rode on, reluctant to leave them but glad that I had experienced the sight.

I stopped that night at a motel in the small town of Parkston. The place had been extended with a new wing consisting of very luxurious rooms and, as the owner was a biker, he allocated me one of them, but at the same rate as the older and cheaper accommodation. We talked for a while about how long he had owned the business, why he had bought it, and bike-related matters. He surprised me when he said that although it was over 300 miles to Sturgis, during the August Bike Week, he would be completely full with people attending the event. I doubt that Daytona would fill places that distance away, though there are probably a lot more hostelries closer to Daytona Beach than Sturgis.

Again the weather was still the driving force to push me forward, for I seemed to be keeping ahead of the front that was chasing me east. I had set a destination of Milwaukee, or to be more specific, the Harley Davidson factory and, whilst I had plenty of time to get there, I pushed on as best as I could.

I'm not going to go into the long history of the company because if you are a Harley person you probably know it better than I do. If you're not HD inclined, then you probably had enough of me talking about Indian's sad story. What I will say however, is that there are certain parallels between the companies, for not only are

they American manufacturers of big twin motorcycles, but they were both brought to the brink of collapse by their owners. In Harley's case, they were acquired by an organisation called AMF in 1969 and, through the leadership of this company and pressure from the Japanese manufacturers, the market share dropped from over three quarters in 1973, to less than one third by 1980. In 1981, AMF decided that it was time to sell the company, not least because one of their own directors issued an internal memorandum recommending it, though his motive was that he had already organised the team and finances for a management buy-out.

The company was sold to the management team, though they were about to experience their toughest times yet. They no longer had the safety net of a cash-rich organisation behind them, demand took a steep dive and the Japanese discounted their bikes in response to the market conditions.

Interestingly enough, the new owners of the company responded by utilising the same quality procedures that the Japanese already employed, the result being that it drastically reduced costs and improved quality. There was still a long way to go though, and in 1985, Citicorp, one of their biggest financiers, decided that enough was enough and called in the debt. Fortunately, the Harley Davidson Board of Directors had seen the threat coming, and organised replacement funds just days beforehand. The company was saved but only just in time.

In 1986 the Board then took the brave step of going public, which the company hadn't been since AMF owned them. Had the flotation gone badly, the company would have been sold to the Public for less than the Board had hoped, and there would have been less to pay off the financiers. As it happened, the success story of the American Icon had captured the interest of the Public so much, that $90 million was raised, which helped to reduce the borrowings as well as buy another company that manufactured motor homes.

266

Of course, since then Harley Davidson have gone from strength to strength, with a continual stream of new models, the formation of Buell, and a renewed growth of interest in motorcycling. At the time of writing this, Harley are enjoying the publicity from the set of financial results of the last quarter, where they saw a near-on 20% increase in sales compared to the same period last year. Quite some growth.

There are actually two factories in Milwaukee; well, three if you count Buell, which is just down the road. The main plant on Capitol Drive accepts visitors, but the other one eight miles to the north, and Buell, unfortunately do not. The tours take place three times a day on three days of the week, but I managed to arrive on one of the other days and was turned away!

I was feeling a little hacked off at this and the ever-nearing end to my adventure took my appetite out of having a look around Milwaukee. Instead I opted to return to the hotel to catch up on some writing.

So the following morning, I turned up for the earliest tour that would take place that day, and parked in the special area outside the front of the building. It was a nice morning and many staff had ridden their own machines to work, so my Ultra wasn't alone, even if it looked dirty and dishevelled amongst all the others.

I regretted not stopping at Starbucks, which was just down the road, as I wasn't able to get a coffee in this reception area either; this time because the machine was broken. As you might expect from such a large company, there was however plenty to look at, with various bikes on show and the opportunity to buy items of clothing that were not available through normal sources. In California, Scott had told me that it was the only place that the special blue sweatshirts were available, but they had been discontinued, so I bought him and Dale T-shirts instead. Again it was a small gesture but I hoped that if I made enough of them, they would go some way to repaying their kindness.

A crowd of visitors had assembled and the tour commenced with a couple of videos being shown. The first featuring Willie G Davidson himself and, if you know of him, you won't be surprised that he was wearing his beret, and then Erik Buell, who was overflowing with enthusiasm for the brand he had started.

The second video was a technical one, and for those not turned on by the sight of machines doing their work, they would have likely been bored stiff.

From there we got a walk around part of the factory, but there was not a complete motorcycle to be seen, for this plant only produces engines for the smaller bikes, whereas the one nearby makes them for the big tourers. However the numbers were impressive as 1,100 units a day are turned out, with thirty of them going to Buell and the remainder being sent to the assembly plant in Kansas. Included in those figures are the engines that have been sent back for reconditioning, though it is a very small part of the work. In addition, the nearby facility produces a further 260 big motors a day, so allowing for something like a 200 day working year, Harley are turning out over a quarter of a million bikes a year, and all but 11% are for the home market!

Everything was better organised than the trip around Indian. We were divided into parties and issued with headsets, so that we could hear what our guide was saying whilst he led us round clutching a wireless microphone, and this time "the rear" was taken care of by another member of staff, to ensure no stragglers.

Again, it would have been nice to have something in the way of a handout with facts and figures, as well as some pretty pictures of various bikes, but there was nothing. In fact, the tour sort of fizzled out when we left the factory area and, after a short talk with the guide, I found myself looking at the exhibits in the reception area again.

I also got into a conversation with a man in his fifties, who was visiting because his son worked in the Development Team, also

based at the facility. William had never ridden a bike in his life but had gained an interest through his son, and was now considering buying a big touring machine and making a journey like I was doing. Many people had thought that I was daft enough to do my trip, but I at least had many years of biking under my belt. I suppose it reinforced what I said right at the beginning of this book, in that the American biking scene is very different and the average age of bikers is older, but I just couldn't get the image out of my mind, of this very personable man, sat on an Ultra Classic with L plates attached. Good luck to him. I hope he does it.

He asked me about my experiences along the way, if I had enjoyed myself and had people treated me well. I told him that I'd had immense fun and, with one exception, everyone had been fantastic. He paid me a great compliment with his response, as he told me that people's attitudes toward me probably reflected mine toward them and, after I thought about it, I decided he was probably right. I really had enjoyed the adventure and my enthusiasm most likely had prompted positive feelings in those that I had met along the way. It was a very nice thing for him to have said though and it has stuck in my mind.

I left the factory and took I55 all the way down to St Louis, a trip of around 400 miles. I planned to meet up with Vicky, a British friend who had been living in the States for a year. She had originally flown to New York on holiday and whilst there, visited the American Headquarters of the German company that we both worked for. They were kind enough to show her round and when she left she joked with them that if they ever had any jobs going, they should give her a call. Three months later the phone rang and she was offered a job, pretty much on the spot, doing the same sort of thing she had been used to in the UK but on much more money. It was an offer she couldn't refuse.

It took a while to make contact with her, mostly because she was out of her apartment, arranging to sell her car and ship her

things home, as she'd had enough of America. I was very surprised to hear it, but whereas I had been touring and having a fantastic time, she was finding that there was too little work to keep her occupied, it was difficult to find friends of her own age, and her boyfriend was still in England. I thought back to the conversation with William and wondered if Vicky had done all she could to attract people to her. I know from my RAF days that if you land in a place and don't make the effort to integrate then it won't be long before the people around you give up inviting you to anything they have organised or planned. Maybe Vicky was a bit shy with her different background and hadn't gone out of her way to make friends. Nevertheless, I really had been lucky to catch her whilst still in the country, but I was less lucky with the weather, with rain that poured incessantly for the two days I spent with her. There wasn't much of an opportunity to do any real sightseeing, though she did take me down to see the St Louis Gateway Arch, a magnificent stainless steel structure standing 630 feet tall, but looking vaguely like one of the famous McDonalds golden arches that make up their trademark. The engineering of the structure was incredibly impressive, though it was apparently forecasted that thirteen people would lose their lives in its construction, and I question how ethical it is to undertake such a project with that sort of statistic on hand. Fortunately, it was completely erroneous and nobody perished, with the arch being completed in 1965 as a symbolic gateway to the west.

St Louis is seen as the Gateway to the West because in 1803, President Thomas Jefferson commissioned Merriwether Lewis and William Clark, to lead an expedition to find an overland route to the Pacific Ocean. The party left on May 14th 1804, from nearby Wood River and headed up the Missouri River, then on across South Dakota, into North Dakota where they spent the winter. The following spring, they continued on the Missouri but eventually had to proceed on foot, though they were lucky when Shoshone

Indians helped them along the way by providing horses and a guide to cross the Bitterroot Mountains. They met some more friendly Indians with whom they left their horses and continued on the Snake, Clearwater and Columbia Rivers until they reached the Pacific in November 1805, where they again waited for spring to come, before returning home in 1806. The trail they set out is approximately 3,700 miles long and passes through Illinois, Missouri, Kansas, Iowa, Nebraska, South Dakota, North Dakota, Montana, Idaho, Oregon, and Washington. A trip that would be worth repeating on two wheels, I thought.

I still had time to kill before heading back up to Chicago and I decided to head southeast into Tennessee. I toyed with the idea of going to Memphis and a trip to Graceland but instead chose to look at Nashville. Maybe I would be converted to Country Music, though it seemed unlikely. The Weather Channel reported more doom and gloom of an earthquake and severe brush fires in southern California, as I headed off under dry but threatening skies. Most of the way to my destination I could see that I really was in the wet South again, as the Mississippi had burst its banks in many places and the floods were evident just feet from the road.

Whilst not a fan of Country Music, I had hoped that I would be continually exposed to it for, after all, Nashville is the Country Capital of the world. With the exception of the radio stations, it was strangely lacking, and not even the Grand Ole Oprey was open during the week. I was disappointed, but my spirits were lifted when one of the male staff at the KOA told me of a free concert that the campsite was hosting that night. He said that he had seen the Holker Sisters and they were "very cute", so you might understand that I was a little worried to find that they were aged eighteen, sixteen and the youngest a mere fourteen. Of course this was the Deep South and some States allow people to marry under the age of fourteen, but it has to be said that they have the Court's permission of course! Good grief, marrying at that sort of age is appalling.

The girls were amateurs who were staying on the site, along with the rest of their families, totalling two parents and no less than nine children! I started to see them as the Von Trapp Family from *The Sound Of Music* and, to my amusement, the impression was strengthened when one of the girls started yodelling. Don't misunderstand me, they were entertaining but it was unfortunate that I was the only member of the audience who was laughing, so you can imagine how difficult I found it when two of their young brothers came on stage and sang *Edelweiss*. I was having to bite my hand to prevent myself laughing out loud, and was glad to be able to join the rest of the crowd as they gave a friendly chuckle, when two of the youngest sisters came on, and Mum had to remove chewing gum from the four-year-old's mouth before she started singing. I am just so grateful that they didn't all come on stage at once and do any other numbers from the musical. *Lonely Goatherd* or *So-Long, Farewell* would have been way too much for me.

I didn't have a set route when I left Nashville, but decided that I would drive through Kentucky, Indiana and into Michigan before heading down again into Chicago. I was conscious that if I did too many more miles, the bike would be due another service before I came to sell it and it would be a waste of money. If buying or selling a Harley in the USA, it is interesting to note that the service history doesn't mean much, so I was only doing the servicing to comply with the extended warranty. The chances of anything going wrong within the few extra miles I would do outside a service interval, seemed low, and I decided that I would take the chance if need be.

The ride north was a pretty one, through areas that very much reminded me of parts of the UK again. I believe the farms were Amish and I was disappointed not to see any of their people travelling around on horse-drawn carts. I was however surprised that I saw a Greyhound bus; I believe the only one on the entire trip.

Eventually I found myself back in Illinois, having now set foot in twenty-four States, and I booked into a private campsite in the outer suburbs of Chicago. It was a cheap enough place but the showers and washing machines used water from their own well, and the stuff stank. I was convinced that I came out dirtier after a shower than I had been before, and had to use copious amounts of deodorant to cover the residue left by the smelly water. However I only planned to be there for a few nights, whilst I sorted out selling the bike, and then I could link up with Beatrice for the last few days. I phoned her the next day to let her know my plans and headed off to the library.

A search on the Harley Davidson website provided me with the addresses of the local dealers and I sat in a Starbucks, working my way through a couple of caramel mochas, marking the places on the map that I had bought, showing the districts of the Chicago area. There were quite a number of dealerships, but the ones near the city centre didn't sell bikes, so I concentrated on those that were on the south edge of the town and therefore close to where I was. I came up with three likely places that could be interested in buying the bike and worked out a route plan.

In the afternoon, I found a carwash that gave me the facilities I needed to make the bike prettier, and spent a few hours cleaning and polishing it, as the last three months had taken their toll on the machine. There were far more scratches than when I started, the front tyre was illegal, the wheels were definitely looking tatty, the screen was losing patches of the laminated surface, and I had damaged the rear seat with the bungee cords I used to strap the luggage on with. Worst of all were the gouges in the fairing from when I had dropped it in California. I could do little about most of these things, but the Ultra certainly looked a lot better after a good clean, and I hoped the dealers that I would be calling on would think so too.

I started with the agent who was the furthest out of town of those I had chosen, and rode over in the morning. As soon as I

walked in the door, a salesman strode over and asked if he could help me with anything, as they often do outside Florida. I told him what I was there for and his response was almost a sneer, as he told me that they don't sell bikes on commission. I explained that I was looking for an outright sale of the bike and he walked off to find his boss, before going outside to have a look over the Ultra. When he came back he was still sneering and told me what an awful state it was in, but they were prepared to give me $13,000. I have to admit that I didn't like the figure, or him for that matter, and I declined the offer. There were still two more places to go on the original list after all.

The next one was worse still as they were just not interested in buying any bikes and would only sell on commission. The problem with that was that I needed a quick sale and that was less likely on a commission basis. I fired up the Ultra and found my way to the district of Crete and the last agent on my very short list. The Sales Manager, Tom, was a tall and enthusiastic individual who gave the bike a good looking over before disappearing into his office to work out the figure that he would offer me. When he came back again, he showed me his calculations and offered me $13,868, so the deal was done. I told him that I would drop the bike in the next day, and Tom agreed to give me a lift to the station when I did.

In the morning, I loaded up the motorcycle for the last time. Finding Beatrice's place took a while, as the long road that she lived on had been closed in several places, and the one-way system was sometimes difficult to work out. As usual, whenever I stopped to look at a map, a local would come along and attempt to help, but the best bit of advice was from a postman who explained to me that as the apartment number was 4722, it meant that it was on the block just south of 47th Street. This may be obvious to city dwellers but it wasn't to me, and everything suddenly made such good sense, meaning I found the place in no time at all.

I unloaded the bike and headed back to Crete, parking up outside the front door. As I did so, two motorcycle Cops pulled up

next to me and I was dreading them taking a look over the bike, lest they should spot the state of the front tyre. I hurried into the shop in case they wanted to strike up a conversation and Tom was standing there waiting for me. They arranged for a cheque to be written and, whilst they did so, I returned to the bike to take off the licence plate, a lasting memento of my horse with no name. The exchange of documents for the cheque took no time at all and, when I turned to look out of the window, the Ultra was already being driven round to the workshops. I felt guilty because I didn't feel guilty, if that makes sense. I had done 14,127 miles on the machine and was happy to hand over the keys for the thirty pieces of silver they gave me but, after all, it was only a machine and I had two more bikes waiting for me in England. You know, I hadn't even said goodbye to the Ultra.

The owner of the dealership took me to the station and, as he did so, he told me that they sell a bike a day, so mine wouldn't be with them for long. He asked me what I'd paid for it in Daytona and I told him. He expressed his surprise and said that he thought the price was below the book figure, which got me feeling all warm and rosy towards Daytona Ron again.

As I got on the train, I realised that all my encounters with this particular mode of transport over the last few months, had been with the freight variety. I hadn't seen a single passenger coach up until that point, but that one made up for it as it was a double-decker affair, similar to a bus.

However, although I had done a fairly reasonable deal on the Ultra, I felt depressed as I really was coming toward the end of the journey now and the great adventure was coming to a close.

The last few days were spent with Beatrice, her brother Leo, her sister Debbie (not to be confused with Californian Debbie) and of course, Beatrice's son James. It was a nice way to finish the trip as they made me more than welcome, even if at times I couldn't always understand the conversation as they lapsed into their native Creole whenever they were at home.

Debbie acted as my guide for most of the time, showing me around the city, and we got on amazingly well from the minute we met, as though we had known each other for all our lives. It is extraordinary how you can just "click" with some people.

Chicago is a huge sprawling place with over 2.8 million inhabitants. It has some pretty major names as the main employers in the area, such as Boeing, Walgreen, Sears and Motorola, and the impression I got was a modern, and mostly well looked after place though that was probably due to Debbie ensuring I only got to see the good side. When I asked her if there was a museum or something similar dedicated to Al Capone, all I got was a blank look; indeed I got the same sort of reaction from her sister and brother. I was sure that I hadn't been mistaken as to the city that the famous gangster had made his home. Another one of my father's favourite TV shows was *The Untouchables* and I was convinced that in the Show Elliot Ness had been fighting "Scar Face" on the streets of this town. Didn't the film with Kevin Costner, Robert DeNiro and Sean Connery take place in the streets of Chicago? Surely there was something that recognised the fact.

We looked through all the directories and tourist guides we could find but there was nothing that indicated I was correct. I had to accept that I had been wrong and the infamous gangster had terrorised some other American city.

It was much later that I was told that I had been quite correct in the location of Mr Capone's activities but the City Authorities are embarrassed by the history and choose not to capitalise on the grip by what must be one of their most famous inhabitants. There is no museum or official tour of Capone's gangland activities, though there is an unofficial tour operated by some enterprising businessman.

I think it's quite extraordinary and a real shame, for although the gangster was an evil and vile individual, he is an important part of the City's background.

He was actually born in New York in 1899 and was expelled from school at the age of fourteen. From there, he did various jobs around Brooklyn and mixed with some very unsavoury, but influential characters and gangsters, including one Johnny Torrio. Fourteen is a young and impressionable age and maybe things would have turned out differently had he not met such people.

After being involved with some small-time gangs, he was employed by a gangster by the name of Frankie Yale to work as a barman and doorman at one of his dance halls. It was there that he got into a fight and ended up with the scars on the left side of his face, giving him the obvious nickname of Scarface.

It was when he was in his early thirties that he and his family moved to Chicago where he officially sold used furniture, but in reality had been invited by his former mentor Johnny Torrio to take advantage of the bootlegging opportunities open in the times of the prohibition. It may well also have been that he was instructed to flee New York for it is believed that he had killed two men, though he was never tried for it due to lack of people who would give evidence against him.

His power and organised crime organisation grew quickly, partly due to "acquisition" of existing activities, and he soon controlled a huge proportion of the Chicago underworld. Certainly some of this growth was due to him taking over Johnny Torrio's businesses when the man was shot by rival gangsters and decided to leave Chicago. Capone's fingers dipped into all sorts of illegal but profitable enterprises including gambling and prostitution, though an enormous amount of the revenue came from the bootlegging (a term that describes the hiding of illegal material in the legging of boots). Indeed it is widely reported that his income from the activities in the mid to late 1920s amounted to $100 million annually.

Capone had his enemies, including Hymie Weiss and George "Bugs" Moran. His car was often riddled with bullets and, on one occasion, a convoy of ten cars drove past The Hawthorne Hotel

where Capone and his gang were eating lunch. The occupants of the cars sprayed the hotel with bullets and several bystanders were injured, including a boy and his mother who would have lost her eyesight had Capone not paid for the best medical care they could get.

The attacks on his life were numerous and it prompted him to add bullet-proof plating and glass to his Cadillac. Later the Treasury seized the car and President Roosevelt used it as his personal limousine.

Whilst the City's Mayor did business with Al Capone, he decided that it was bad for his political image and appointed a new Police Chief to run the man out of town. Capone bought a place in Florida and continued to run much of his organisation from there. He was often the victim of murder plots but because he had such a well-organised network of spies, the plots were never successful, and conversely he was well skilled in murdering his enemies from afar.

On 14th February 1929, four of Capone's men committed the famous "Valentine's Day Massacre" when they entered a garage at 2122N, the building actually being the headquarters of bootlegger Bugs Moran's north-side gang. Two of Capone's men were dressed as policemen so the seven occupants of the garage laid their guns on the floor and put their hands against the wall. Their opponents using two machine guns and two shotguns quickly gunned them down. Six of the men were Moran's gang members and the other was an unfortunate visitor. Moran wasn't even in the building at the time but was across the street when he saw the two apparent policemen arrive and, thinking it was a raid, he kept clear.

You know, I have heard of the Valentine's Day Massacre but had no idea that it related to Al Capone until I researched the man.

Quite bizarrely, the villain also had a good side to him. Apart from being a family man, he opened soup kitchens for those that

suffered from the 1929 stock market crash and also told shop owners to give clothes to the needy at his expense. It's hard to understand the balance of the two sides of him.

Whilst Capone ordered the murder of dozens of men and murdered several himself, it could never be proved because of the lack of witnesses. Indeed he was arrested in 1926 for killing three people but only spent one night in custody before being released due to lack of evidence. His grip on people's fear prevented anyone speaking against him. When he served his first prison sentence it was only for carrying a gun in 1929.

However, it was also in 1929 that Elliot Ness from the Bureau of Prohibition started an intense and successful campaign against the villain. He started knowing that there were many corrupt officers in the treasury department. He went through record after record, choosing his team carefully and firstly selecting fifty officers. Later that reduced to fifteen officers and then ten. Bit by bit he brought down the illegal empire, seizing brewery after brewery and speakeasy after speakeasy (places that illegally sold alcohol during the prohibition). Within six months Ness claimed to have seized breweries worth over $1 million and an attempt by Capone to bribe his men resulted in the forming of the name "The Untouchables". However, whilst Elliot Ness's attack on the organisation did phenomenal damage, it was another thing altogether that brought his downfall and put him in jail.

It was wrongly believed by many that the illegal earnings from gambling were not taxable. Capone had never filed a tax return, didn't own anything in his own name and did all his business through third parties so as to make him invisible to the Inland Revenue Service. However, one Frank Wilson from the IRS's Special Intelligence Unit was tasked with looking into Capone's affairs and came into possession of a ledger that clearly showed his earnings from gambling activities. Capone was indicted in 1931 for tax evasion, failure to file a tax return and also for violation of prohibition laws. Initially he pleaded guilty to the charges thinking

that he would be able to plea bargain. It was when Judge Wilkerson, who was presiding over the case, said that he would not entertain any bargaining that he then changed to Not Guilty. Instead he hoped to bribe or coerce the jury, but Wilkerson changed the whole jury at the last minute and they found him guilty on eighteen charges, resulting in a sentence of ten years in federal prison and a further one in county jail.

In 1932 he was sent to Atlanta Federal Prison where he soon gained special privileges and control over the other prisoners. When word of this spread, he was sent to Alcatraz where there were no other members of his gang and security was incredibly tight. He could gain no special conditions and instead conformed to the rules in an attempt to get time off for good behaviour.

However, his former habit of personally "interviewing" all new recruits for the prostitution rackets seemed to have gained him a problem with syphilitic dementia and he spent much of his time in the prison hospital.

After his release, he spent more time in hospital and then returned to his home in Palm Island, Florida. His mind and body continued to degrade and he was no longer able to continue with his gangland activities. Then on January 21st 1947 he had an apoplectic fit that led to a stroke. Pneumonia set in three days later and he died on the fourth.

So, with such a colourful and infamous resident, how could the City not take advantage of all the tourist money they could have taken with a museum, tours and merchandising??? Completely beats me!

Eventually my departure day came and I said my farewells to my hosts. I headed to the airport early, as I didn't know what was in store for a passenger without a passport. I checked in at the British Airways desk, presenting my photocopied form stating that I had reported my loss, and my UK driving licence. I explained the problem to the lady, as well as informing her that I had actually

phoned BA some days earlier so there should be a note on her screen. She checked and there was, but not surprisingly she chose to "just go and have a word with British Immigration". I waited where I was for around five minutes, whereupon she returned and told me that the man would like a word with me. She invited me to clamber over the baggage scale and I followed her into a backroom where I expected some uniformed official to already have the thumbscrews waiting for me. The office was untidy with files everywhere and there was a telephone on the desk with the receiver off the hook. I picked it up and said, 'Hello'.

The very English accent came back, 'Hello, I understand you have had your wallet stolen.'

I wasn't sure where the wallet bit had come from, but I didn't want to cause myself more problems so I chose my words carefully with, 'Well my passport has gone, yes.'

'Were you in the States on business or pleasure?' came the question.

'Both I suppose,' I said and told the faceless voice what I had done with touring for three months and writing a book on the way.

'You're not that man who has done fifty States in fifty days are you?' he asked. I had heard of this particular guy several times on my travels and whilst it's an impressive feat, I much preferred the thought of my slower, more leisurely travel.

'No,' I replied, 'though I have heard of him. I have only hit twenty-four States.'

'Okay,' he replied. 'Put the lady back on and I'll give her an authorisation number.'

I think you'll understand that I was more than a little surprised how easy this had been and told the man so. After all, this was only six months after 9/11.

'Well,' he said, 'if you'd had a strong accent, a South African one for example, I would have been suspicious, but you are obviously English. You also have to remember that we get about twenty Brits a day in the States, who are trying to get home after

having lost their passport, but I can usually tell if they are British after talking to them on the phone.' There wasn't much more to say to that. Incredible as it was, I had just had the shortest telephone interview of my life and that had apparently proved that I wasn't a suicide bomber. I'd like to think that the report I'd made losing my passport had got to British immigration and they had been expecting the call. As I say, that's what I'd like to believe!

I passed the receiver back to the lady and she spoke with the faceless voice again. She indicated to me that I should return to the check-in area whilst she did so, and I duly complied. A couple of minutes later she came out, handed me a scrappy piece of paper with a four-digit number on it and completed my check-in. I didn't have any problem getting on the plane or even getting through immigration at Heathrow. I simply presented the photocopied form, driving licence and tatty paper, to the lady at desk, as well as telling her that if she checked her screen she would see that I was already recorded on the system. She didn't even bother and just waved me through, though this time I do think she was already aware of who I was and that I was travelling without a passport.

It would be nice to be sure though, wouldn't it?

www.onebritonebike.com

WHAT NEXT ?

The trip was something that I felt I had to do and, now it's done, I am so glad I did it.

It was a hundred times better than I expected it would be, and has completely changed my views on America and Americans.

A few people have asked me if I would like to live there. With higher salaries, lower taxes, lower prices on a lot of things, the answer is yes, but they are only a small part of the attractions the country holds for me. The people, the incredible scenery, the millions of miles of road and, depending on the area, the weather, all have their influence too. I loved the country and would willingly live and work there, though I don't know exactly where I would choose. Most likely it would be California, because not only is the weather good, but wherever you are, you're within a few hours drive of the ocean, the mountains, or the desert. Most important of all, I liked the people, well most of them anyway. If there is anyone out there looking for an Englishman to go and work in the State, please give me a call.

There is also a downside to most things, but it is hard to think of anything I encountered that would be significant. I guess the worst of it was the road surfaces, which were appalling all over the country, and I swear that I'll never criticise English roads again. On the other hand, Americans are better at keeping traffic moving, with it being acceptable to turn right at a red light, and traffic signals at slip roads to busy freeways. These are minor points though.

I think it fair to say the journey has changed me, as every experience we have changes us a little. Now I'm ready to work

hard again, but I won't ever become a slave to the job like I felt I was before. I want to work to live and not the opposite.

The question of course is what to do, and it is a big one. I will most likely get back into sales as one of the attractions of the job was always the people, but in what field is something I still need to work out.

If I made another journey, it wouldn't be on a Harley. That isn't because I don't like the machines. I do, and I now understand so much better why they are made the way they are. No, the reason it would be on a different form of motorcycle is that the adventure I have forming in my mind is across much rougher terrain, and a Harley wouldn't be the right machine for it. I can't say that I'll definitely do the trip, especially as it probably isn't all that wise as a white English speaker, but who knows? Maybe I'll take Vince's advice and do the planning part, just for the fun of it.

If you have waded through this book, I hope I have given you a few laughs but, most importantly, I hope I have made you think. It's not my intention to sound patronising, but if you are like so many people these days, working ridiculously long hours, not getting to spend time with their families, and really a slave to the company, then please ask yourselves if it is what you want. None of us know when our time will be up, and, even if you live a long life, make sure you do something that you enjoy. If you want to undertake a big adventure, like this one was for me, then get on with it. Don't find excuses not to do it, but ways that mean you _can_ do it. It's a wonderful and interesting world out there. Go and see as much of it as you can.

Since I wrote these words things have moved on.

When I returned to the UK, I spent a while working for a friend and, whilst doing so, a leaflet arrived on my doormat offering a free local two hour seminar on property investment. It was a good time spent, the purpose of it to hook the attendees in for an expensive property investment course. Although it was an American organisation, they put up the names of their UK tutors and, when I saw that one of them was a successful person that I knew, I signed up there and then. So my property investment career began.

I now have a reasonable sized and profitable portfolio. I have learned so much along the way and have benefited tremendously from meeting other like-minded property people. So much so, that I formed a property networking group in Peterborough. If you have an interest in property investment then you are welcome to attend our monthly meetings and you can find the details at www.petpig.org (the "petpig" comes from PETerborough Property Investors Group).

Many people in property also get involved with a multi-level marketing company called The Utility Warehouse, and I too saw it as a fantastic opportunity. I became a distributor and can see my business really taking off. If you would like to work for yourself, are worried about a pension, or perhaps would like to work part-time but get paid for full-time, then it is perhaps something you should look at. If it interests you, then take a look at www.greatbizop.co.uk and watch the short video.

So the future looks great. I'm now married with a wonderful wife, stepdaughter and a couple of businesses, providing me with a good income, that are set to increase steadily. I've come a long way, not just in mileage, but also because I've completely changed my life to how it was before the trip. I'm no longer a wage slave having to kowtow to the bosses of the business I worked for. I have a family and I can work when I want to, letting me see my wonderful stepdaughter, Hannah, grow up. I can spend time with my wife and I can enjoy the fruits of my labour, instead of helping someone else get rich.

Life is good.

www.onebritonebike.com

Lightning Source UK Ltd.
Milton Keynes UK

174252UK00001B/168/P